\mathcal{D}ECORATIVE
~ *painting* ~

of the \mathcal{W}orld

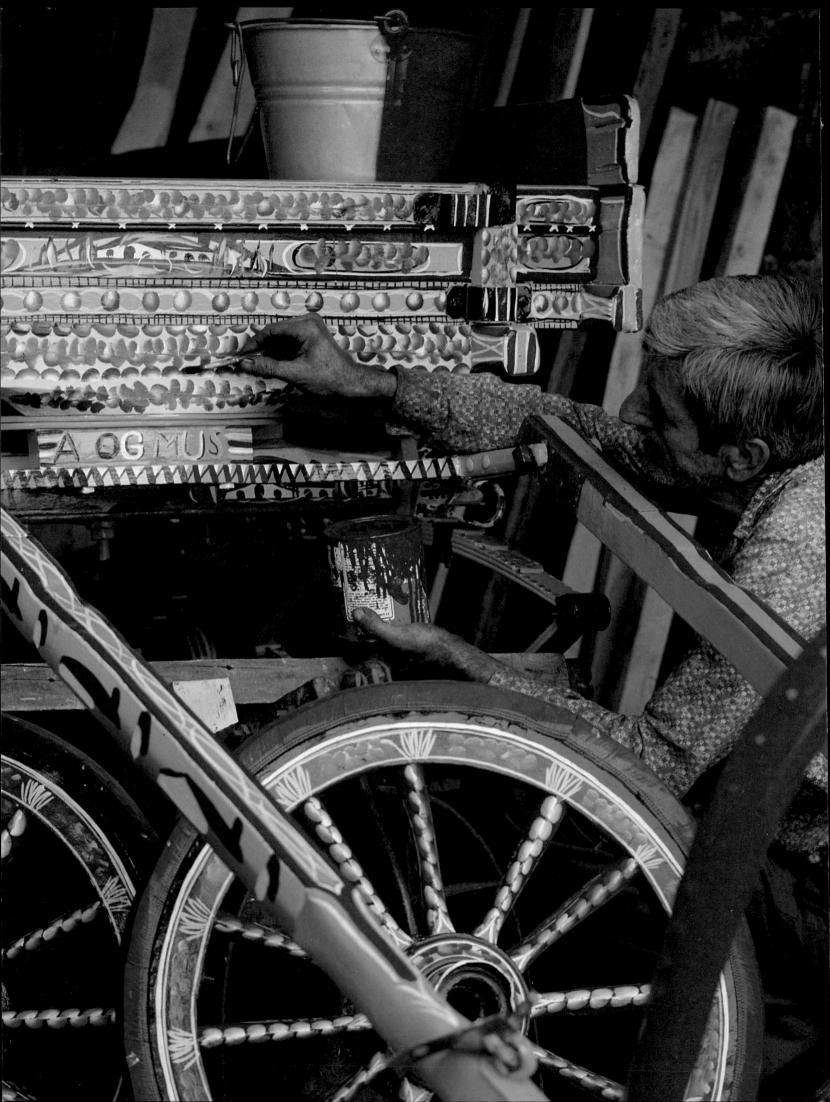

*D*ECORATIVE
~ *painting* ~

of the W*orld*

THUNDER BAY
P·R·E·S·S

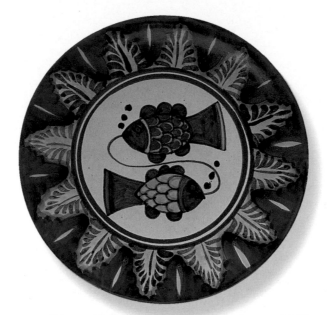

First published in the United States 1995
by Thunder Bay Press
5880 Oberlin Drive, Suite 400, San Diego, CA 92121-9653

Copyright © 1995 WORLD LIVING ARTS Pty Limited

Publisher: Tracy Marsh
Art Director: Vicki James
Project Coordinator: Debi McCulloch
Editor: Susan Gray
Editorial Assistant: Leonie Draper
Graphic Designer: Peta Nugent
Photographer: Adam Bruzzone
Photographic Stylist: Anne-Maree Unwin
Production Manager: Mick Bagnato

Library of Congress Cataloging-in-Publication Data
Decorative painting of the world.
 p. cm.
 "First published in Australia in 1995 by RD Press" --T.p. verso.
 Includes index.
 ISBN (invalid) 157145645
 1. Painting. 2. Folk art. 3. Decoration and ornament.
I. Thunder Bay Press.
TT385.D44 1995
745.7'23--dc20 95-18365
 CIP
Manufactured by Mandarin Offset, Hong Kong
Printed in Hong Kong

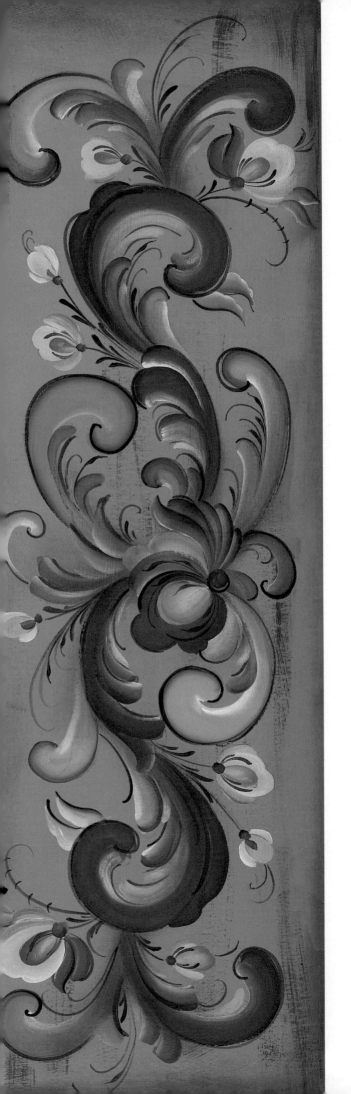

CONTENTS

ABOUT THIS BOOK

As LONG as people have had homes, they have decorated them with paint or pigments. Drawing images from everyday life and using the colors of a traditional palette, ordinary people have tried to brighten their surroundings and express their sense of belonging to a cultural group. The embellishment of domestic objects and surfaces in this way is sometimes called folk art or, more commonly, decorative painting.

Remarkable similarities can be found in the history of decorative painting. The ancient Egyptians used many techniques common to eighteenth century Bavaria, such as woodgraining and false marbling. However, the development of painting in each

Mexican plate

society very much depended on the materials available and contact with outside cultures. Even within Europe, great stylistic differences arose between such neighboring countries as Norway and Sweden, or Germany and Poland. There is a clear pattern of influence along trade routes—the East on Dutch Hindeloopen—and along the paths of domination: the conquering Moors diverted Spanish decoration and, in turn, the conquistadors affected the art of Mexico. The study of cultural history through folk painting is a fascinating one.

In many societies there is no distinction between decorative painting and fine art painting. Even in the West, this discrimination is relatively new and possibly shortlived, as decorative painting is enjoying recovered status today. There is also a growing interest in the lifestyle of other countries; more and

more we are looking to cultures around the world for inspiration in decoration and design.

This book brings those two strands together by encouraging interest in decorative painting and inspiring the reader to draw from folk styles from around the world. To achieve this, the information it provides has been made as accessible as possible.

Each chapter looks at a different painting tradition, either of a region or of a cultural group. The opening pages provide insight into the heritage of those people and the Designs and Variations spread offers a wealth of ideas for adapting designs, creating borders and varying the color schemes. The projects then guide you through the painting stages to produce a piece in the style of that tradition. Each project is graded in the following way:

BEGINNER
No painting experience required, but you will need to refer to the General Information chapter

INTERMEDIATE
Requires some practice on brushstrokes before undertaking the project

ADVANCED
Includes difficult brushstrokes and will require some skill

The General Information chapter explains how to scale designs, prepare surfaces, paint different brush-strokes and finish your masterpiece. A color chart is included, giving a recipe for each project color using a small range of basic colors. There are twenty-five pages of designs, ready for tracing and transferring, plus a comprehensive glossary and index to help you find your way around the book.

Lascaux cave paintings in the Dordogne region of France are an early example of decoration with colored pigments.

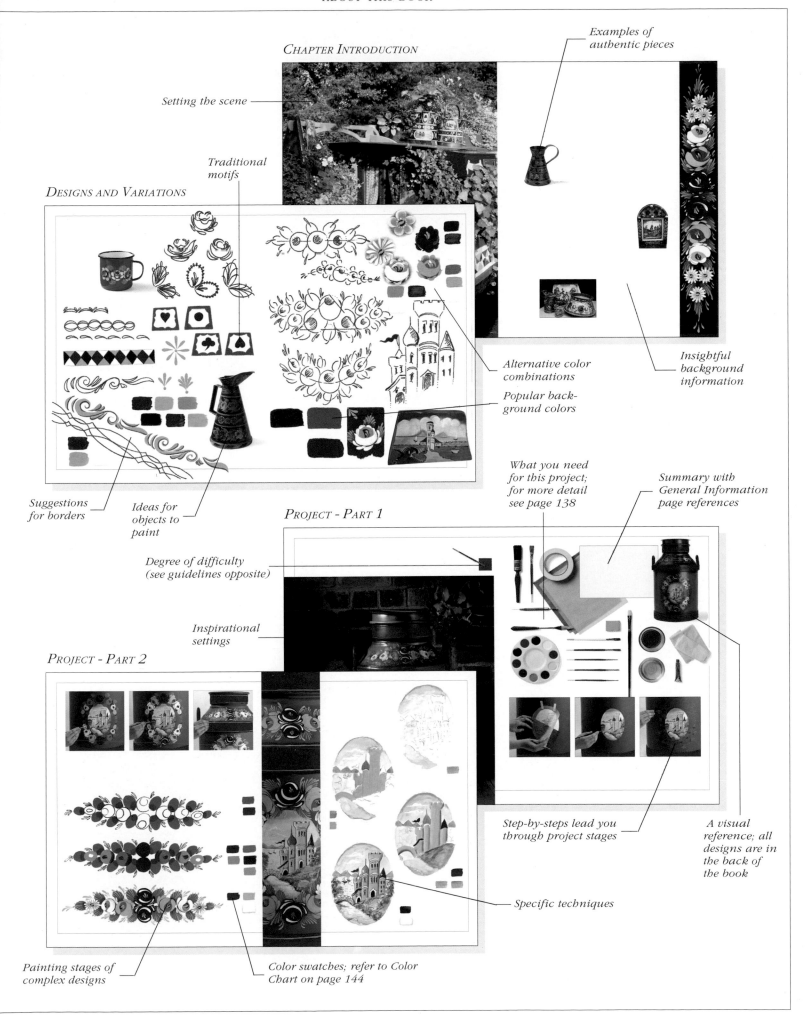

CHAPTER INTRODUCTION

Setting the scene

Examples of authentic pieces

Traditional motifs

DESIGNS AND VARIATIONS

Alternative color combinations

Popular back-ground colors

Insightful background information

Suggestions for borders

Ideas for objects to paint

PROJECT - PART 1

What you need for this project; for more detail see page 138

Summary with General Information page references

Degree of difficulty (see guidelines opposite)

Inspirational settings

PROJECT - PART 2

Step-by-steps lead you through project stages

A visual reference; all designs are in the back of the book

Specific techniques

Painting stages of complex designs

Color swatches; refer to Color Chart on page 144

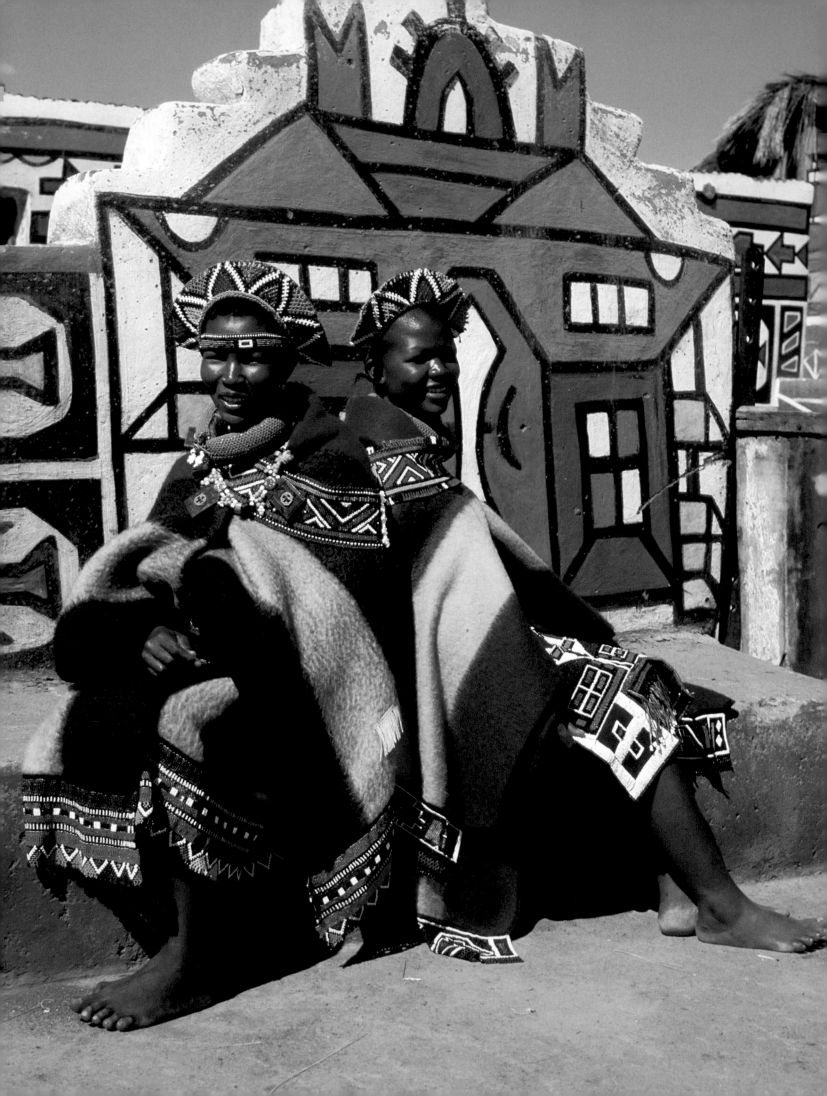

AFRICAN TRIBAL ART

THROUGHOUT THE WORLD, traditions of folk art are handed down through succeeding generations. In Africa, each tribe's traditions of belief, art and ceremony distinguish it from neighboring tribes. This has resulted in an exciting array of styles, designs, symbols and displays of color in African decorative painting. Here, art is not a separate arena of life, but an essential form of individual and tribal expression.

Beaded neckbands

The earliest forms of African painting can be seen even today on rock faces and in the caves of the Sahara desert. These works of art depict the people, tools and activities of daily life, as well as animals: the elephant, rhinoceros, antelope, ostrich and giraffe. Today, artists still decorate small stones, creating a design which emerges from the rock's natural shape: a curled cat or other animal.

Many everyday implements, including combs, bobbins, spoons and bowls, are decorated to reflect social status or simply for their aesthetic appeal. Ceremonies play an important part in tribal life and the face and body are often painted with ochres for festivals or rites of passage. Ceremonial objects such as drums, weapons and masks are lavishly painted and adorned with beads, feathers and bones.

When western-style settlements developed, the exterior walls of homes, particularly those facing communal courtyards, were often decorated with pigments. Colors had different powers: red ochre enabled communication with one's ancestors; white, particularly around windows, protected against vengeful spirits. Today, earth pigments have generally been abandoned for acrylic paints and whole South African townships are alive with dramatic wall paintings.

The decorative art of Africa strikes us as fresh and un-complicated; apart from the early influence of ancient Egypt, it is a highly original style. It is no wonder that Western artists such as Picasso, who sought to break away from the Renaissance tradition, found in it a rich source of ideas and images. Perhaps the greatest difference between the two traditions is the way in which art is perceived: in Africa, the process of creation is valued more highly than the finished piece.

Branded gourd

The colors of a Ndebele wall mural match the traditional costumes of the women for brilliance.

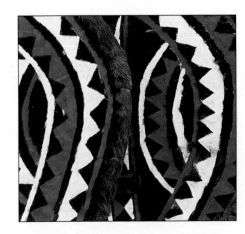

Ceremonial shields in earth colors

9

DESIGNS AND VARIATIONS

African artists delight in combining contrasting colors,
which are frequently separated from one another by black
or dark brown outlines. Animals are sometimes depicted,
but geometric shapes are the basic
unit in African design. For some
tribes, these bear a symbolic
meaning; for others,
they are simply
pleasing to the eye.

HATCHING
*Striking banded designs can be
taken from these pokerwork bowls.*

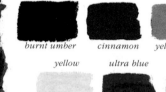
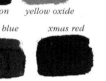

burnt umber cinnamon yellow oxide

yellow ultra blue xmas red

SYMBOLS
*For the Nsibidi
tribe, repeated
triangles and
diamonds signify
the leopard and
his spots.*

COLORWAYS
*The combination
below features in
the project overleaf.*

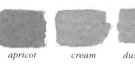

apricot cream dusty blue

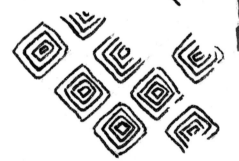

BORDERS
*Triangles can be connected in a
variety of ways and repeated with
great effect, as on this shield.*

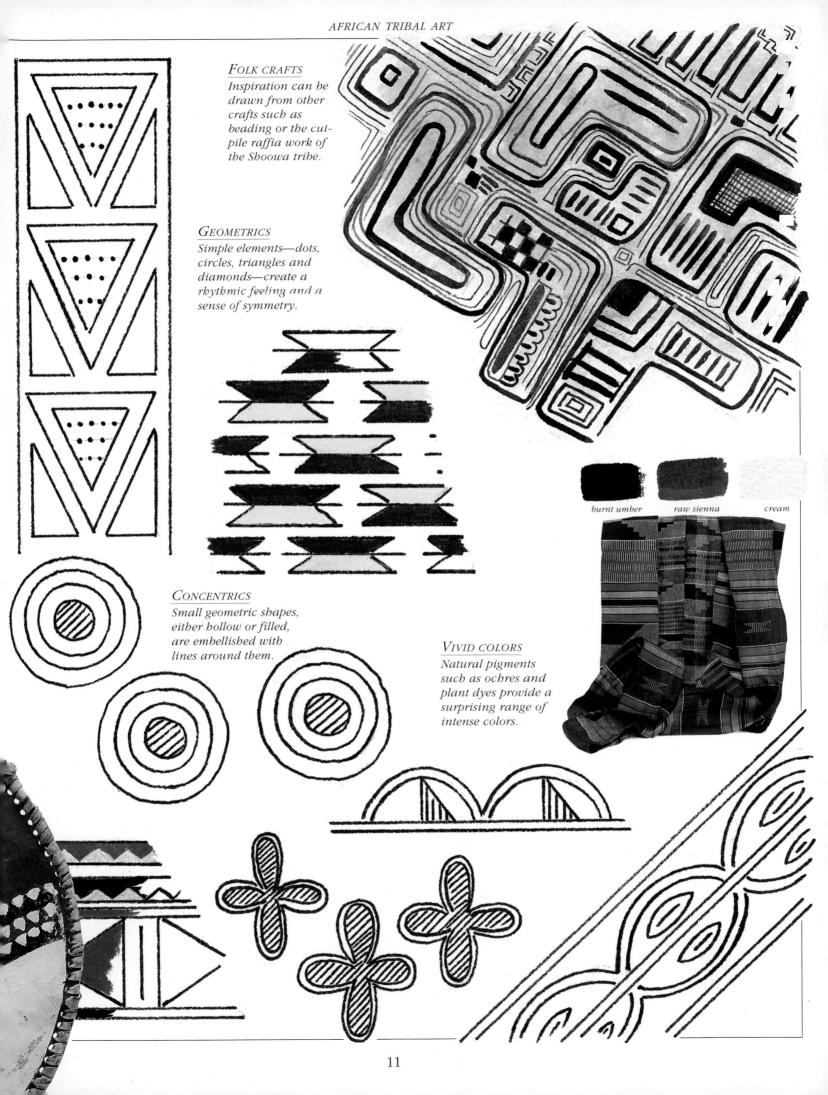

FOLK CRAFTS
Inspiration can be drawn from other crafts such as beading or the cut-pile raffia work of the Shoowa tribe.

GEOMETRICS
Simple elements—dots, circles, triangles and diamonds—create a rhythmic feeling and a sense of symmetry.

CONCENTRICS
Small geometric shapes, either hollow or filled, are embellished with lines around them.

burnt umber raw sienna cream

VIVID COLORS
Natural pigments such as ochres and plant dyes provide a surprising range of intense colors.

PROJECT: AFRICAN POT

The simple lines and natural colors of this design make it an attractive starting point for new painters. This piece is made of basecoated papier-mâché; a sealed terracotta pot would also be suitable.

Level of difficulty: Beginner

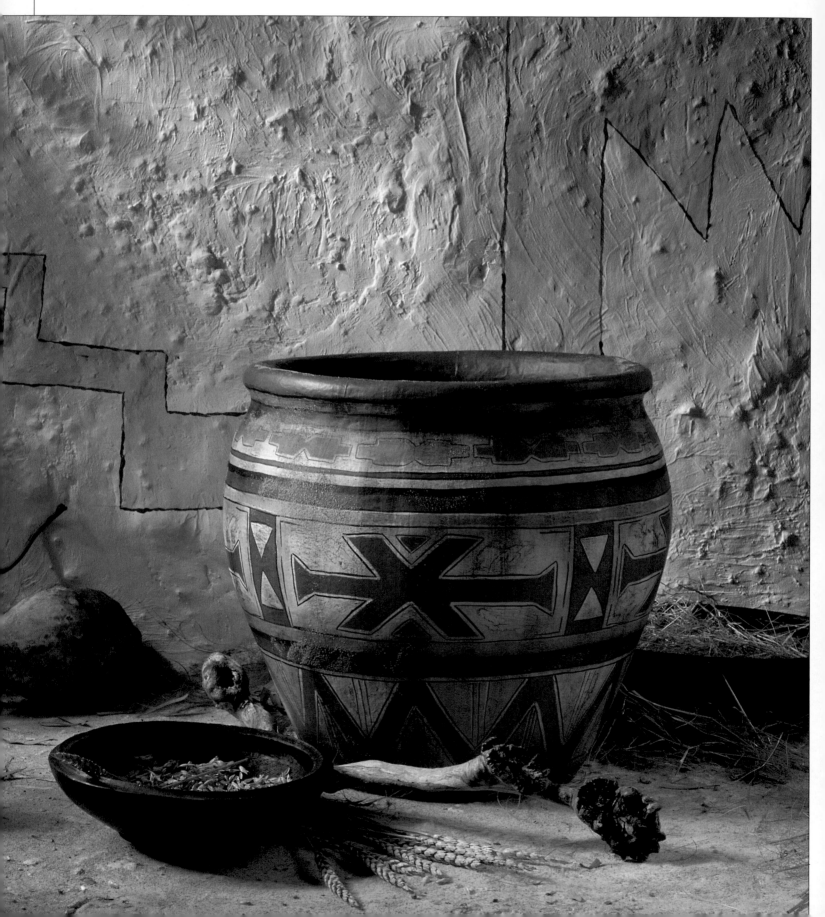

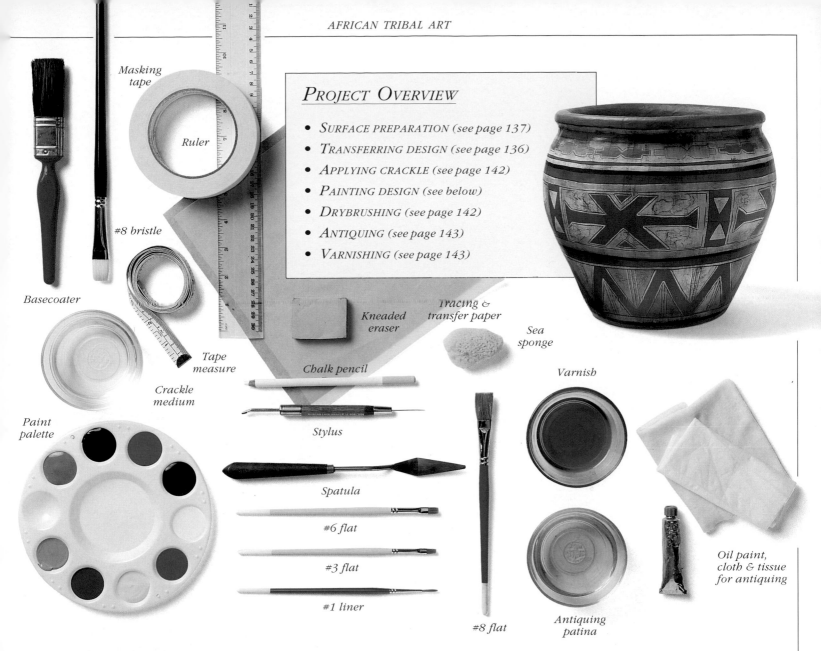

Masking tape

Ruler

#8 bristle

Basecoater

Crackle medium

Tape measure

Paint palette

Kneaded eraser

Chalk pencil

Stylus

Tracing & transfer paper

Sea sponge

Varnish

Spatula

#6 flat

#3 flat

#1 liner

#8 flat

Antiquing patina

Oil paint, cloth & tissue for antiquing

PROJECT OVERVIEW

- SURFACE PREPARATION (see page 137)
- TRANSFERRING DESIGN (see page 136)
- APPLYING CRACKLE (see page 142)
- PAINTING DESIGN (see below)
- DRYBRUSHING (see page 142)
- ANTIQUING (see page 143)
- VARNISHING (see page 143)

PAINTING STEP-BY-STEP

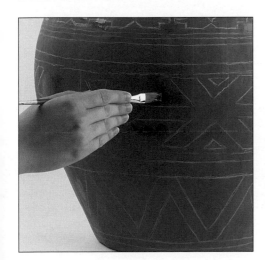

1 Prepare the surface as appropriate. Transfer the design (page 146) freehand with a tape measure and ruler. With a #8 bristle brush, apply crackle medium to major color areas.

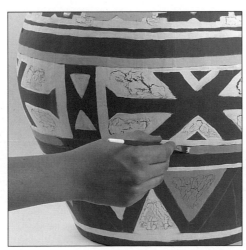

2 Block in cream, apricot and dusty blue where shown. Use a sea sponge to cover crackled area and a #6 or #3 flat brush in other areas as appropriate. Leave to dry before continuing.

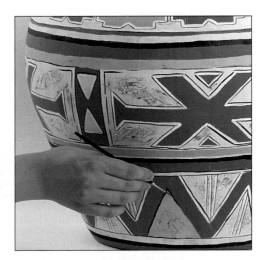

3 Use a #1 liner to paint narrow bands and detail in dark brown. Leave to dry. Use a #8 flat to drybrush burnt umber at random. When dry, erase lines and antique. Varnish to complete.

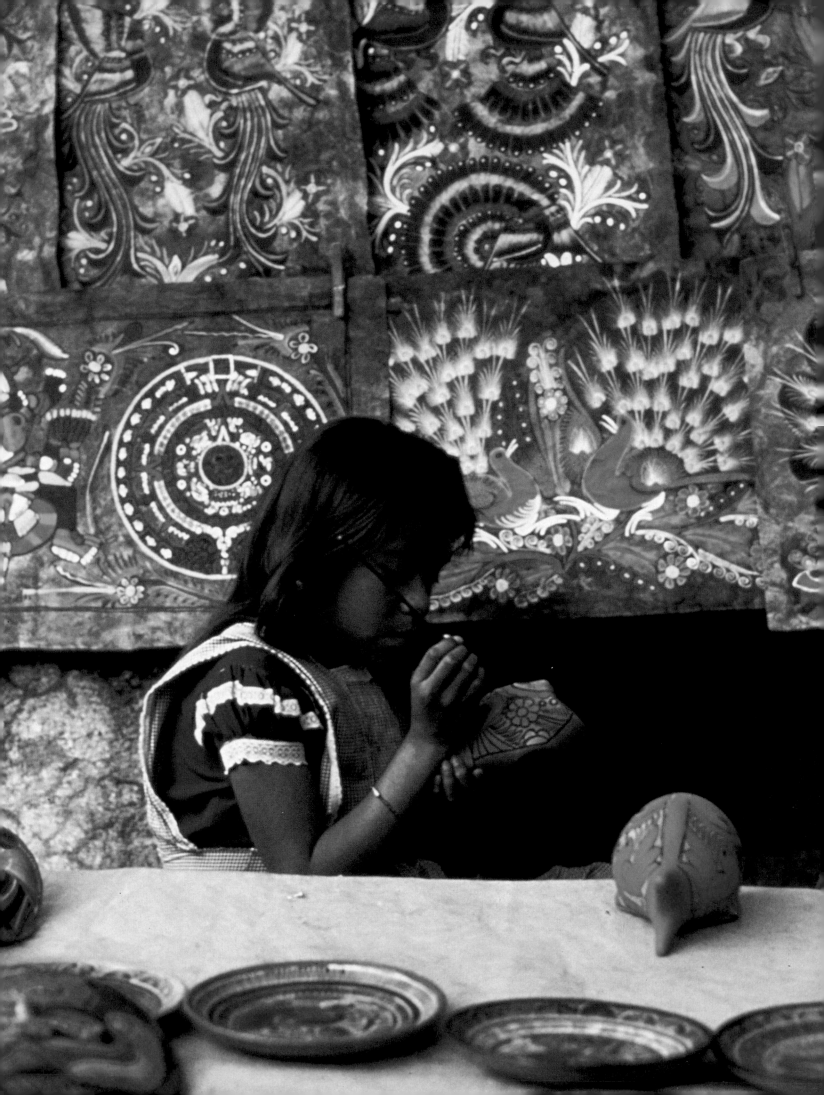

MEXICAN PAINTING

MEXICO is a land of bright colors and dramatic history. Vibrant sunsets, luscious fruits, vivid flowers, and birds with resplendent plumage have inspired Mexico's decorative painters to juxtapose brilliant hues. The vast heritage of Mexico's ancient cultures and its conquistadores also provide a wealth of motifs and designs. The folk art of this country is as striking as its origins.

Art played an important role in the pre-Hispanic civilizations of Mexico. The pyramids and temples of the Aztec and Maya carried brightly painted sculptural reliefs and large frescoes of mythical animals. A wealth of information about their world is provided by pictorial manuscripts, or codices. These documents, painted onto deerskin or bark paper and then folded concertina-fashion, were decorated with highly stylized images of gods, rulers and warriors. The arrival of the Spanish in 1519 marked the destruction of the Aztec empire but, in remote areas, many Indian communities retained the customs of their ancestors and, today, crafts are an essential part of life.

This mix of the functional with the decorative is seen in the labor-intensive art of lacquerworking. Fruit from the calabash tree has a hard rind which provides villagers with bowls for food and drink. Once dried, the inside of the gourd is smeared with oil from chia seeds and coated with a colored paste. The surface is then decorated with brilliant flower, bird and animal motifs and sealed with oil. In the village of Olinala, dishes, trays, screens, boxes and trunks of pine and sweet-smelling *linaloe* wood are lavishly decorated. Here they also practice the art of *rayado*: painting two coats of lacquer in contrasting colors, scratching a design with a thorn or needle, and then scraping away the topcoat to reveal the image.

Lacquerwork

Papier-mâché doll

Some forms of painting have changed over time. Nahua villagers who once decorated pottery now paint striking landscapes on handmade bark paper, combining fantasy with realism. Papier-mâché dolls and animals abound, all in bizarre shapes and garish colors. Popular painting is found in fairs and markets or on shopfronts and houses and reflects the Mexican love of beauty and ornament.

Against a backdrop of bark paintings, a Nahua child paints pottery for market.

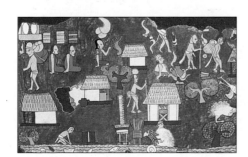

Mayan fresco, depicting daily activities

DESIGNS AND VARIATIONS

The palette of the Mexican painter is a vivid one: purples and pinks are combined with bright greens and startling yellows. The images are also startling: colorful skeletons and devils abound during the Festival of the Dead, while everyday art is a profusion of birds, animals and brilliant flowers. Decorative painters can also draw inspiration from the ancient art of the Aztec and Maya civilizations.

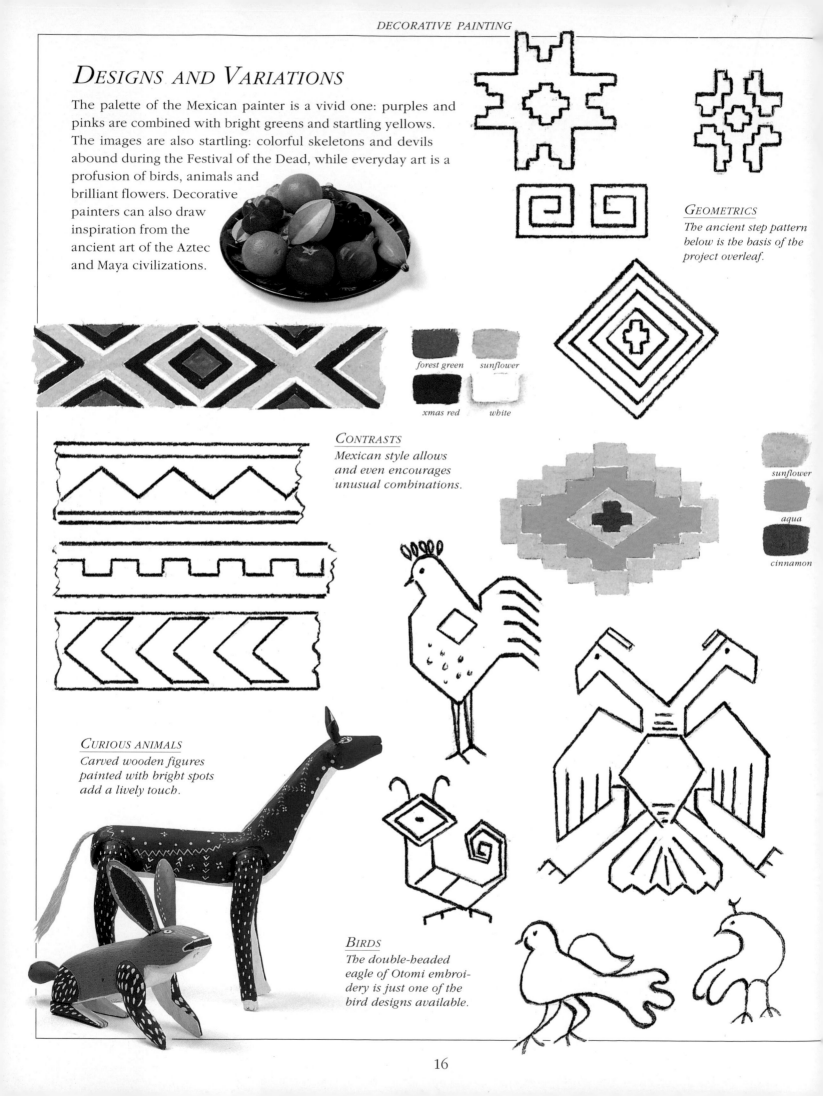

GEOMETRICS
The ancient step pattern below is the basis of the project overleaf.

forest green sunflower

xmas red white

CONTRASTS
Mexican style allows and even encourages unusual combinations.

sunflower

aqua

cinnamon

CURIOUS ANIMALS
Carved wooden figures painted with bright spots add a lively touch.

BIRDS
The double-headed eagle of Otomi embroidery is just one of the bird designs available.

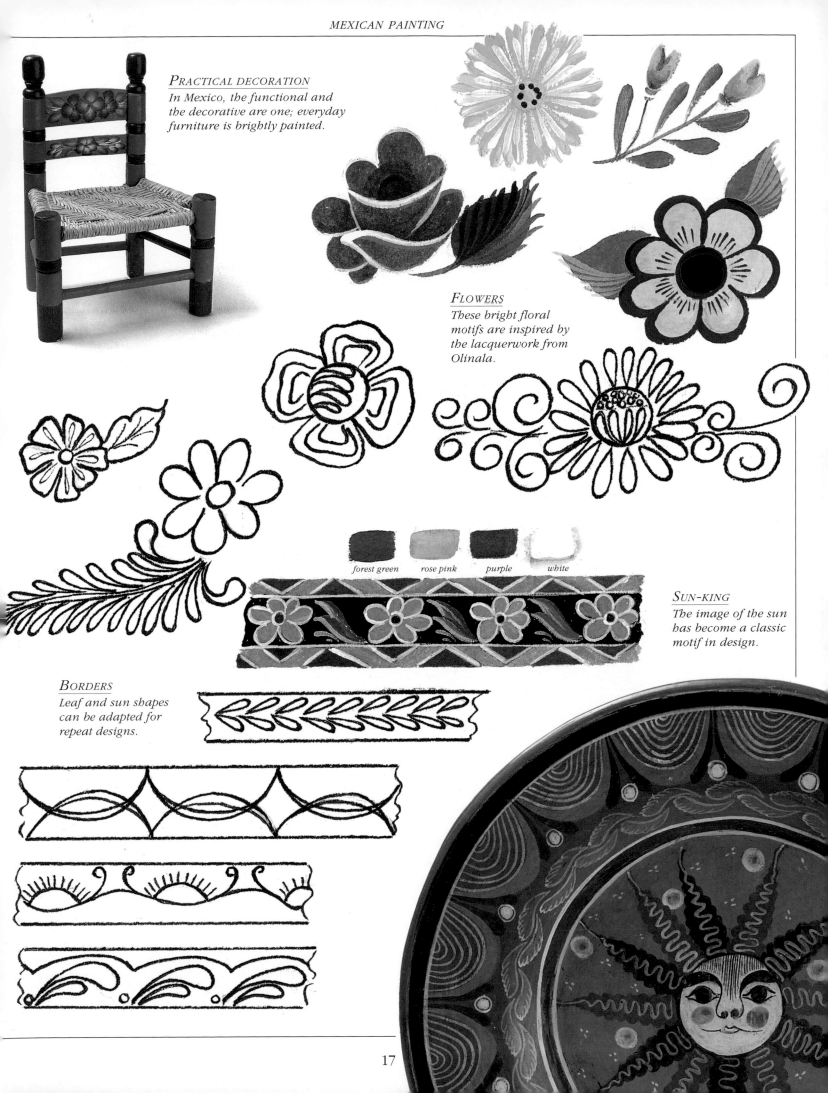

PRACTICAL DECORATION
In Mexico, the functional and the decorative are one; everyday furniture is brightly painted.

FLOWERS
These bright floral motifs are inspired by the lacquerwork from Olinala.

forest green rose pink purple white

SUN-KING
The image of the sun has become a classic motif in design.

BORDERS
Leaf and sun shapes can be adapted for repeat designs.

17

PROJECT: MEXICAN CHAIR

Contrasting colors and matte textures are characteristic of
Mexico; in this design, three strong colors are combined in an
Aztec step pattern. This is a quick and straightforward project,
ideal for beginners.

Level of difficulty: Beginner

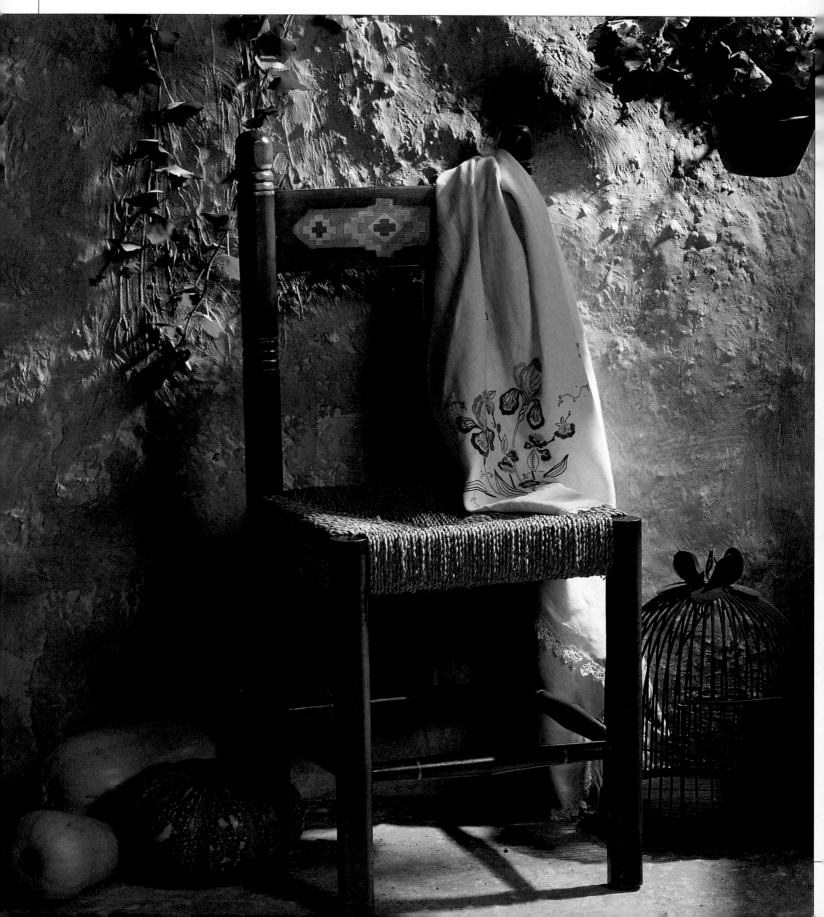

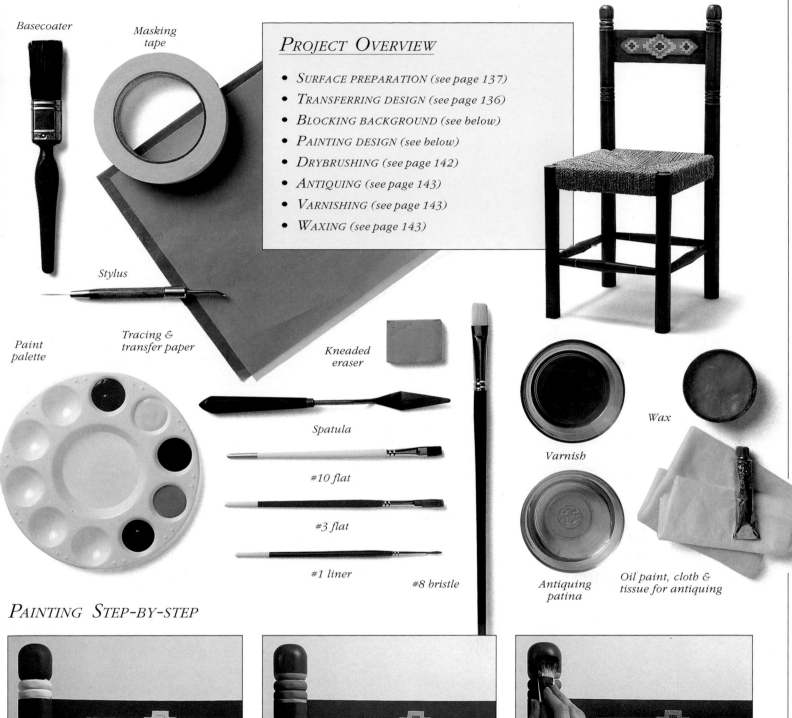

Basecoater

Masking tape

Stylus

Paint palette

Tracing & transfer paper

Kneaded eraser

Spatula

#10 flat

#3 flat

#1 liner

#8 bristle

Varnish

Wax

Antiquing patina

Oil paint, cloth & tissue for antiquing

PROJECT OVERVIEW

- SURFACE PREPARATION (see page 137)
- TRANSFERRING DESIGN (see page 136)
- BLOCKING BACKGROUND (see below)
- PAINTING DESIGN (see below)
- DRYBRUSHING (see page 142)
- ANTIQUING (see page 143)
- VARNISHING (see page 143)
- WAXING (see page 143)

PAINTING STEP-BY-STEP

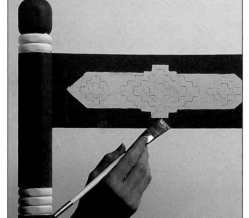

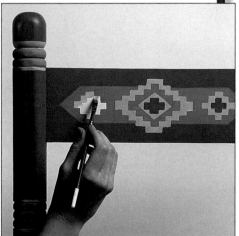

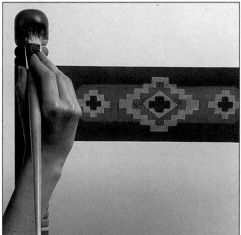

1 Prepare the surface; if the chair is dark base color, undercoat white with a basecoat brush. Transfer the design (page 146). Paint the background with two coats of cinnamon using a #10 flat brush.

2 When background is dry, block in the aqua, sunflower and cinnamon on the design using a #3 flat brush. Paint bands on chair rung with a #1 liner. Apply a second coat to the design and the bands.

3 Use a #8 bristle brush to drybrush burnt umber, emphasizing around the design and rungs and lightly over the design. When dry, erase lines and antique. Varnish the chair and wax to complete.

PROJECT: MEXICAN WASHSTAND

Sky and earth colors are used to paint this bedside washstand or cabinet. As well as the color gradation, it features the popular sun motif which could decorate a box or platter on its own.

Level of difficulty: Intermediate

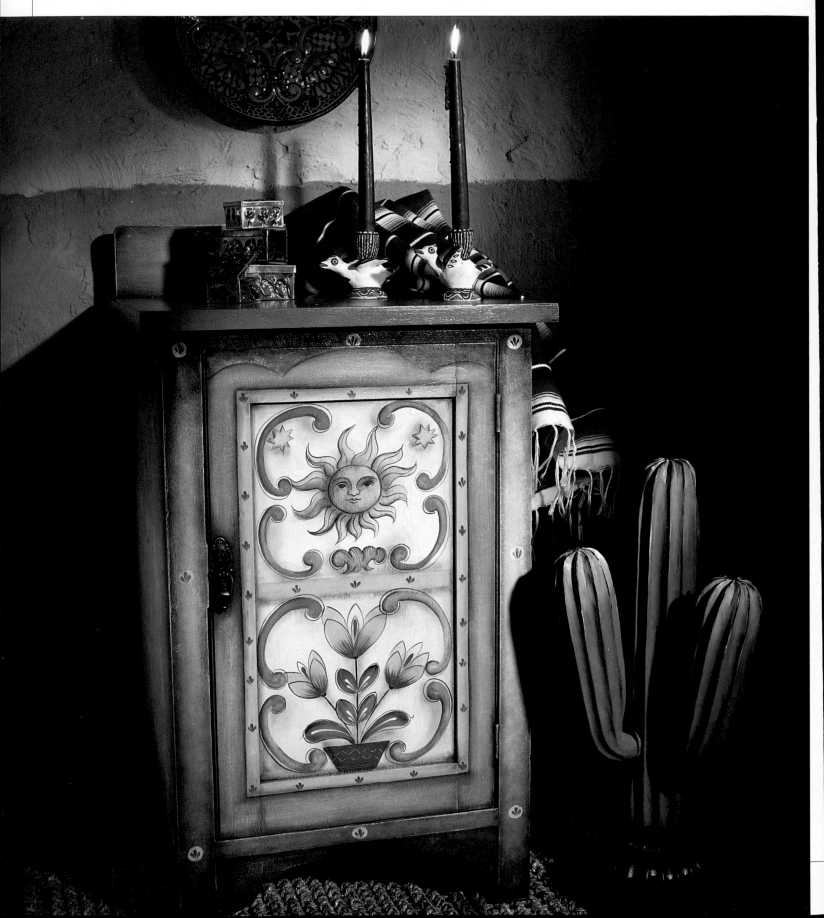

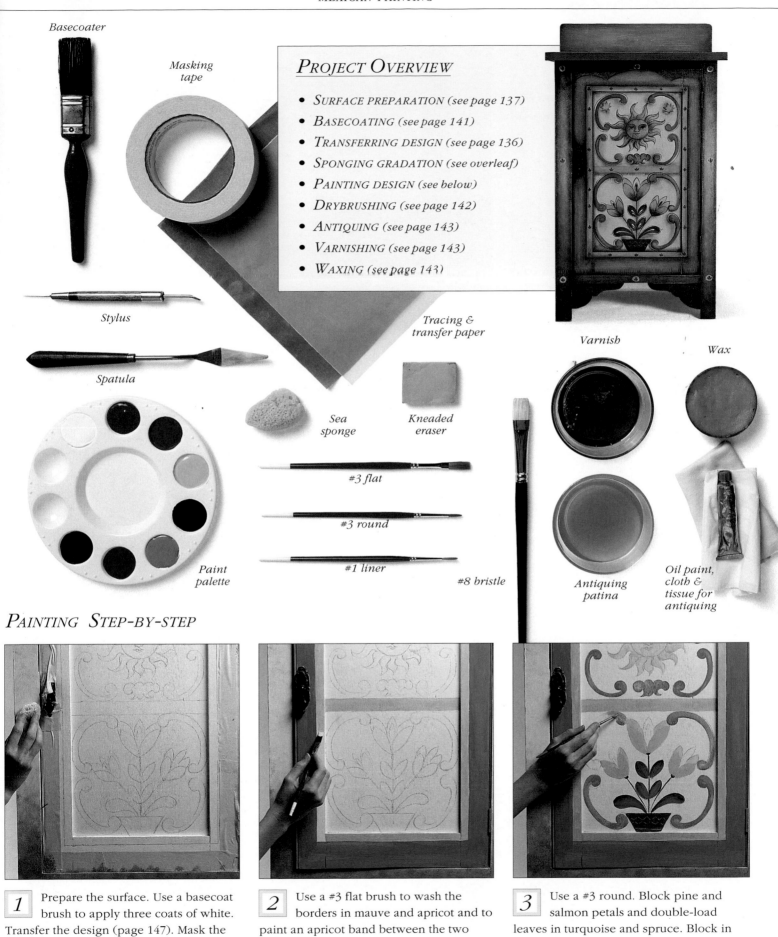

Basecoater

Masking tape

Stylus

Spatula

Tracing & transfer paper

PROJECT OVERVIEW

- SURFACE PREPARATION (see page 137)
- BASECOATING (see page 141)
- TRANSFERRING DESIGN (see page 136)
- SPONGING GRADATION (see overleaf)
- PAINTING DESIGN (see below)
- DRYBRUSHING (see page 142)
- ANTIQUING (see page 143)
- VARNISHING (see page 143)
- WAXING (see page 143)

Varnish

Wax

Sea sponge

Kneaded eraser

Paint palette

#3 flat

#3 round

#1 liner

#8 bristle

Antiquing patina

Oil paint, cloth & tissue for antiquing

PAINTING STEP-BY-STEP

1 Prepare the surface. Use a basecoat brush to apply three coats of white. Transfer the design (page 147). Mask the door and apply the color gradation with a brush and sea sponge; see overleaf for painting stages.

2 Use a #3 flat brush to wash the borders in mauve and apricot and to paint an apricot band between the two sections of the design.

3 Use a #3 round. Block pine and salmon petals and double-load leaves in turquoise and spruce. Block in cinnamon vase and, before dry, scratch with a stylus. Wash in ultra blue scrolls and pine sun (see overleaf for painting stages).

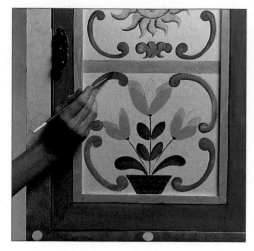

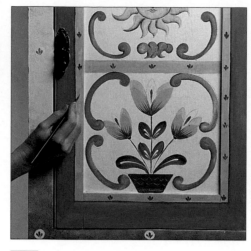

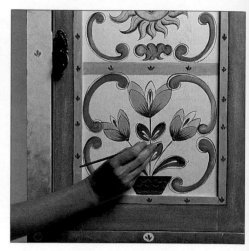

4 Paint white circular patches spaced around the panel with the tip of your finger. Use a #3 flat brush side-loaded with burnt umber to shade the sun and stars.

5 Paint cinnamon overstrokes on petals and cream on leaves with a #3 round brush. Paint teardrop strokes on the white patches and on apricot borders, in either turquoise or cinnamon, using the #3 round.

6 Add detail in burnt umber with a #1 liner. When dry, use a #8 bristle brush to drybrush cream lightly around panels. Mix cinnamon and salmon and paint top of washstand. Erase lines, then antique, varnish and wax.

SUN PAINTING STAGES

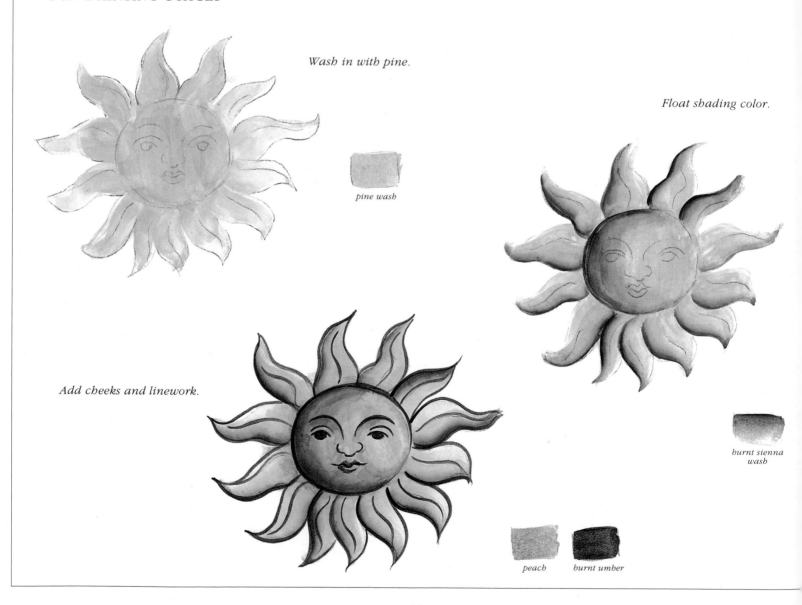

Wash in with pine.

pine wash

Float shading color.

burnt sienna wash

Add cheeks and linework.

peach *burnt umber*

COLOR GRADATION PAINTING STAGES

By using a sponge to apply paint, you can control the amount of color and combine colors in a mottled effect. It is most effective on larger areas, particularly if a color gradation is being applied. Sponge colors wet-on-wet.

Sponge spruce at top and burnt sienna at base.

Overlap with mauve and salmon, moving towards center.

Overlap with turquoise and apricot. Sponge white in center.

SCRATCHING

Block in shape and, while the paint is still wet, scratch a design with a stylus or the end of a brush.

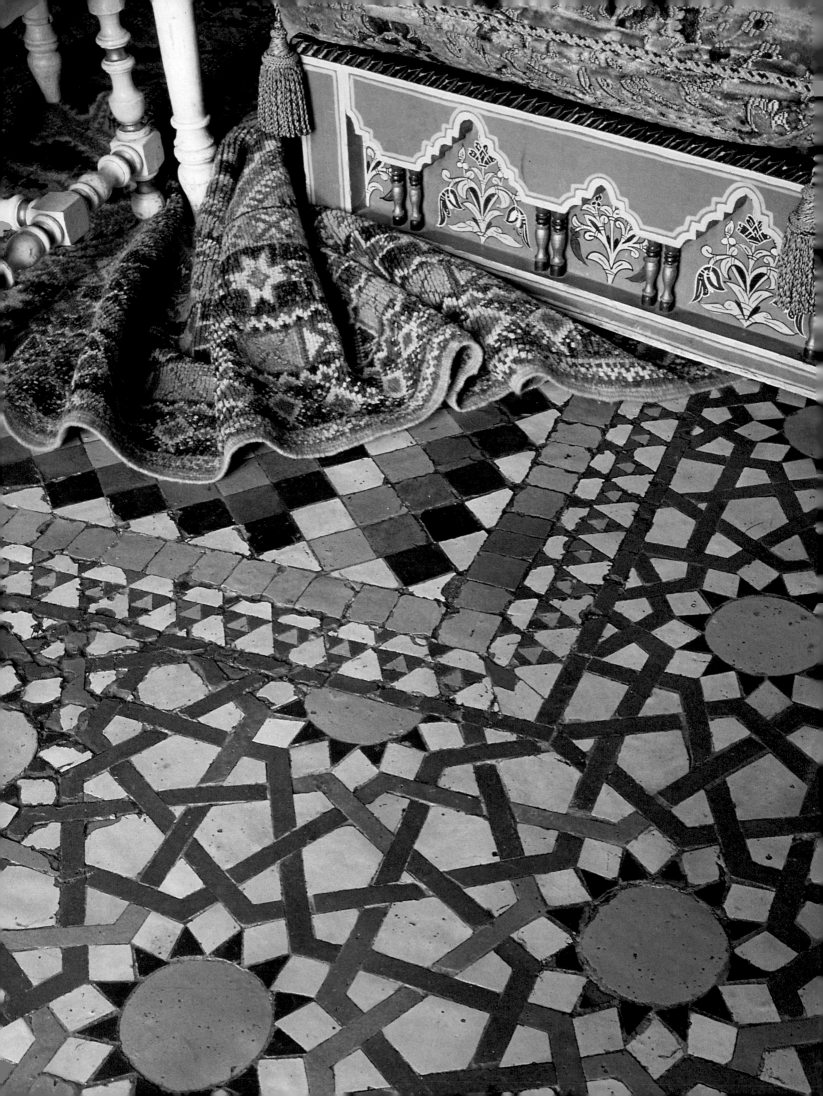

ISLAMIC STYLE

The Islamic Age dates from the seventh century AD when the words of the prophet Mohammed were recorded as the Koran. Its influence spread across an enormous area, stretching from North Africa and Spain to Egypt, Turkey and Iran, and beyond the China Sea as far as Indonesia. An integral part of the religion is its expression in Muslim art, characterized by sophisticated colors and intricate patterns.

Sandalwood trunk

From the twelfth century on, strong colors adorned clothing, items of daily use, houses and entire mosques. The Koran forbade the carving of images or idols and this rule was extended to painting. As artists were not permitted to paint figures which cast shadows, they did not use shading to imply dimension, but used pure colors which have a brilliant, enamel-like sheen.

This same religious ruling encouraged the painting of patterns and abstract designs: even natural motifs such as leaves are stylized. Basic elements of Islamic design include polygons (geometric figures with many sides, such as a star or octagon), the arabesque (leafy foliage which twines in and out of a continuous stem) and calligraphy, or ornamental script. The first two can be repeated endlessly. The latter, once prized for its role in recording the word of Mohammed, now has a decorative value and is often impossible to read.

Muslim houses contain few pieces of furniture; seating areas are often built into the architecture and tiled, while cushions and rugs are used to create lounging areas. However, chests are commonly used to store clothes and belongings, and most homes have low tables on which tea and coffee are served. Morocco, which had an early French influence, developed its own

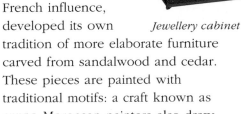

Jewellery cabinet

tradition of more elaborate furniture carved from sandalwood and cedar. These pieces are painted with traditional motifs: a craft known as *zwaq*. Moroccan painters also draw on a unique palette, with darker and richer colors, including red, green and navy blue.

Islamic design has many forms of expression: Turkish carpets, Egyptian textiles, Iranian ceramics and the mosaics which adorn so many Muslim buildings. All offer great inspiration for the decorative painter.

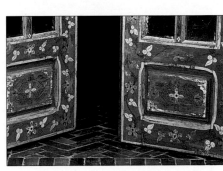

A profusion of color and pattern is created with paint, ceramic and fabric. Islamic doors are seldom left undecorated.

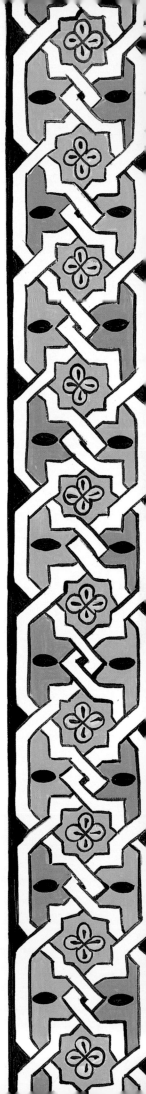

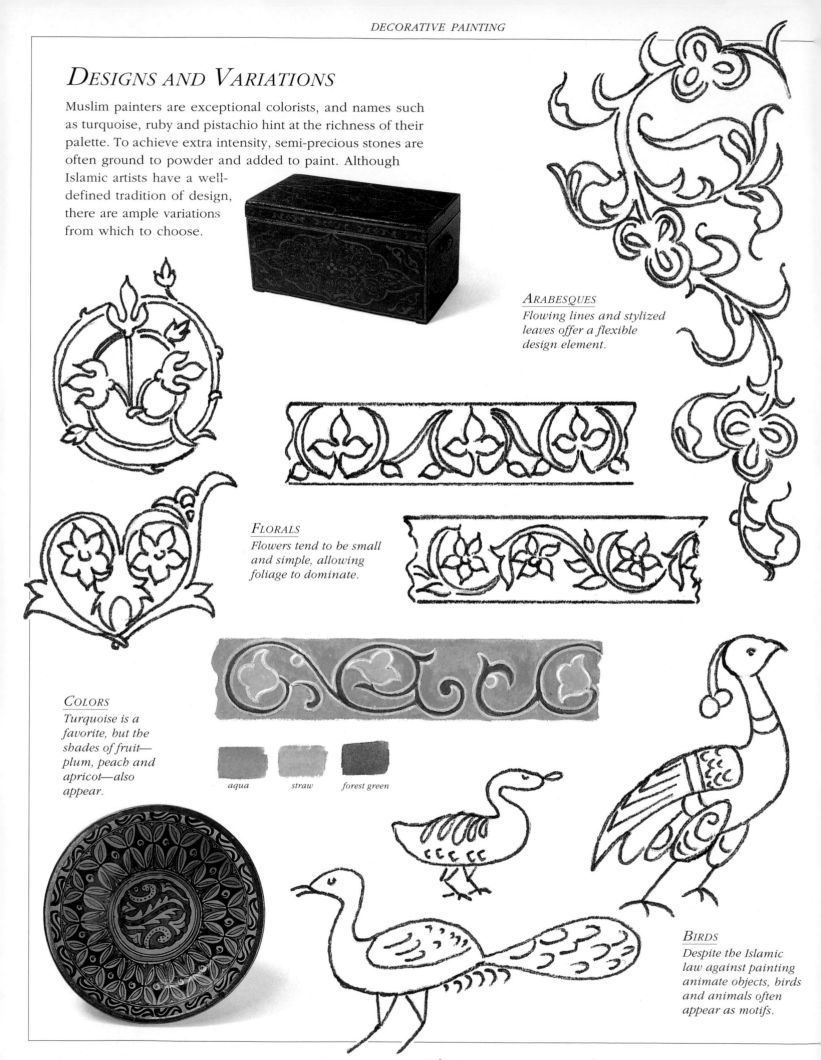

DESIGNS AND VARIATIONS

Muslim painters are exceptional colorists, and names such as turquoise, ruby and pistachio hint at the richness of their palette. To achieve extra intensity, semi-precious stones are often ground to powder and added to paint. Although Islamic artists have a well-defined tradition of design, there are ample variations from which to choose.

ARABESQUES
Flowing lines and stylized leaves offer a flexible design element.

FLORALS
Flowers tend to be small and simple, allowing foliage to dominate.

COLORS
Turquoise is a favorite, but the shades of fruit—plum, peach and apricot—also appear.

aqua straw forest green

BIRDS
Despite the Islamic law against painting animate objects, birds and animals often appear as motifs.

POLYGONS
Multi-faceted figures can stand alone or be incorporated in an endless pattern.

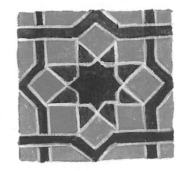

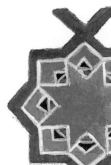

CALLIGRAPHY
Script incorporated in designs is often ornamental rather than functional.

ZWAQ
These painted shutters or mushrabiyya are an example of Moroccan work.

BORDERS
Geometrics make ideal borders; the colors below are featured in the project overleaf.

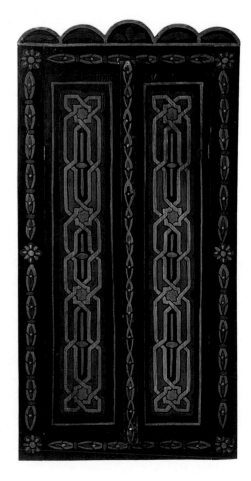

red oxide olive cream red spruce French blue

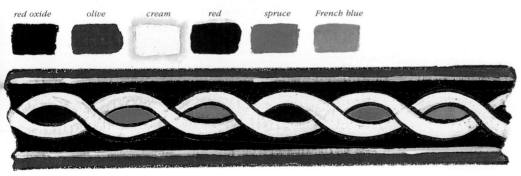

PROJECT: MOROCCAN SHOEBOX

This typical Islamic shoebox is decorated with curling arabesques and flowers in rich Moroccan colors which are identified on the previous page. Despite the impressive appearance, this project is completed with simple brushstrokes.

Level of difficulty: Beginner

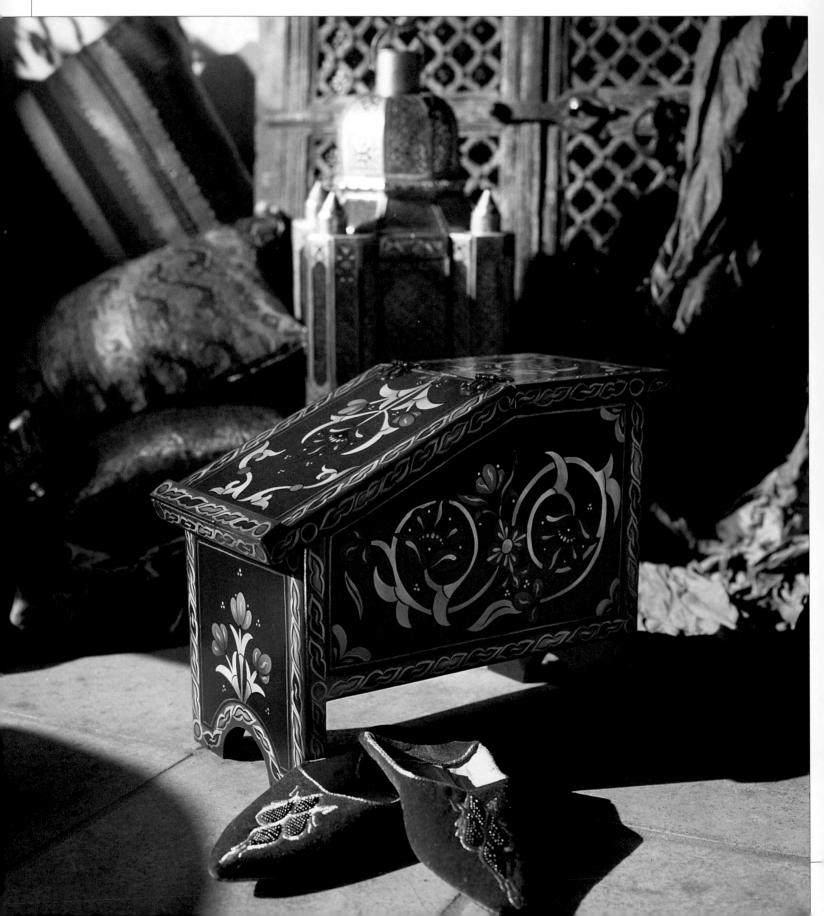

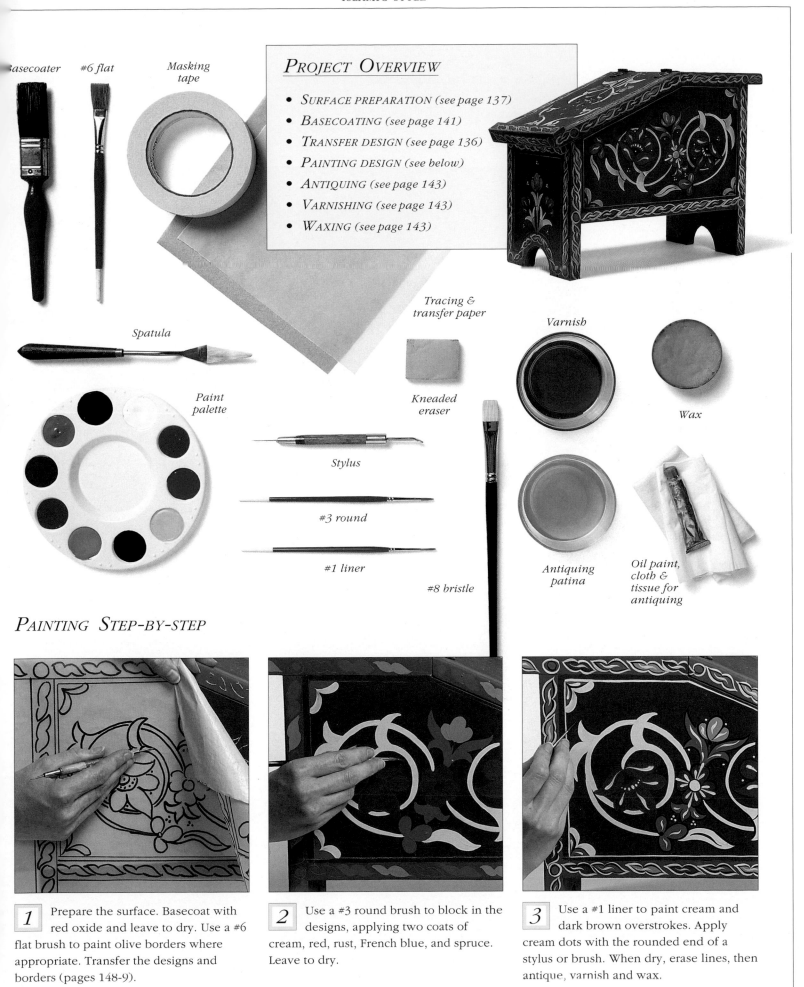

Basecoater #6 flat Masking tape

PROJECT OVERVIEW

- SURFACE PREPARATION (see page 137)
- BASECOATING (see page 141)
- TRANSFER DESIGN (see page 136)
- PAINTING DESIGN (see below)
- ANTIQUING (see page 143)
- VARNISHING (see page 143)
- WAXING (see page 143)

Tracing & transfer paper

Spatula

Varnish

Wax

Paint palette

Kneaded eraser

Stylus

#3 round

#1 liner

#8 bristle

Antiquing patina

Oil paint, cloth & tissue for antiquing

PAINTING STEP-BY-STEP

1 Prepare the surface. Basecoat with red oxide and leave to dry. Use a #6 flat brush to paint olive borders where appropriate. Transfer the designs and borders (pages 148-9).

2 Use a #3 round brush to block in the designs, applying two coats of cream, red, rust, French blue, and spruce. Leave to dry.

3 Use a #1 liner to paint cream and dark brown overstrokes. Apply cream dots with the rounded end of a stylus or brush. When dry, erase lines, then antique, varnish and wax.

PROJECT: TURKISH CHEST

An unusual painting technique has been used to transform this papier-mâché box into a metal chest like those found in Turkey. This 'metallic' relief work would also look striking on a mirror frame.

Level of difficulty: Beginner

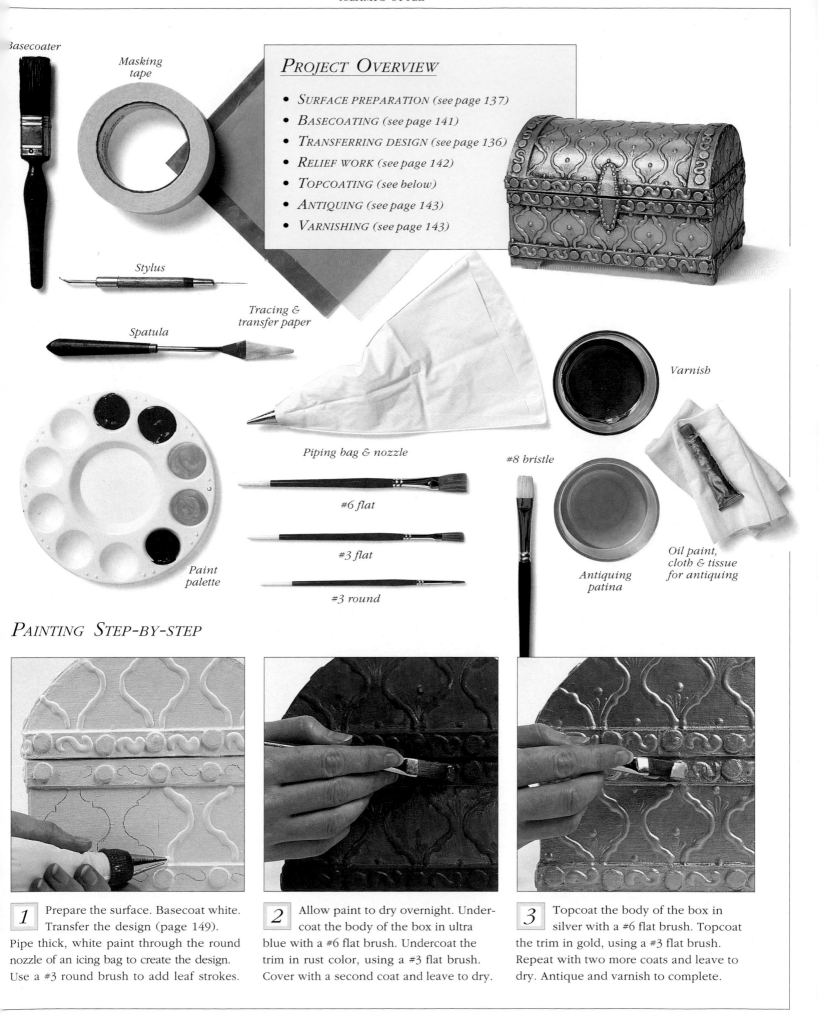

Basecoater

Masking
tape

PROJECT OVERVIEW

- SURFACE PREPARATION (see page 137)
- BASECOATING (see page 141)
- TRANSFERRING DESIGN (see page 136)
- RELIEF WORK (see page 142)
- TOPCOATING (see below)
- ANTIQUING (see page 143)
- VARNISHING (see page 143)

Stylus

Tracing &
transfer paper

Spatula

Varnish

Piping bag & nozzle

#8 bristle

#6 flat

#3 flat

Paint
palette

#3 round

Antiquing
patina

Oil paint,
cloth & tissue
for antiquing

PAINTING STEP-BY-STEP

1 Prepare the surface. Basecoat white. Transfer the design (page 149). Pipe thick, white paint through the round nozzle of an icing bag to create the design. Use a #3 round brush to add leaf strokes.

2 Allow paint to dry overnight. Undercoat the body of the box in ultra blue with a #6 flat brush. Undercoat the trim in rust color, using a #3 flat brush. Cover with a second coat and leave to dry.

3 Topcoat the body of the box in silver with a #6 flat brush. Topcoat the trim in gold, using a #3 flat brush. Repeat with two more coats and leave to dry. Antique and varnish to complete.

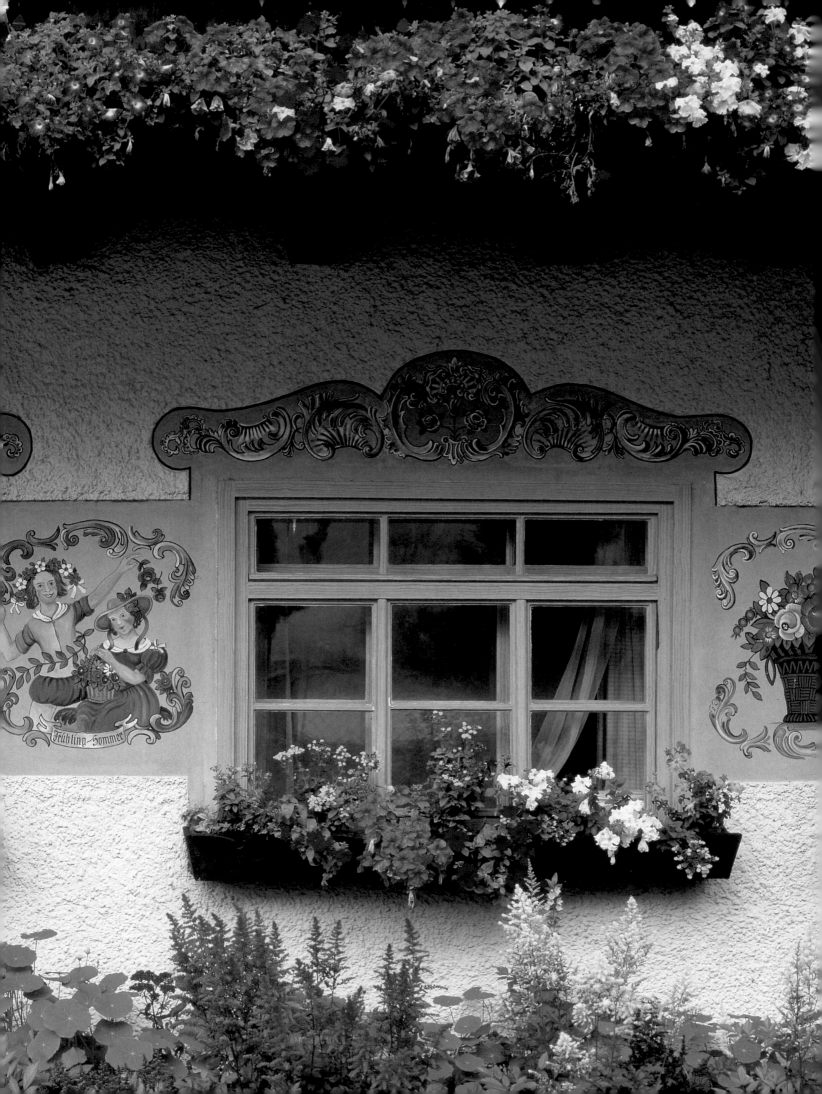

BAUERNMALEREI

FOR MANY PEOPLE, the name Bauernmalerei is synonymous with folk painting. Certainly, the painting tradition which developed in the Bavarian and Austrian alps and the Swiss Apenzell was a strong one, spanning several centuries and influencing decoration widely. Bauernmalerei translates as 'farmer painting,' but the farmer was more often customer than artist; most pieces were painted by traveling artisans or cabinet makers.

Spanschachtel

Originally, simple designs were painted directly onto raw wood, either freehand or by stencil. Painted backgrounds were introduced to enhance cheaper woods and were sometimes used to conceal flaws and woodworm holes, although this was illegal in some areas. Favored background colors were green and black, but the practice of painting an imitation wood grain using a paste—*kleister* in German—was also popular.

No part of the house was left undecorated. Bouquets or garlands were painted between windows on outside walls, while repeat designs often framed doors. Inside the home, armoires, chests for storing corn or clothes, headboards and footboards all provided painting surfaces. Personal belongings were

often kept in *spanschachteln*, boxes made of thin shavings of wood bent around a mold. These boxes, given as gifts or as part of a dowry, might be painted with flowers or a portrait of the bridal couple.

Floral designs were a favorite subject, painted in exuberant bunches with blossoms too large for their stems. The simple Tölzer rose became a pattern for painters and tulips, imported from the East, were painted as a three-petaled flower to symbolize the Trinity. Religious scenes, pictures of the seasons or of secular life were sometimes featured on panels, though this required more skill on the part of the painter.

Milking stool

Trends in art and architecture trickled down to affect rural art. Renaissance designs were quite flat and heavily outlined. With the advent of Baroque tastes, much ornament was added, with leafy borders and brighter coloring. In the rococo period, symmetry was discarded and scrollwork filled designs. Pale blue became popular in rustic art, though Bauernmalerei continued to be characterized by contrasts, combining greens and blues with yellows and reds.

Painted and real alpine flowers complement each other on an Austrian home (left) and on a wall in Gryon, Switzerland.

DESIGNS AND VARIATIONS

The appeal of Bauernmalerei is in its rustic approach to decoration. Color schemes can be somber or bright, but are rarely sophisticated. The subject matter is traditional but personalized by the addition of simple portraits and text. Lettering, an important element in design, might be used to date the painting, name the artist or the owner, or add a sentiment or scripture.

SCRIPT
Proverbs and expressions of love can add ornament to a design.

SPANSCHACHTELN
A bridal couple adorn a dowry box as they have done for centuries.

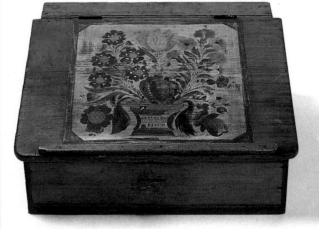

RENAISSANCE
Flowers painted in this style are flat, both in shape and color.

yellow oxide

olive *tomato*

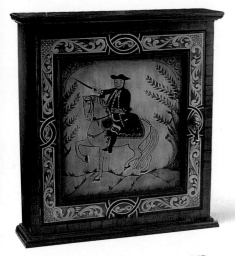

HORSEMEN
St. Florian rides by
on this Austrian
wall cupboard.

pimento *black*

forest green

BORDERS
Simple strip designs
are worked in
austere colors.

DETAIL
Hatching and
scrollwork can
be added as
ornamentation.

black *rust*

BACKGROUNDS
Green was popular
throughout the Tyrol;
Austrians favored
black as a background.

forest green

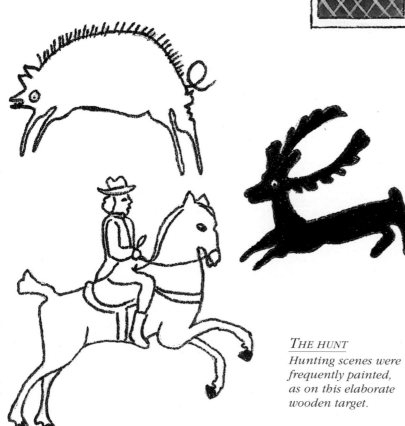

THE HUNT
Hunting scenes were
frequently painted,
as on this elaborate
wooden target.

PROJECT: BERRY PICKER

After the rose, the tulip is the favorite symbol of
Bauernmalerei. Here it is painted in a flat, primitive style with
little regard for realism. The repetitive design is ideal for
narrow panels or as a border.

Level of difficulty: Beginner

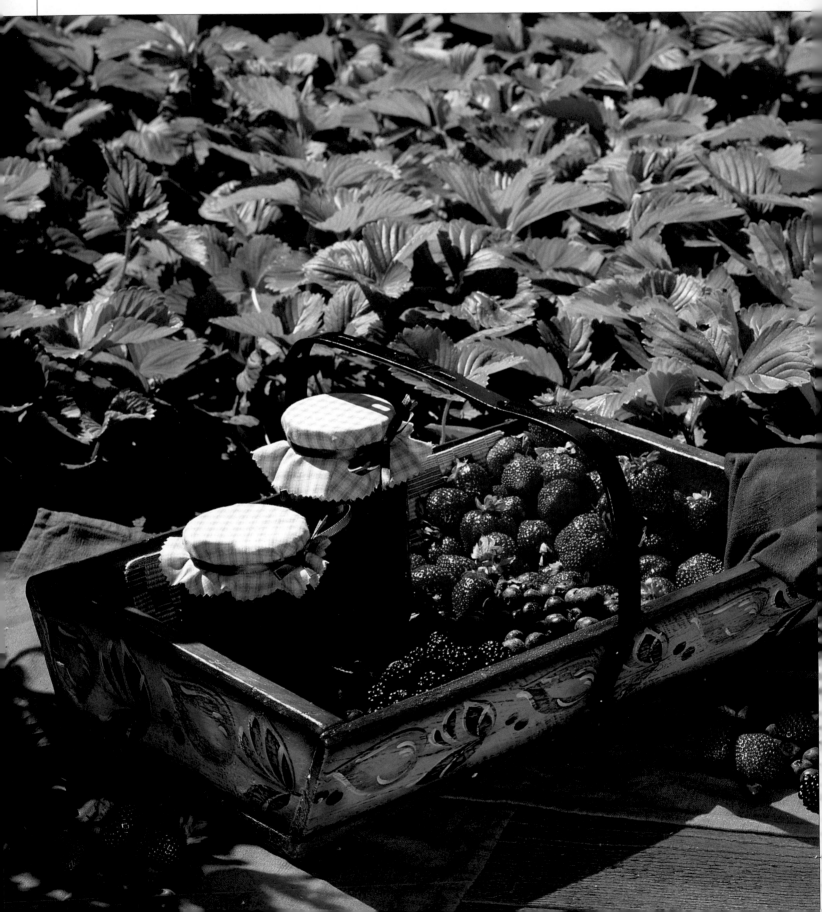

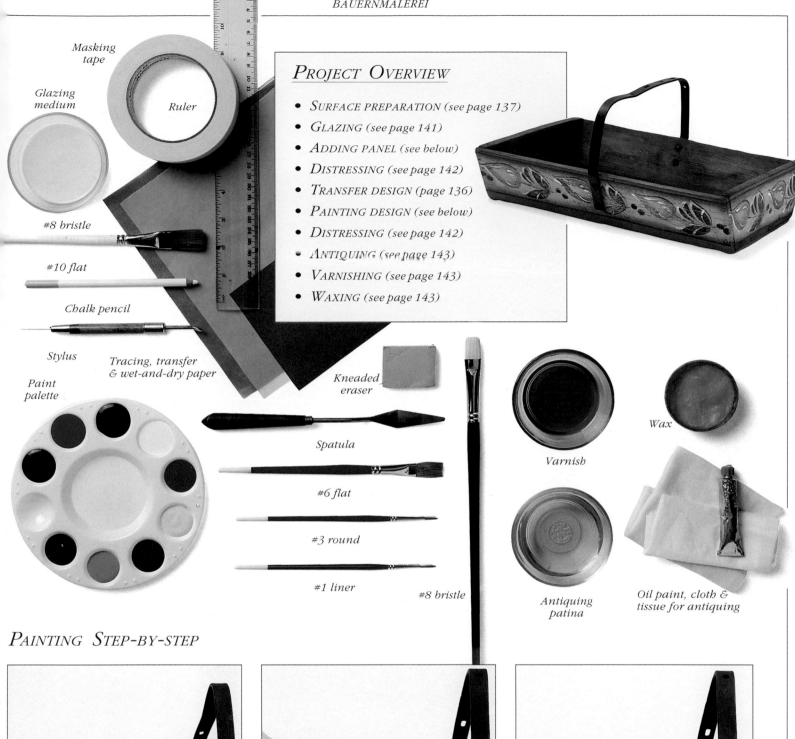

Masking tape

Glazing medium

Ruler

#8 bristle

#10 flat

Chalk pencil

Stylus

Paint palette

Tracing, transfer & wet-and-dry paper

Kneaded eraser

Spatula

#6 flat

#3 round

#1 liner

#8 bristle

Varnish

Wax

Antiquing patina

Oil paint, cloth & tissue for antiquing

PROJECT OVERVIEW

- SURFACE PREPARATION (see page 137)
- GLAZING (see page 141)
- ADDING PANEL (see below)
- DISTRESSING (see page 142)
- TRANSFER DESIGN (page 136)
- PAINTING DESIGN (see below)
- DISTRESSING (see page 142)
- ANTIQUING (see page 143)
- VARNISHING (see page 143)
- WAXING (see page 143)

PAINTING STEP-BY-STEP

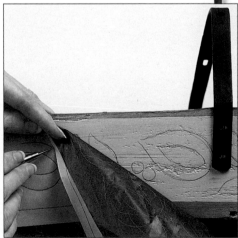

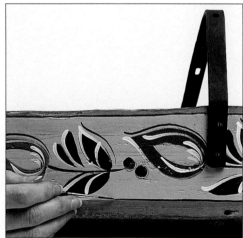

1 Prepare the surface. Tint glazing with brown earth and glaze the piece with a #10 flat, or coat with a brown wash. Leave to dry. Use a chalk pencil and ruler to mark appropriate panels on each side.

2 Paint panels dusty blue with a #6 flat. When dry, distress panels with wet-and-dry paper. Transfer design (page 150). Block in fire red and Prussian blue flowers and teal leaves, with a #3 round.

3 Paint white overstrokes with a #3 round. Add Prussian blue dots with fingertip and paint detail and trim with a #1 liner. When dry, erase lines and distress design lightly. Antique, varnish and wax.

PROJECT: GERMAN CHEST

This Baroque project features several faux painting techniques to
create an instant antique: woodgraining to imply an expensive timber,
spattering and threadwork to suggest the activity of insects over time,
and the application of an antiquing patina to further age the chest.

Level of difficulty: Intermediate

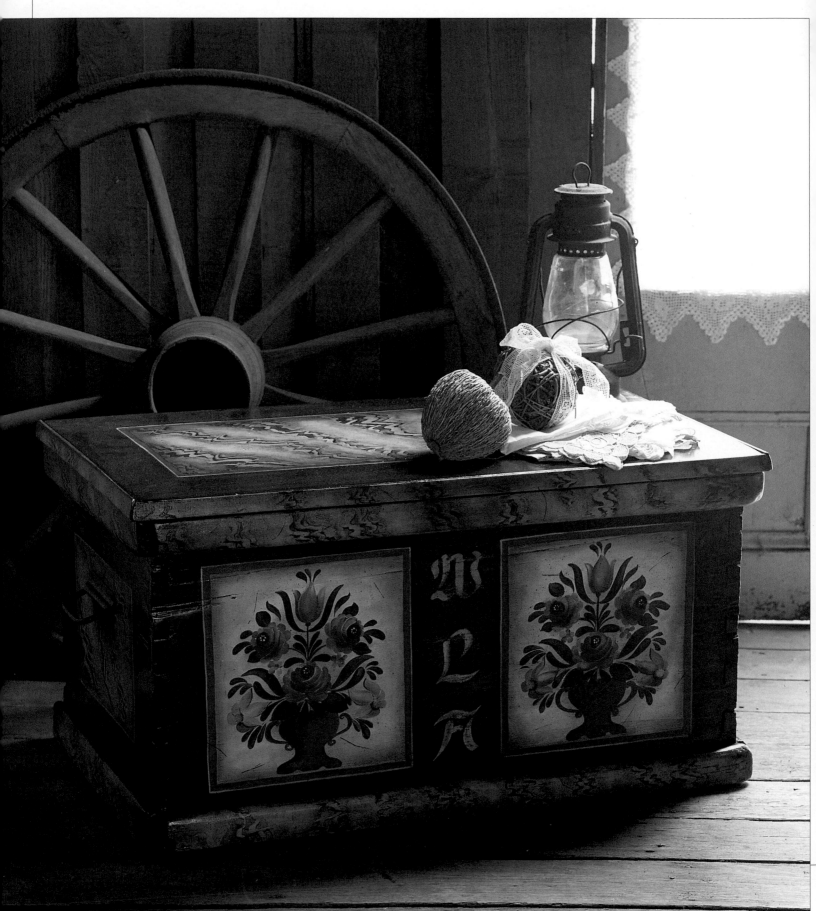

Basecoater

Pencil

Ruler

Masking tape

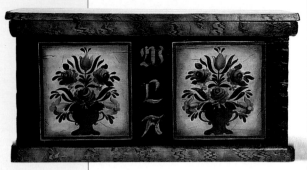

Stylus

Spatula

Tracing, transfer & wet-&-dry paper

Comb

Sea sponge

Kneaded eraser

Thread

Varnish

Wax

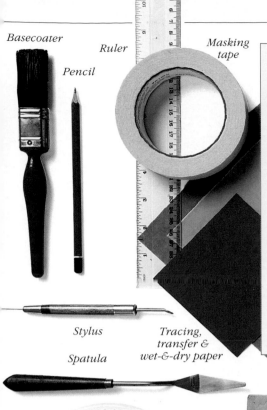

Paint palette

#6 flat

#3 flat

#3 round

#1 liner

Toothbrush

#8 bristle

Antiquing patina

Oil paint, cloth & tissue

PAINTING STEP-BY-STEP

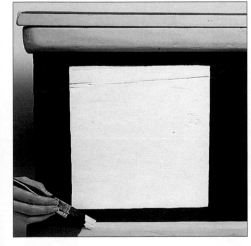

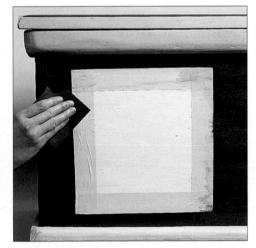

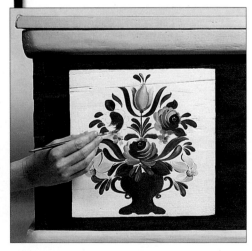

1 Prepare surface. Mark panels with a ruler and pencil. Basecoat side and top panels in pine and front panels with three coats of white. Basecoat rust around the panels. When dry, topcoat forest green around panels and pine on molding.

2 Mask off all panels with tape and distress the forest green areas with wet-and-dry paper. Remove the masking tape. Transfer the design (page 150) onto one or more panels.

3 Paint the design wet-on-wet, using a #3 round brush and a #1 liner as appropriate. Refer to the bouquet painting stages overleaf for colors and brush-strokes.

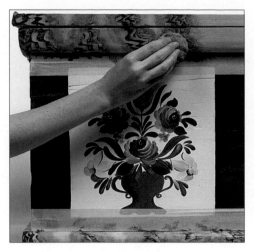

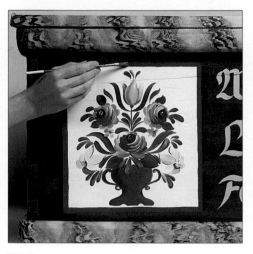

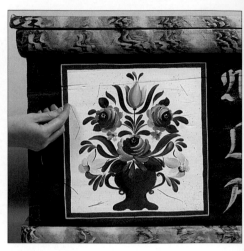

4 Tint paste with burnt umber and paint the top and side panels of the chest and the molding with a woodgrain. Refer to the woodgraining painting stages opposite for details.

5 Use a #3 flat brush to paint panel border in rust. Paint trim line in pine with a #1 liner. Paint lettering in pine with a #3 round brush. Leave to dry, then erase all design lines.

6 Dilute burnt umber with water. Load a toothbrush with paint and spatter panels lightly. Dip thread in paint solution and create drag marks on the panels. Antique, varnish and wax to complete.

BOUQUET PAINTING STAGES

Paint foliage wet-on-wet. Allow to dry, then paint vase and flowers wet-on-wet.

forest green

rust

pine

yellow

French blue

red

burnt umber

white

WOODGRAINING PAINTING STAGES

There are as many techniques for imitating grains and knots as there are different types of wood. The basic principle is the same, that of laying down a thick, tinted paste and making impressions in it. It is the selection of the tool that determines the pattern or grain. Crumpled newspaper or plastic wrap, combs, jagged brushes and cardboard shapes are all suitable tools.

Seal with untinted paste.

Brush on paste tinted with burnt umber acrylic.

Drag with an uneven comb.

Sponge to mottle edges.

PROJECT: SWISS WALL CUPBOARD

If German folk art is typified by solid shapes and dark colors,
Swiss design is lighter in touch. This small project bears a
distinctive alpine freshness. The panel bouquet or side designs
could be used independently on a box lid or clock face.

Level of difficulty: Beginner

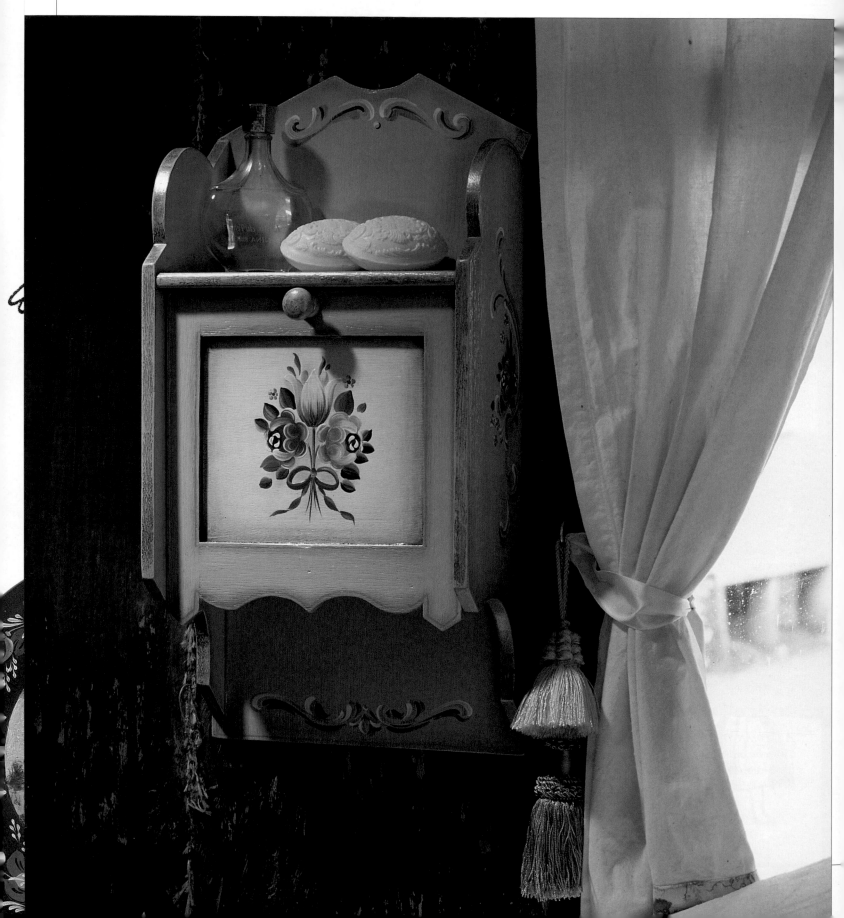

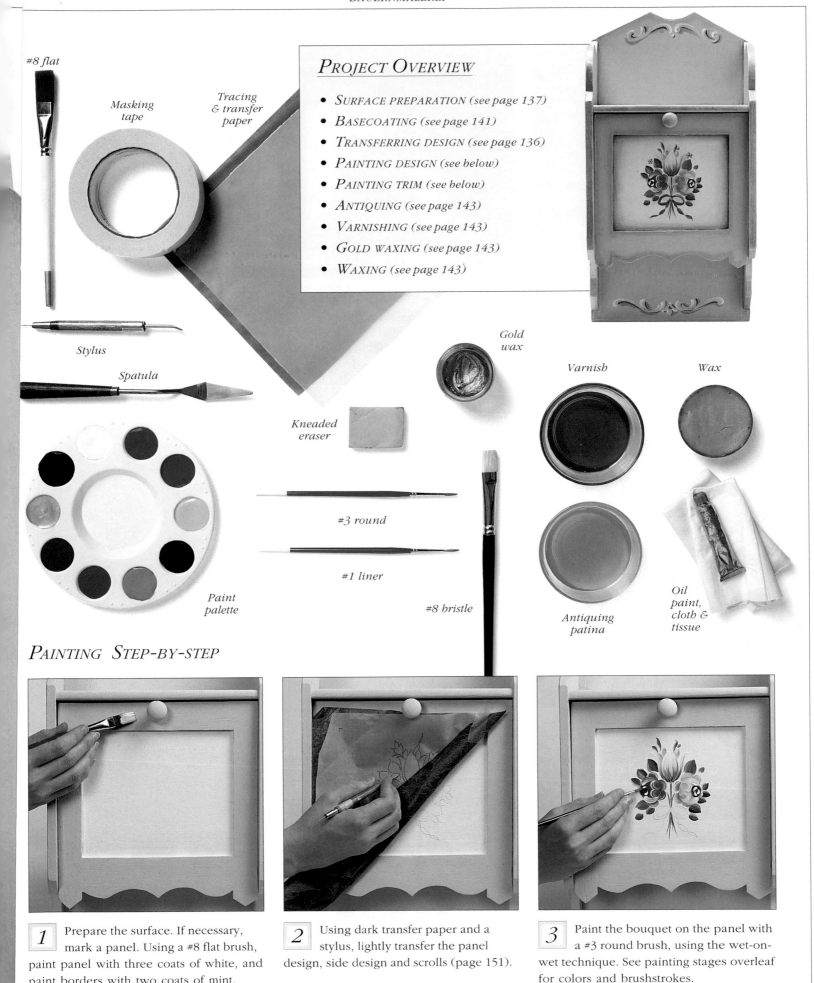

#8 flat

Masking
tape

Tracing
& transfer
paper

PROJECT OVERVIEW

- SURFACE PREPARATION (see page 137)
- BASECOATING (see page 141)
- TRANSFERRING DESIGN (see page 136)
- PAINTING DESIGN (see below)
- PAINTING TRIM (see below)
- ANTIQUING (see page 143)
- VARNISHING (see page 143)
- GOLD WAXING (see page 143)
- WAXING (see page 143)

Stylus

Spatula

Gold
wax

Varnish

Wax

Kneaded
eraser

#3 round

#1 liner

Paint
palette

#8 bristle

Antiquing
patina

Oil
paint,
cloth &
tissue

PAINTING STEP-BY-STEP

1 Prepare the surface. If necessary, mark a panel. Using a #8 flat brush, paint panel with three coats of white, and paint borders with two coats of mint.

2 Using dark transfer paper and a stylus, lightly transfer the panel design, side design and scrolls (page 151).

3 Paint the bouquet on the panel with a #3 round brush, using the wet-on-wet technique. See painting stages overleaf for colors and brushstrokes.

PROJECT: AUSTRIAN CHEST OF DRAWERS

The design for this project is adapted from an Austrian pine armoire painted in 1810. Imitation woodgraining was often painted to suggest more expensive and popular timbers; here, two graining techniques are used to mimic different woods.

Level of difficulty: Intermediate

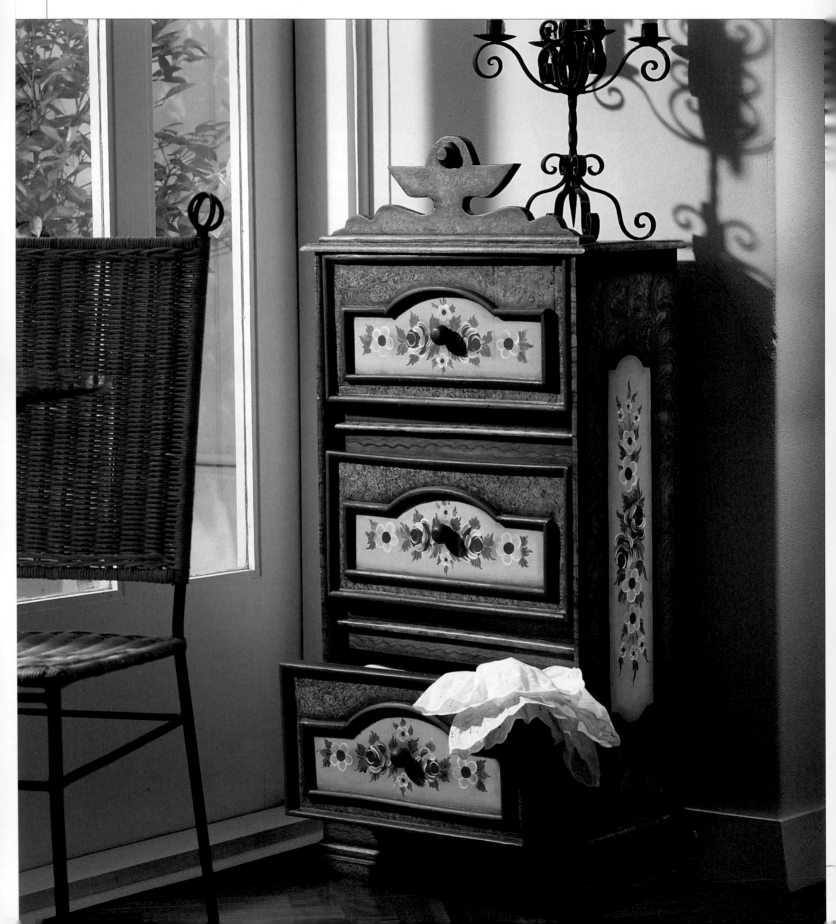

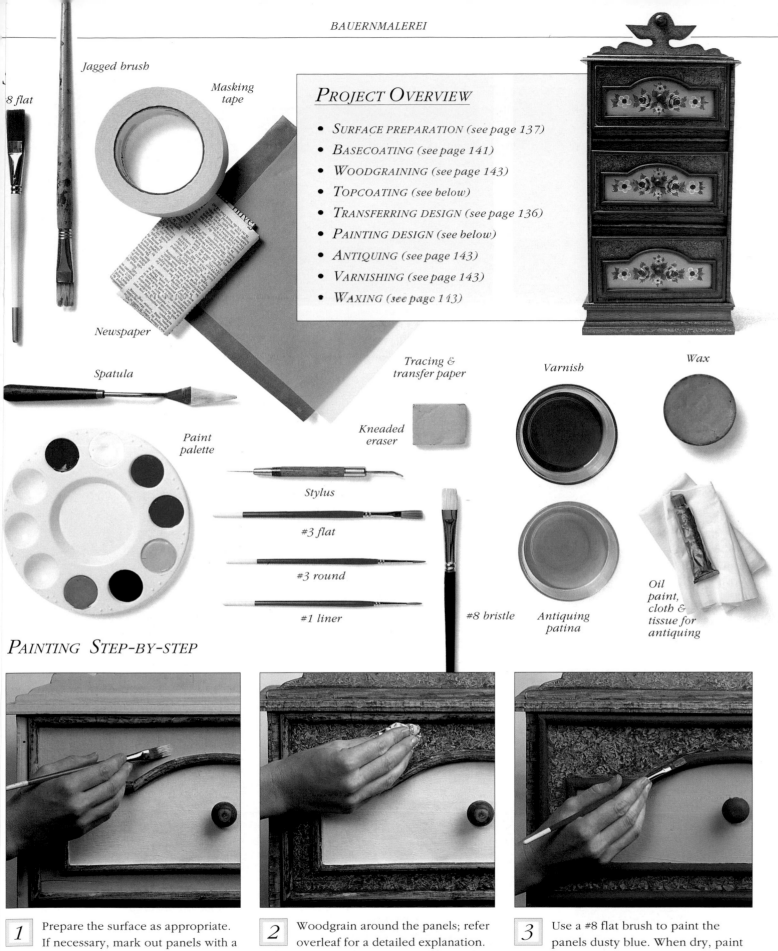

8 flat

Jagged brush

Masking tape

Newspaper

Spatula

Paint palette

Tracing & transfer paper

Kneaded eraser

Varnish

Wax

Stylus

#3 flat

#3 round

#1 liner

#8 bristle

Antiquing patina

Oil paint, cloth & tissue for antiquing

PROJECT OVERVIEW

- SURFACE PREPARATION (see page 137)
- BASECOATING (see page 141)
- WOODGRAINING (see page 143)
- TOPCOATING (see below)
- TRANSFERRING DESIGN (see page 136)
- PAINTING DESIGN (see below)
- ANTIQUING (see page 143)
- VARNISHING (see page 143)
- WAXING (see page 143)

PAINTING STEP-BY-STEP

1 Prepare the surface as appropriate. If necessary, mark out panels with a ruler and pencil. Use a #8 flat brush to basecoat around the panels in pine and within the panels in white. Leave to dry.

2 Woodgrain around the panels; refer overleaf for a detailed explanation. Use crumpled newspaper on the top of the chest and on the drawers. Use a jagged brush in a swiveling motion on the sides.

3 Use a #8 flat brush to paint the panels dusty blue. When dry, paint the beading or borders in rust color with a #3 flat brush.

CLASSIC FRENCH STYLE

FRENCH FURNITURE summons to mind beautifully carved or turned pieces, delicately painted with flowers or fruit seen through a patina of age. Whether they have the elegance of the Parisian court or the simplicity of the provinces, French pieces painted in the seventeenth and eighteenth centuries have a charm that distinguishes French style from English or German design of the same period.

Provincial cupboard

The kings who reigned over France at that time were fond of displaying their wealth and had a penchant for things exotic and elaborate. Chinoiserie—the imitation of Oriental design—took a strong hold in France during this period. Potters and furniture-makers copied oriental designs and strove to simulate lacquerware. This fashion paved the way for the fanciful style known as rococo, in which the asymmetry and motifs of chinoiserie were combined with feathery curves and subtle embellishments.

Provincial artisans imitated work done in the capital and the relative proximity of a region to Paris affected its design. Normandy, the neighboring province, produced graceful armoires and buffets with such sculpted motifs as flower baskets or kissing doves. Brittany, further afield and more isolated, created plainer pieces decorated with marquetry or *brulage au fer*, otherwise known as pokerwork. The quality of wood available affected whether rustic decoration was carved or painted. Pine, an inexpensive wood, was not suitable for marquetry or sculpture and so was painted with red and green geometric patterns and rosettes. Local timbers were sometimes treated to take on the color and patina of mahogany and ebony.

The region which is most closely identified with French provincial is Provence. Despite its distance from Paris, it was strongly affected by the styles of Louis XV and XVI. Here, however, the motifs reflected rural concerns: sheaves of wheat, olive branches, pine cones and grapes, along with the more conventional roses and shells.

The Revolution dampened the enthusiasm for ornate rococo design, but Napoleon's victories soon inspired a taste for classical emblems and proportions. The neo-classical style called on motifs of ancient Greece and Rome, adding wreaths and anthemions to the repertoire of classic French style.

The palace of Fontainebleau, once the residence of Napoleon, is decorated in a curious mixture of styles.

This chinoiserie tray is an example of tôle peinte *or* japanned tinware.

PROJECT: FRENCH TABLE AND CHAIR

The rococo style is characterized by light patterns, pastel colors
and delicate proportions: all three meet in this classic rose
design. The graceful cabriole legs on these two pieces are also
a feature of furniture from that period.

Level of difficulty: Intermediate

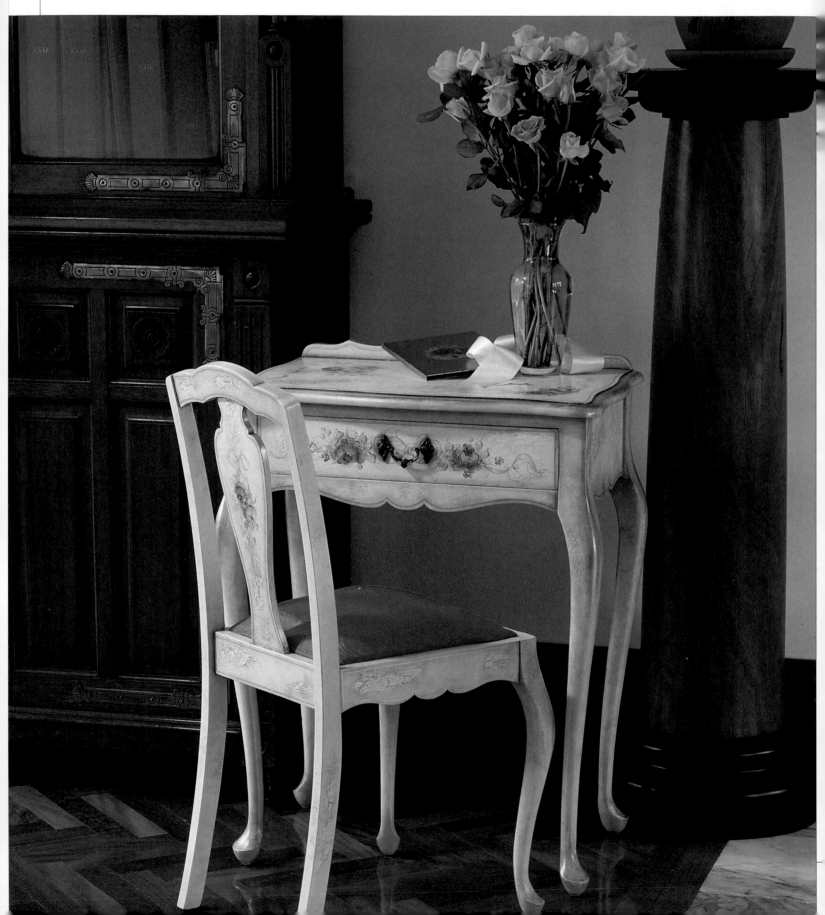

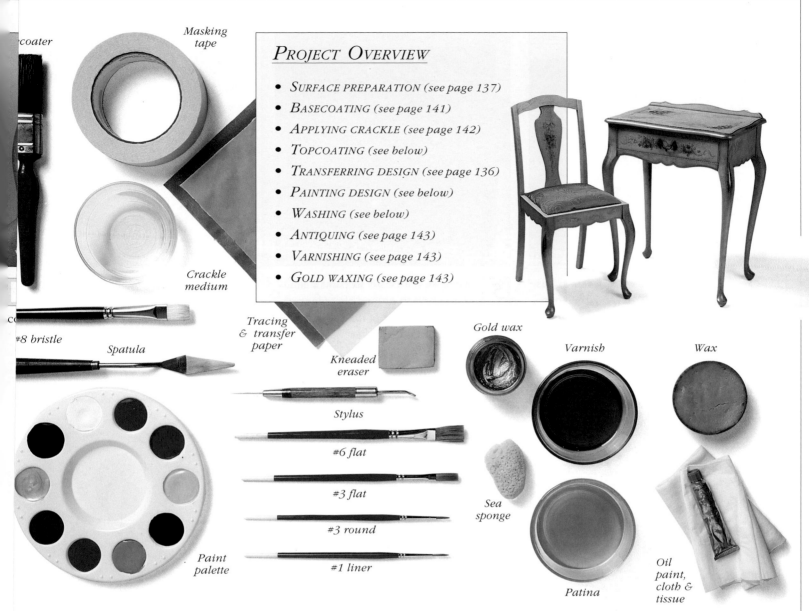

coater

Masking
tape

#8 bristle

Spatula

Crackle
medium

Tracing
& transfer
paper

Kneaded
eraser

Stylus

#6 flat

#3 flat

#3 round

#1 liner

Paint
palette

Gold wax

Varnish

Wax

Sea
sponge

Patina

Oil
paint,
cloth &
tissue

PROJECT OVERVIEW

- SURFACE PREPARATION (see page 137)
- BASECOATING (see page 141)
- APPLYING CRACKLE (see page 142)
- TOPCOATING (see below)
- TRANSFERRING DESIGN (see page 136)
- PAINTING DESIGN (see below)
- WASHING (see below)
- ANTIQUING (see page 143)
- VARNISHING (see page 143)
- GOLD WAXING (see page 143)

PAINTING STEP-BY-STEP

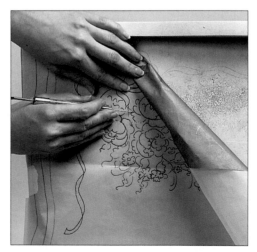

1 Prepare the surface as appropriate. Basecoat with rust color. With a #8 bristle brush, paint patches of crackle medium; avoid areas where the design will be painted.

2 When the crackle medium is almost dry, lightly sponge on a cream topcoat. Continue sponging the entire surface lightly with paint to create a mottled effect and then leave to dry.

3 Using dark transfer paper and a stylus, lightly transfer the designs (page 152-3). There are two for the top of the table and one which can be used on both sides of the chair back.

PROJECT: ROCOCO JEWELRY BOX

The term rococo is derived from the French word *rocaille* meaning 'shell.' This box features a shell with elaborate scrolls, as well as a delicate floral arrangement which owes much to chinoiserie. Paint the inside of the box or line it with fabric to complete the project.

Level of difficulty: Intermediate

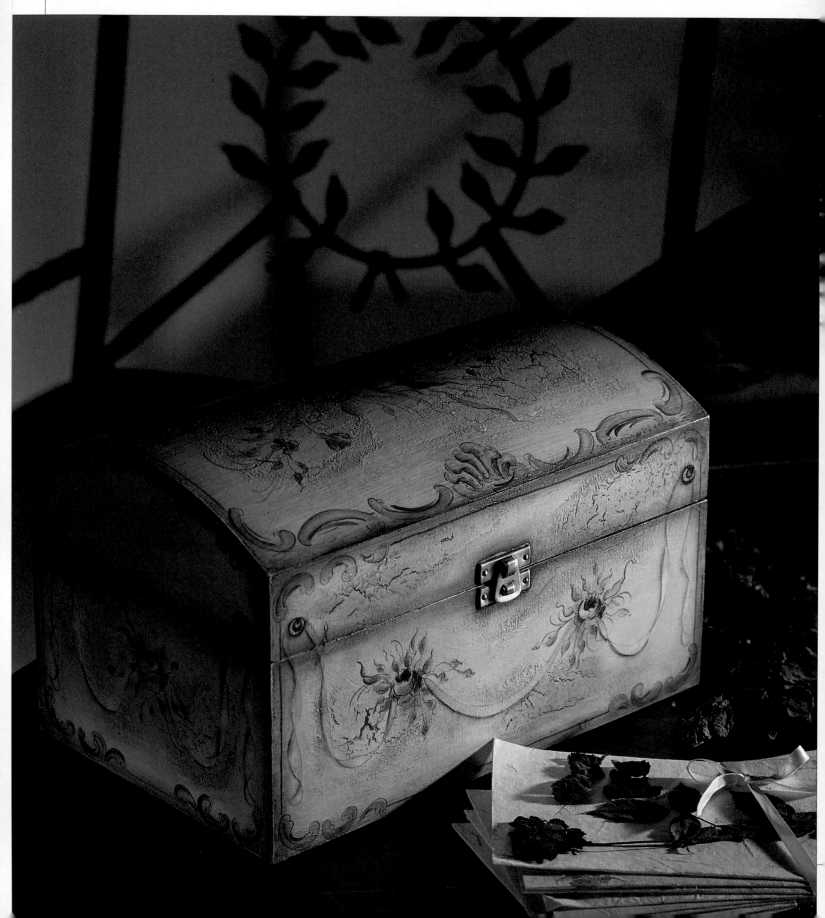

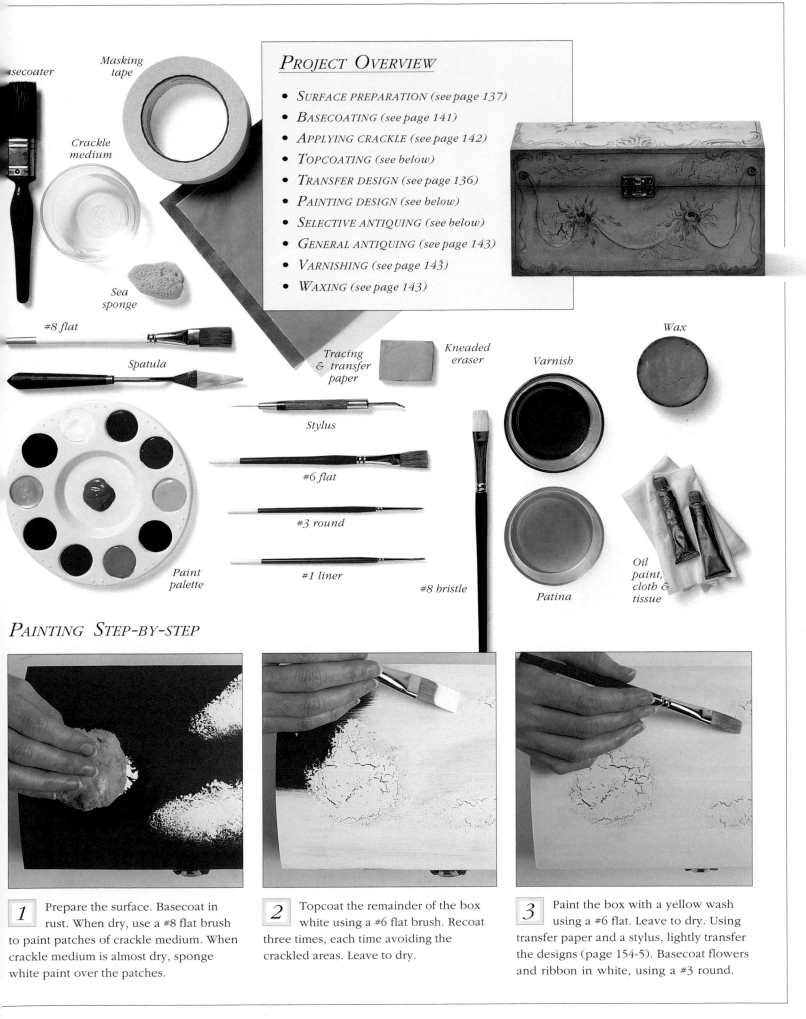

Basecoater

Masking tape

Crackle medium

Sea sponge

#8 flat

Spatula

Paint palette

Tracing & transfer paper

Stylus

#6 flat

#3 round

#1 liner

#8 bristle

Kneaded eraser

Varnish

Wax

Patina

Oil paint, cloth & tissue

PROJECT OVERVIEW

- SURFACE PREPARATION (see page 137)
- BASECOATING (see page 141)
- APPLYING CRACKLE (see page 142)
- TOPCOATING (see below)
- TRANSFER DESIGN (see page 136)
- PAINTING DESIGN (see below)
- SELECTIVE ANTIQUING (see below)
- GENERAL ANTIQUING (see page 143)
- VARNISHING (see page 143)
- WAXING (see page 143)

PAINTING STEP-BY-STEP

1 Prepare the surface. Basecoat in rust. When dry, use a #8 flat brush to paint patches of crackle medium. When crackle medium is almost dry, sponge white paint over the patches.

2 Topcoat the remainder of the box white using a #6 flat brush. Recoat three times, each time avoiding the crackled areas. Leave to dry.

3 Paint the box with a yellow wash using a #6 flat. Leave to dry. Using transfer paper and a stylus, lightly transfer the designs (page 154-5). Basecoat flowers and ribbon in white, using a #3 round.

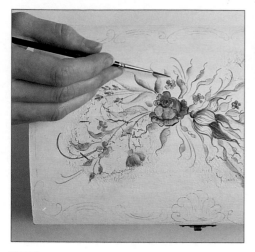

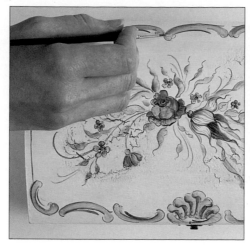

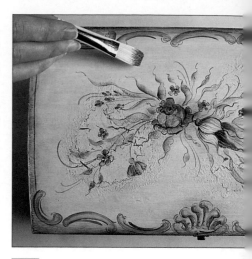

4 Paint the floral design, using a #3 round brush for base colors and floatwork and a #1 liner for detail. Refer to the floral painting stages for colors and brushstrokes.

5 Paint the scrolls and shell, using a #3 round for the wash and floatwork and a #1 liner for detail. Refer to the painting stages below for colors. When dry, erase all lines.

6 Antique edges and corners with raw umber oil paint and allow to dry. Antique generally with raw sienna, taking care to avoid the ribbon. Varnish and wax to complete.

ROCAILLE PAINTING STAGES

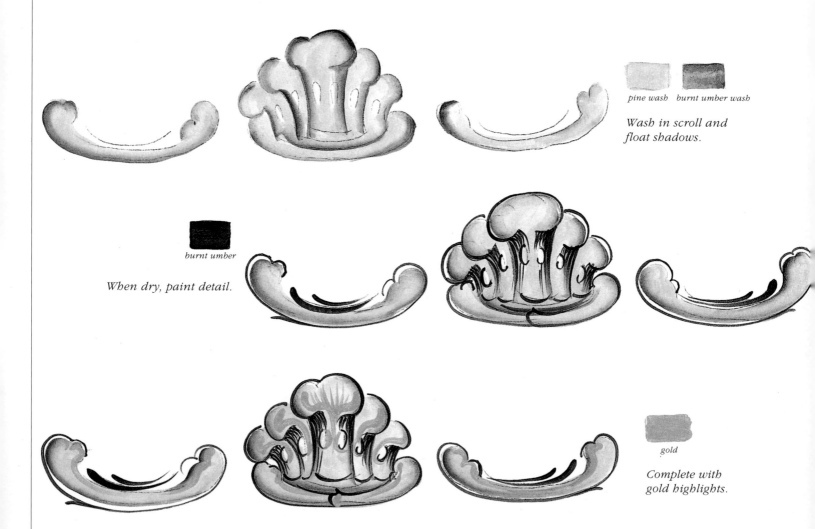

pine wash *burnt umber wash*

Wash in scroll and float shadows.

burnt umber

When dry, paint detail.

gold

Complete with gold highlights.

FLORAL PAINTING STAGES

Note: all colors are washes.

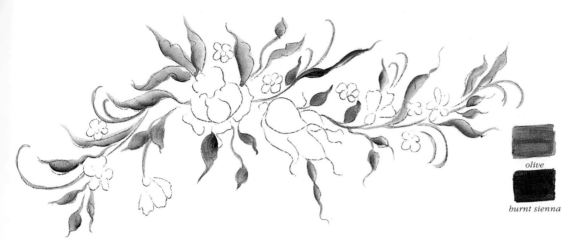

olive

burnt sienna

Wash leaves in green and float a highlight.

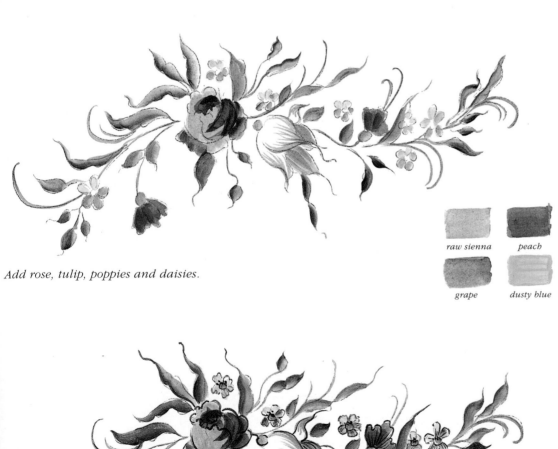

raw sienna *peach*

grape *dusty blue*

Add rose, tulip, poppies and daisies.

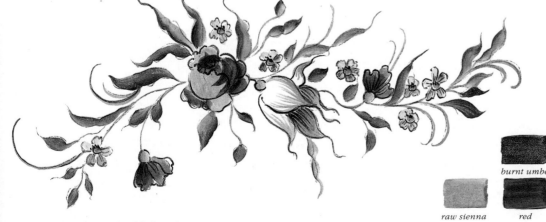

burnt umber

raw sienna *red*

Complete daisies and add detail.

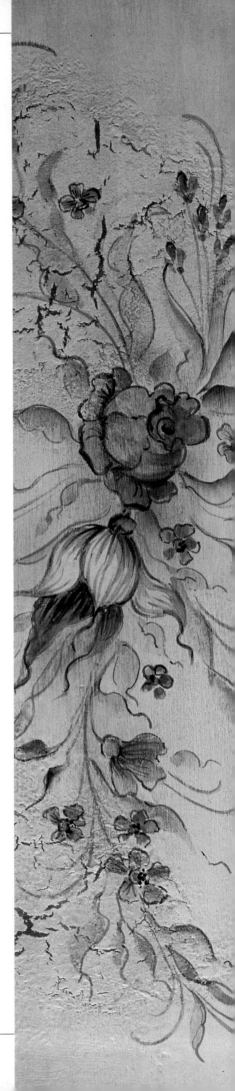

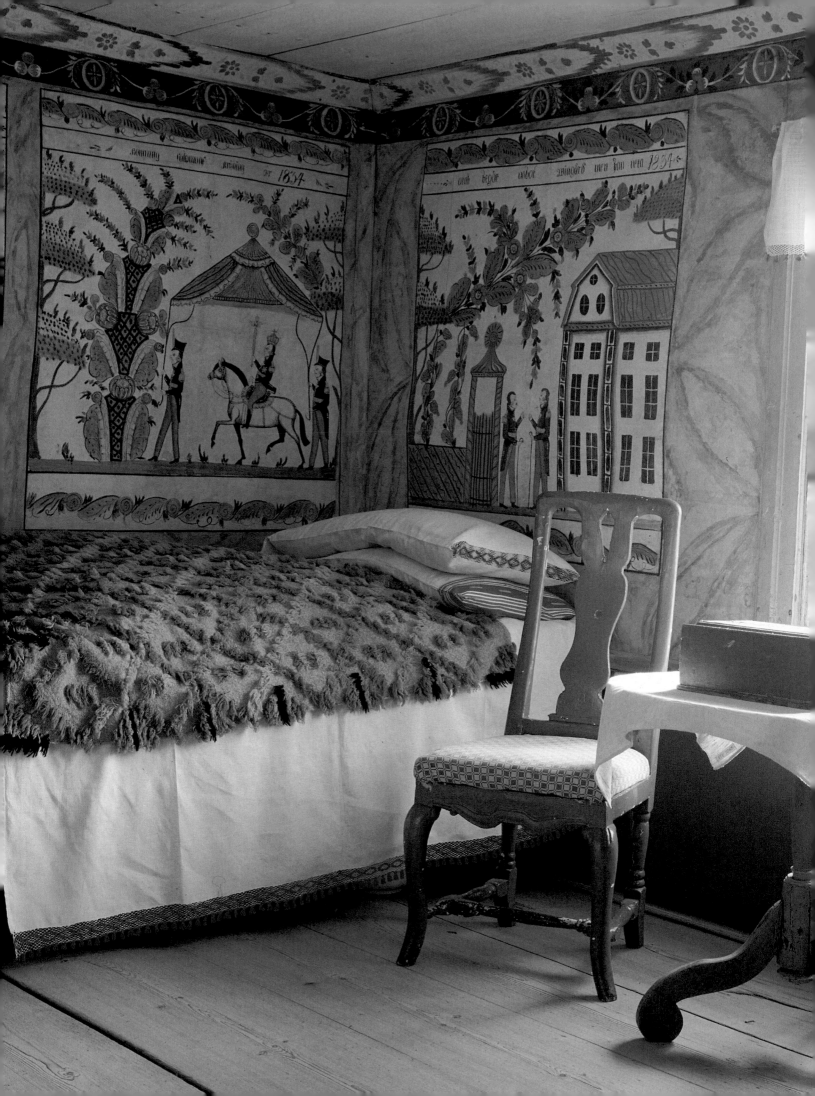

FOLK PAINTING
OF SWEDEN

Sweden's monarch in the 1770s was Gustavus III, a man of culture who set the standard for which Swedish design is now renowned. The folk artists of his country simplified Gustavian neoclassicism, but kept the clean lines and delicate palette to produce a style that is fresh and appealing.

Mora clock

The central district of Dalarna was a stronghold for decorative painting. This farming region, which includes the towns of Mora, Leksand, Rattvik, Falun and Borlange, gained a reputation for its traveling painters, who used linework and strokes to define the flowers and leaves, instead of the delicate shading used by the Norwegians. These folk artists received small commissions for painting pieces of furniture: clocks, large cabinets, doors of bed chambers and room panels. The latter were painted on to cloth or on heavy paper which was then attached to the wall.

Many of the scenes depicted in the wall paintings were biblical in theme but the figures wore the local dress of the time and biblical towns were depicted as present-day Swedish towns, offering a picture book of the scriptures for those unable to read. Special events in the community, such as weddings or baptisms, were represented and sometimes the artist added a portrait of the peasants who had commissioned the work, with an inscription noting some quaint detail of their lives.

Most designs feature a kurbits: a floral spray or vine that arches over the scene or sprouts out of an urn or a building. Each kurbits is made up of large leaves, a middle flower, side flowers, stamens and swirling tendrils. The original kurbits was said to be a gift of the Lord to Jonah, intended to provide shelter and comfort, but to the Swedish country-folk it also represented fertility.

Another motif from the Dalarna area is the Dala horse, a carved figure painted red or blue. Today, one cannot visit Sweden without seeing hundreds of these brightly painted horses in many sizes. Together with kurbits and wall scenes they have become known as the signatures of Sweden.

A series of wall panels adds interest to an otherwise plain room; the rustic furniture reflects the orange and blue tones.

This panel, complete with kurbits, probably depicts a biblical scene.

PROJECT: SWEDISH CHAIR

A plain chair is given much grace with a kurbits motif, modified and repeated. Raw pine furniture is inexpensive and, once pickled, beautifully conveys the fresh Swedish style. This project also demonstrates the process of selective antiquing.

Level of difficulty: Beginner

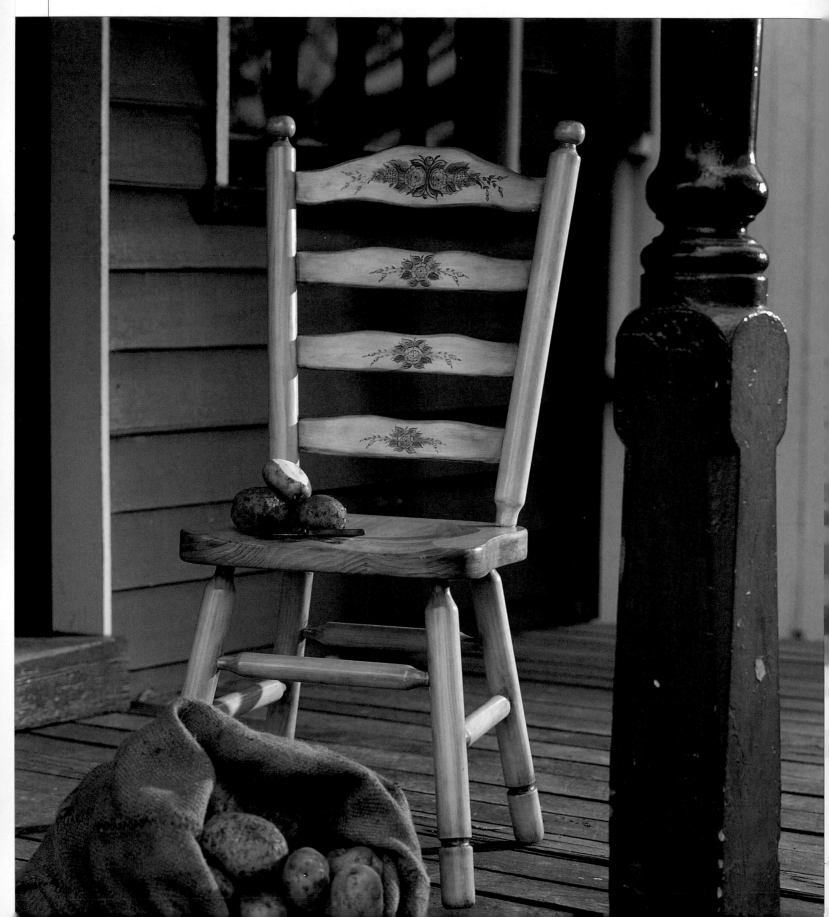

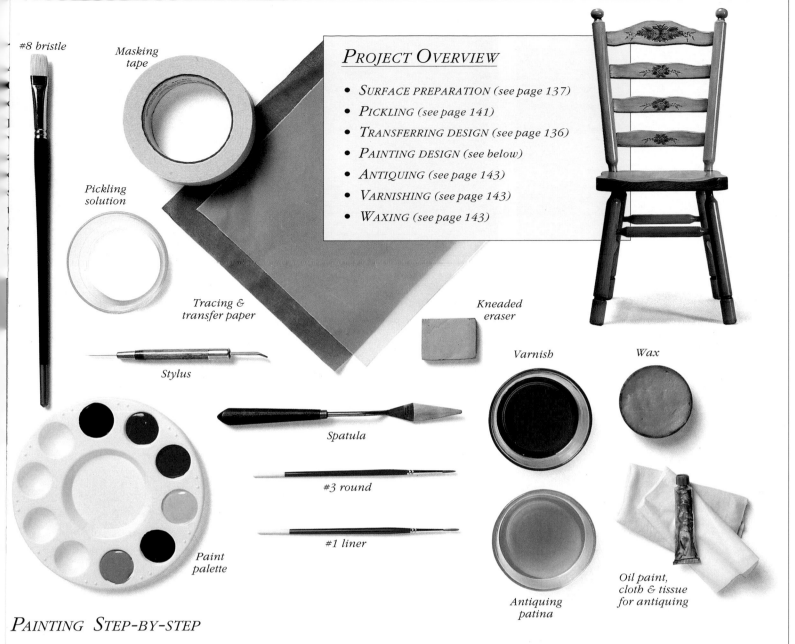

#8 bristle

Masking tape

Pickling solution

PROJECT OVERVIEW

- SURFACE PREPARATION (see page 137)
- PICKLING (see page 141)
- TRANSFERRING DESIGN (see page 136)
- PAINTING DESIGN (see below)
- ANTIQUING (see page 143)
- VARNISHING (see page 143)
- WAXING (see page 143)

Tracing & transfer paper

Kneaded eraser

Stylus

Varnish

Wax

Spatula

#3 round

#1 liner

Paint palette

Antiquing patina

Oil paint, cloth & tissue for antiquing

PAINTING STEP-BY-STEP

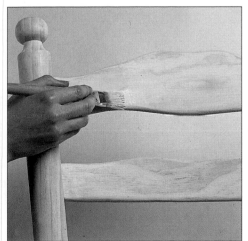

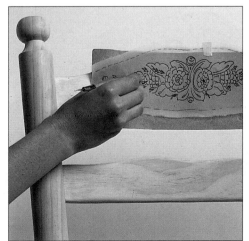

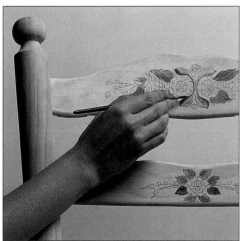

1 Prepare the surface if using an old piece. Dampen the raw wood slightly with a cloth. Using a #8 bristle brush, paint on the pickling solution. Apply a second coat and leave to dry.

2 Transfer the designs (page 155). Be careful not to press too heavily with the stylus or the lines of the design will show through the paintwork.

3 Refer to the kurbits painting stages overleaf for colors and brush-strokes. Use a #3 round brush to paint the large leaves with an olive wash.

PROJECT: SCANDINAVIAN WRITING BUREAU

This design reflects the taste of the Swedish nobility for decorating furniture in the style of the French court, however the soft gray-blue wash gives it a strong Scandinavian flavor. The delicate floatwork requires some practice.

Level of difficulty: Advanced

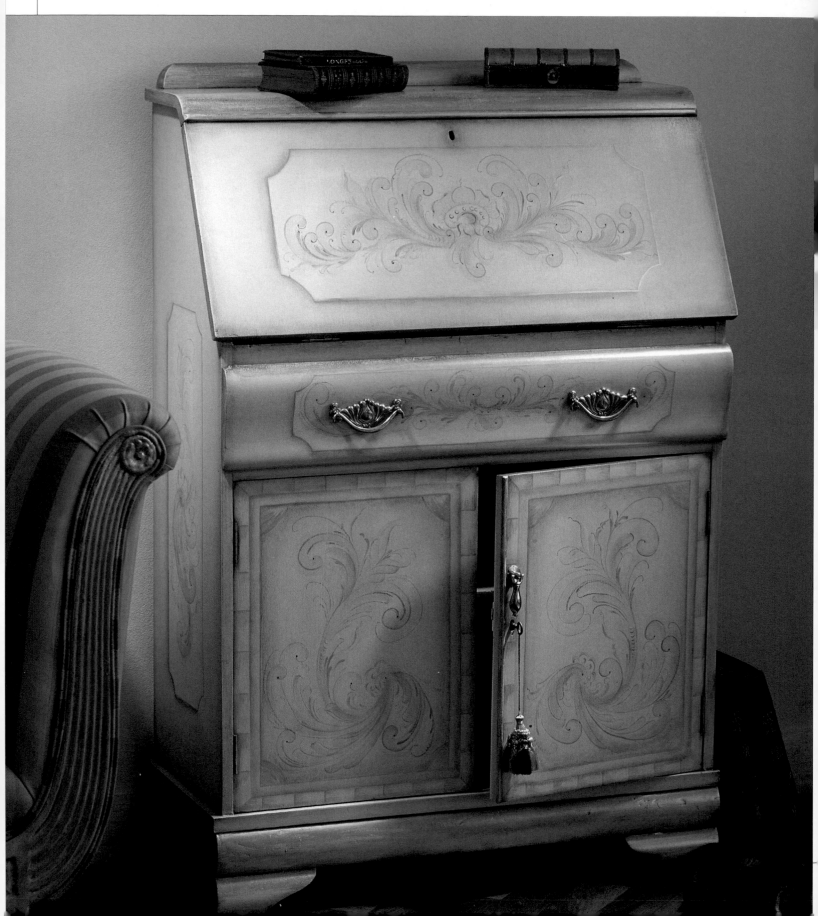

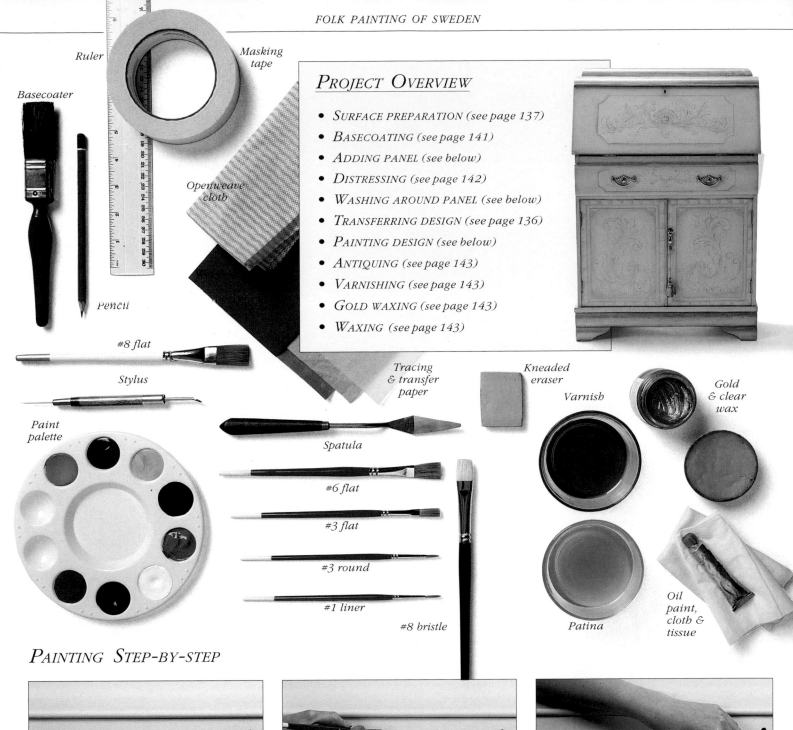

Ruler

Masking tape

Basecoater

Openweave cloth

Pencil

#8 flat

Stylus

Paint palette

Tracing & transfer paper

Spatula

Kneaded eraser

Varnish

Gold & clear wax

#6 flat

#3 flat

#3 round

#1 liner

#8 bristle

Patina

Oil paint, cloth & tissue

PROJECT OVERVIEW

- SURFACE PREPARATION (see page 137)
- BASECOATING (see page 141)
- ADDING PANEL (see below)
- DISTRESSING (see page 142)
- WASHING AROUND PANEL (see below)
- TRANSFERRING DESIGN (see page 136)
- PAINTING DESIGN (see below)
- ANTIQUING (see page 143)
- VARNISHING (see page 143)
- GOLD WAXING (see page 143)
- WAXING (see page 143)

PAINTING STEP-BY-STEP

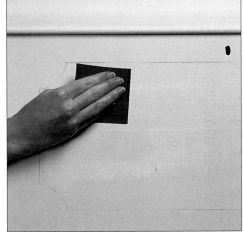

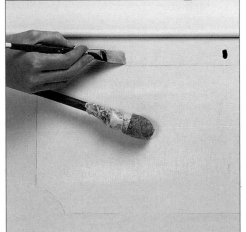

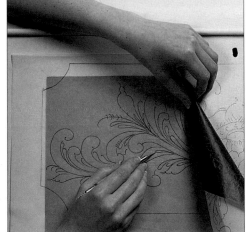

1 Prepare the surface. Basecoat in white and, when dry, topcoat in cream. Using a pencil and ruler, mark in panel shapes and borders. Distress within the panels using wet-and-dry paper.

2 Moisten the paintwork around the panel with a damp cloth. Using a #8 flat brush, wash oatmeal around the panel. You may need a maulstick to support your arm. Moisten and wash a section at a time.

3 Transfer the designs (page 156-7) onto the front and sides, taking care not to press too hard with the stylus. See overleaf for colors and brushstrokes of painting stages.

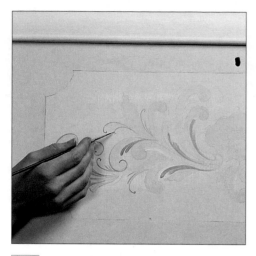

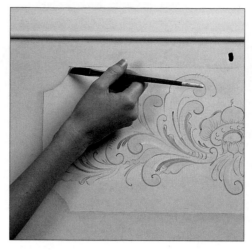

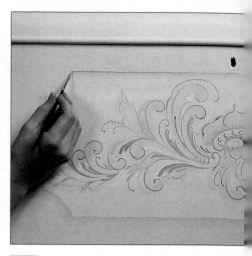

4 Paint design as indicated below. Use a #3 flat to float scrolls and a #3 round to paint flowers. Add highlights and linework with a #1 liner.

5 Side-load a #6 flat brush with a mixture of oatmeal and gray and paint a wash of this mixture in a shadow around the panel to add depth.

6 Paint gold trim around panel with a #1 liner. Distress designs lightly. Erase lines, antique and varnish. Apply gold wax selectively and wax clear.

SCROLLWORK PAINTING STAGES

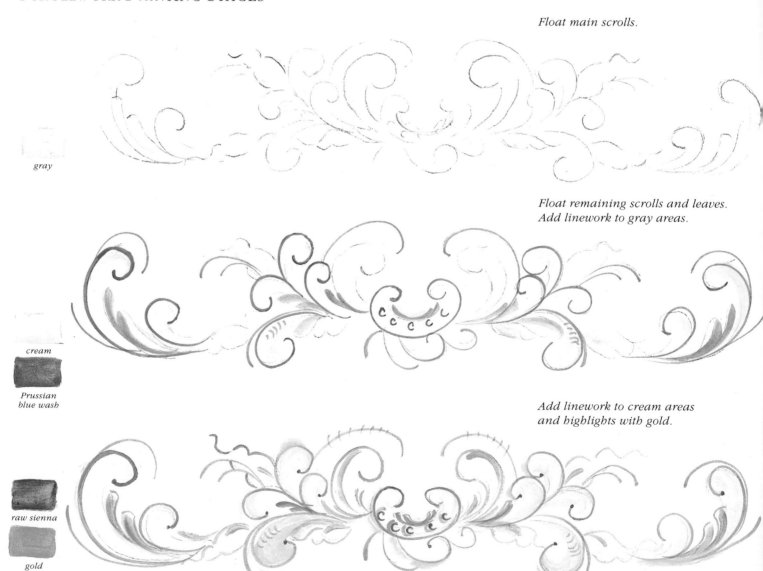

Float main scrolls.

gray

Float remaining scrolls and leaves. Add linework to gray areas.

cream

Prussian blue wash

Add linework to cream areas and highlights with gold.

raw sienna

gold

FLOWER PAINTING STAGES

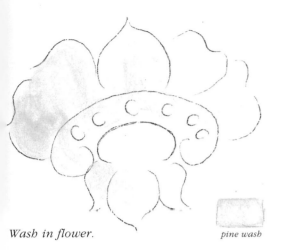

Wash in flower. *pine wash*

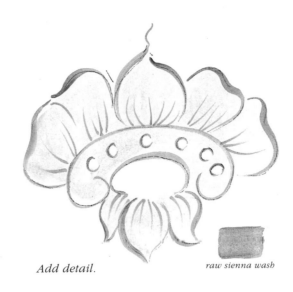

Add detail. *raw sienna wash*

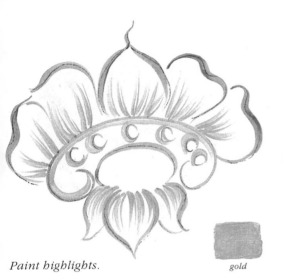

Paint highlights. *gold*

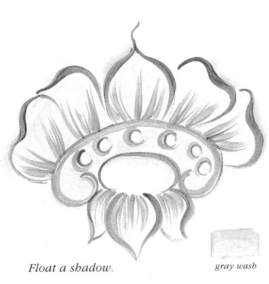

Float a shadow. *gray wash*

PAINTING THE BORDER

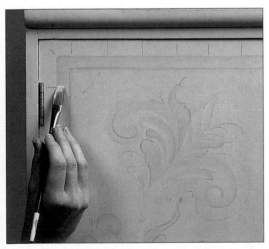

1 Use a #6 flat to float oatmeal-gray on the door to create a false beading. Paint the gold trim line with a #1 liner.

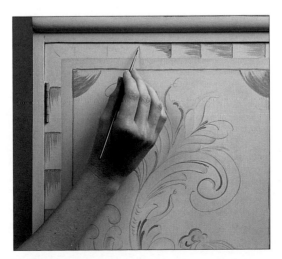

2 Paint gold strokes at intervals along the border with a #3 round. Use a #1 liner to pull fine lines from each stroke.

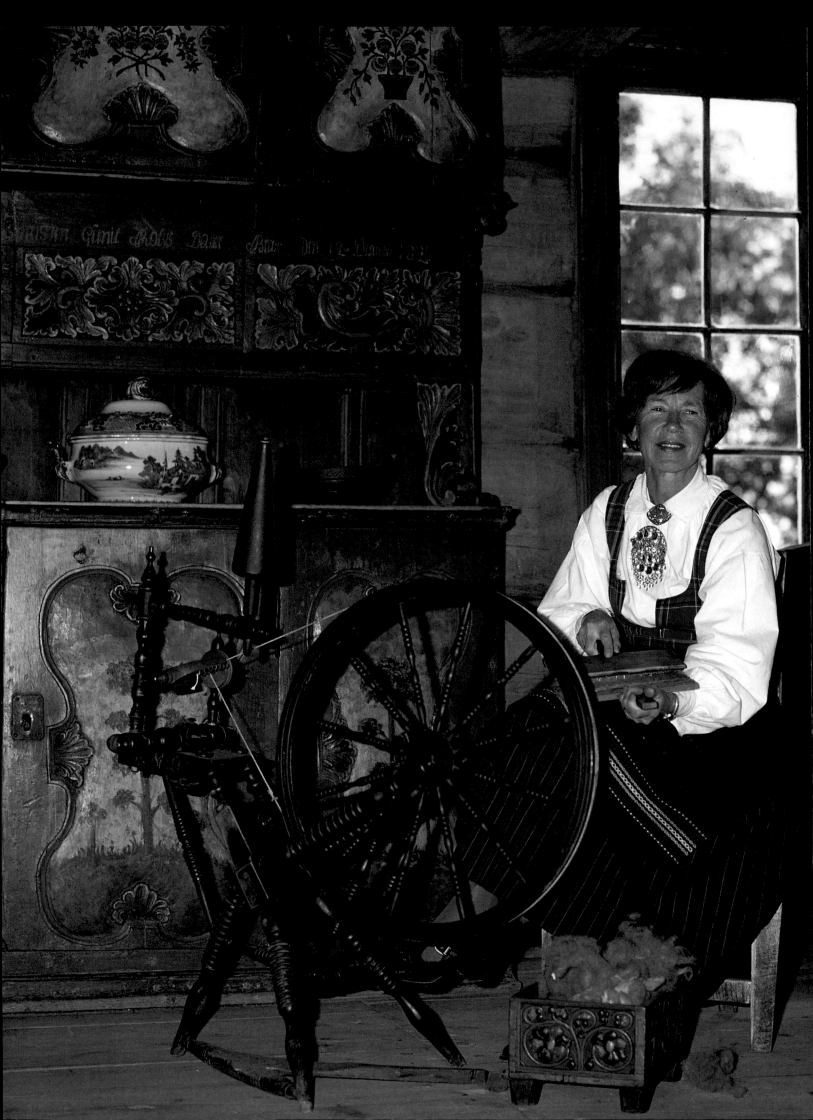

NORWEGIAN ROSEMALING

ROSEMALING, or 'rose painting,' is the name given to the Norwegian rustic painting of the eighteenth and nineteenth centuries. Roses—together with the acanthus scroll—were the most important elements of Norwegian folk art, the roots of which lie in the elaborate carved scrolls found on Viking longboats.

Rosemaling was introduced in rural homes on small objects: ale bowls, tankards and the prized dowry chest. These gave color to the otherwise plain interiors where families spent long dark winters. Early homes were poorly ventilated; so much soot covered the walls and furnishings that decoration was reserved for festival days. The arrival of the fireplace with an attached chimney made it feasible to display decorations year 'round. Entire rooms were covered in rosemaling, geometrics and feathering on walls, cupboards, ceilings and furniture. Rosemalers sometimes added biblical and wedding scenes painted in a primitive style, in sharp contrast to the sophisticated flower painting.

Norway's mountainous terrain isolated various regions, resulting in three distinct styles of rosemaling.

Telemark bowl

The Hallingdal Valley in central Norway produced a Baroque style characterized by strong symmetrical designs and bold hues. Rosemaling in the Telemark area, influenced by the rococo style, is flowing and asymmetrical with intricate shading and linework. Many Telemark painters used a transparent technique on the background, allowing the woodgrain to show; others preferred black, red and white as background colors. The Rogaland style developed on the southwest coast where trading vessels brought Oriental influences, such as dark backgrounds and delicate cross-hatching. Tulips and other flowers were painted with a degree of realism, and light and dark colors were used as contrasts. In each of these painting traditions, design elements were arranged quite differently.

Hallingdal cupboard

All rosemaling is strokework painting at its finest. The artist must first master the 'C' and 'S' strokes that comprise the scrolls. The design is then enhanced with commas, teardrops, long delicate lines and detailing in a single color which ties the design together.

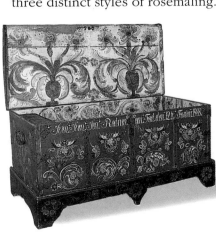

The interior of many Norwegian homes bore carved paneling, heavily decorated with rosemaling.

Dowry chest dated 1808

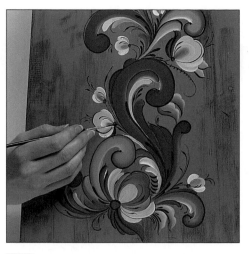

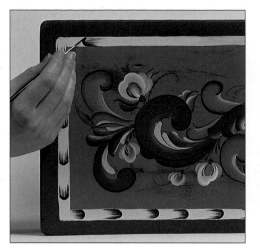

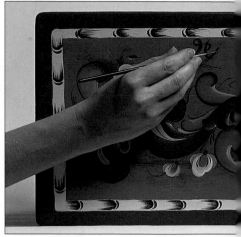

4 Add overstrokes and other detail with a #1 liner. Using a #3 flat brush, paint two coats of cream in a border as shown in Step 5. While paint is still wet, continue with the next step.

5 Use a #1 liner to paint a series of Prussian blue crescents at intervals around the border, then pull out fine lines from the crescent. Paint a rust crescent beside each blue one.

6 Use a #3 round brush with a fine point to paint the rust lettering. Leave to dry, erase the lines of the design and then antique. Varnish and wax to complete.

FLOWER PAINTING STAGES

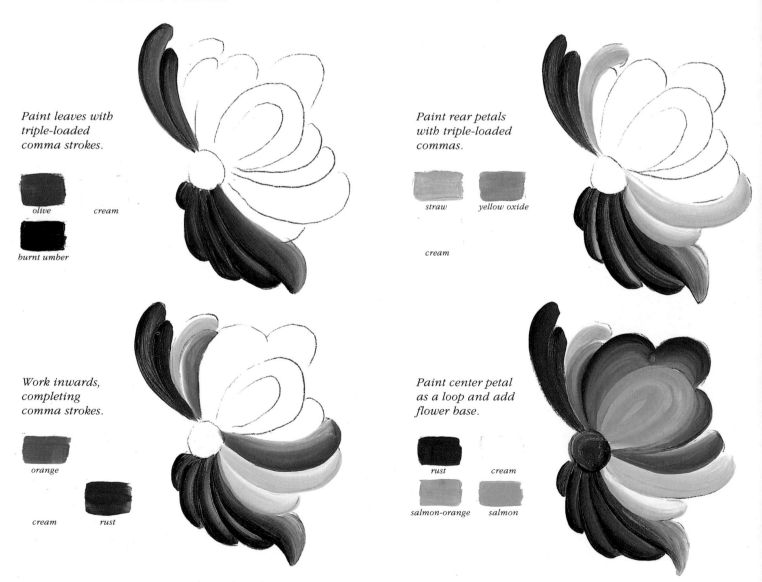

Paint leaves with triple-loaded comma strokes.

olive cream

burnt umber

Paint rear petals with triple-loaded commas.

straw yellow oxide

cream

Work inwards, completing comma strokes.

orange

cream rust

Paint center petal as a loop and add flower base.

rust cream

salmon-orange salmon

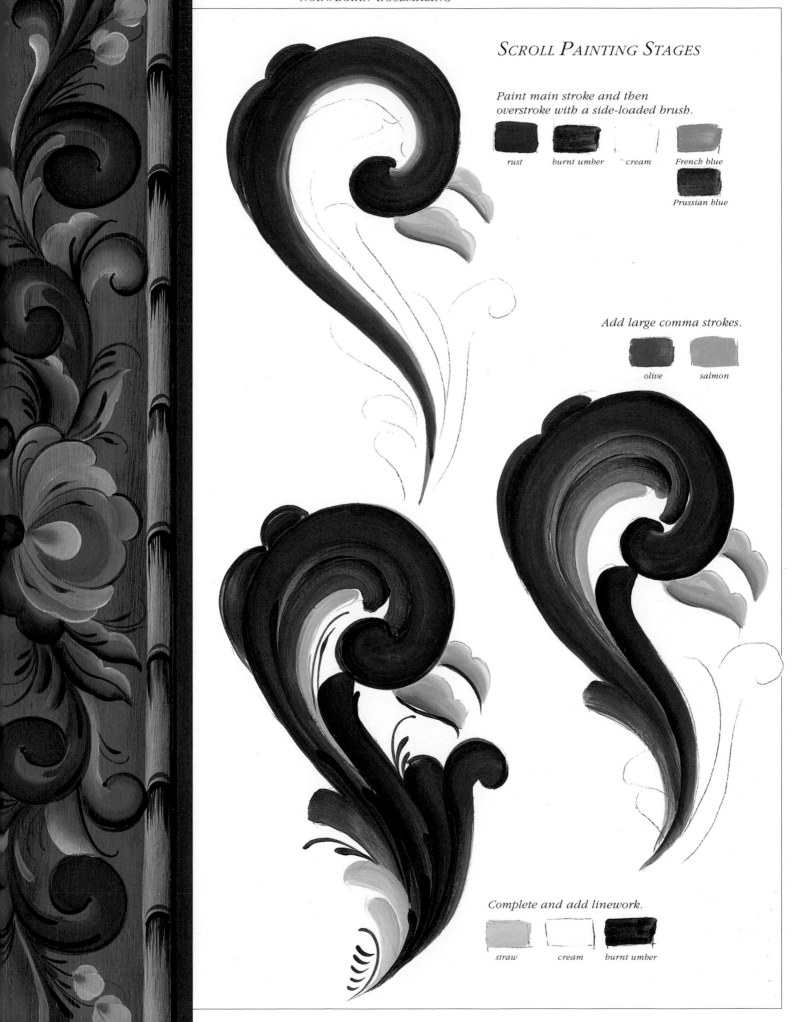

SCROLL PAINTING STAGES

Paint main stroke and then overstroke with a side-loaded brush.

rust burnt umber cream French blue

Prussian blue

Add large comma strokes.

olive salmon

Complete and add linework.

straw cream burnt umber

HINDELOOPEN OF THE NETHERLANDS

In the Netherlands, a history of trade with distant cultures produced a unique painting tradition that borrows decorative elements of both the West and East. Hindelooper art is unusually complex in design and combines colors to produce a strange and dramatic effect.

Traditional butte

From the fifteenth to the eighteenth centuries, the town of Hindeloopen in Friesland was an important base for ships trading around the world. Much of this trade was in wooden objects, and woodcarving was a local craft popular among the sailors. The painting of these carvings led naturally to painting on the furniture, doors and interior walls of Dutch homes. These early efforts were influenced by the Norwegian painting styles, but whatever Hindeloopen once owed to the Norwegian rosemalers, it quickly developed its own set of characteristics.

When the East India Company was founded in 1602, much of the Hindelooper fleet sailed for Japan, India, China and Indonesia. Dutch sailors brought home many objects of Eastern art, such as Chinese porcelain and heavily decorated fabrics known as chintz. The designs of chintz greatly influenced the basic style of Hindeloopen, with its rich, dark backgrounds and intricate detail. Hindelooper artists also attempted to imitate Chinese porcelain by painting designs in a single color, such as blue, on an off-white background. By custom, this technique was used to decorate wedding gifts. A third variation appeared: the use of a dark blue background to signify mourning. Household objects were repainted in this somber color scheme for the duration of the mourning period, which traditionally lasted seven years.

In each of these stylistic variations, motifs were painted using three colors or shades: a main color, a shadow color and a highlight, which combined to emphasize the detail of the design. To provide some visual relief, Hindelooper artists made good use of false marbling techniques and often added biblical scenes or landscapes in a cartouche or panel. It is the striking colors and the graceful wave lines of the basic pattern, however, that sum up the Hindelooper style and best convey the unusual blend of Western and Eastern influences.

These well worn clogs have been painted in the red-brown color of basic Hindeloopen.

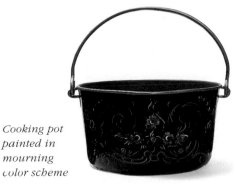

Cooking pot painted in mourning color scheme

DESIGNS AND VARIATIONS

Hindelooper designs are a graceful combination of acanthus scrolls
and small flowers and often feature a lucky bird perched among the
flowers. There is little attention to proportion; the bird is a
relatively small motif, while whole landscapes are happily
painted within the confines of
a garland. Favored
flowers include daisies,
poppy heads, roses,
chrysanthemums
and tulips.

tomato

red oxide *ivory*

FLOWERS
*Wild roses are often
painted front on,
using contrasting
overstrokes on a
hollow circle
of color.*

SHADES
*The use of several shades
in one color is just one
of the Hindelooper
color schemes.*

dusty blue

Prussian blue

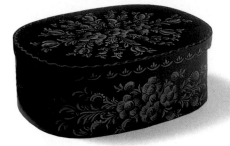

SCENES
*Landscapes can
be added in a
cartouche, as on
this coal scuttle.*

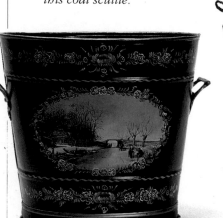

PATTERNS
*A basic floral spray can be
adapted to fit various panels.*

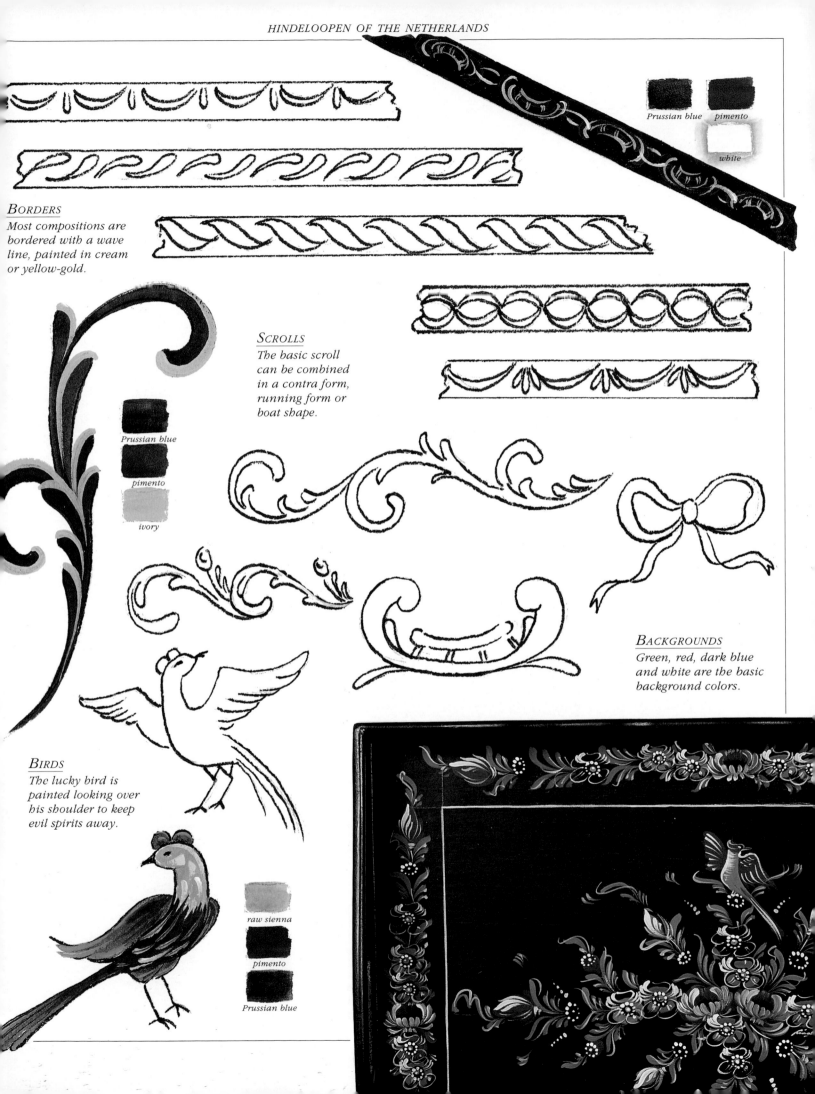

BORDERS
Most compositions are bordered with a wave line, painted in cream or yellow-gold.

Prussian blue pimento

white

SCROLLS
The basic scroll can be combined in a contra form, running form or boat shape.

Prussian blue

pimento

ivory

BACKGROUNDS
Green, red, dark blue and white are the basic background colors.

BIRDS
The lucky bird is painted looking over his shoulder to keep evil spirits away.

raw sienna

pimento

Prussian blue

PROJECT: HINDELOOPEN BUTTE

This butte, or food box, is decorated in the basic Hindeloopen
style with a strong red background and marbled trim. Hindelooper
artists paint freehand, sketching loosely in chalk, however
beginners may prefer to trace the design.

Level of difficulty: Intermediate

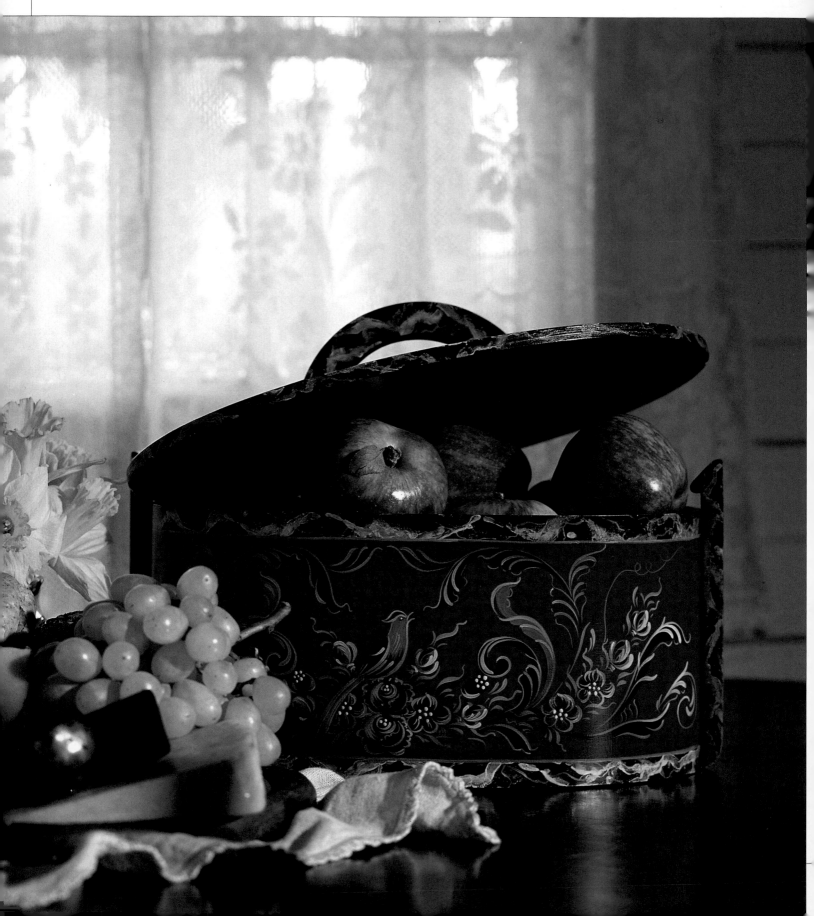

Basecoater

Ruler

Masking tape

Chalk pencil

PROJECT OVERVIEW

- SURFACE PREPARATION (see page 137)
- BASECOATING (see page 141)
- MARBLING BORDER (see overleaf)
- TRANSFERRING DESIGN (see page 136)
- PAINTING DESIGN (see below)
- ANTIQUING (see page 143)
- VARNISHING (see page 143)
- WAXING (see page 143)

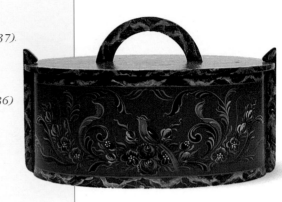

Stylus

Tracing & transfer paper

Kneaded eraser

Varnish

Wax

Spatula

Retarder

Plastic wrap

#6 flat

#3 round

#1 liner

Paint palette

Patina

Oil paint, cloth & tissue

#8 bristle

PAINTING STEP-BY-STEP

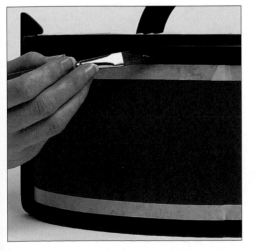

1 Prepare the surface and basecoat in tomato. Using a pencil and ruler, mark in the border. Apply masking tape along the pencil line and, using a #6 flat brush, paint the exposed border and handle Prussian blue.

2 When the Prussian blue paint is dry, marble the border and handle as shown on next page. Leave to dry. Transfer the designs (page 160-1) onto the base and lid. Note that only half of the lid design has been included.

3 Refer to painting stages on next page for colors and brushstrokes. Use a #3 round to block in scrolls, flowers and bird and to paint overstrokes. Detail with a #1 liner. When dry, erase lines then antique, varnish and wax.

LUCKY BIRD PAINTING STAGES

Paint in scrollwork.

pimento *Prussian blue*

yellow oxide *burnt umber*

Add foliage, flowers and bird.

pimento *Prussian blue*

yellow oxide *burnt umber*

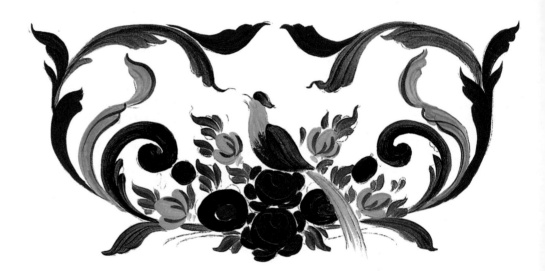

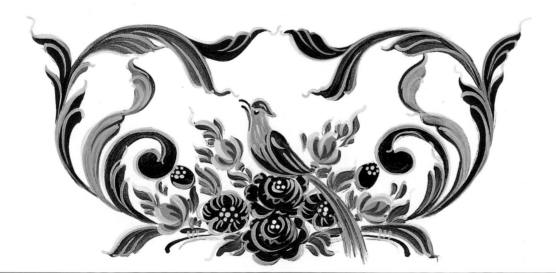

Add linework.

ivory *straw*

MARBLING

For almost as long as marble has been quarried, decorative artists have imitated the veins and fractures of this symbol of wealth. In France, where it is known as *faux marbre*, the results were often convincing. Among the rural Dutch, the false finish was painted with less attention to accuracy.

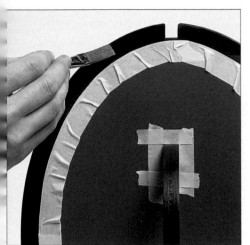

1 Use a #6 flat brush to paint retarder medium onto the marbling areas. Move quickly on to the next step.

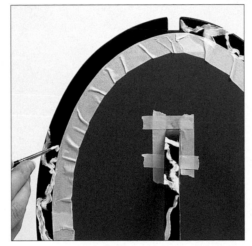

2 While the retarder is still damp, paint random white lines on the marbling area with a #3 round brush. Again, move quickly on to the next step.

3 Before the white lines dry, smudge them with crumpled plastic wrap, changing the angle at which the wrap is dabbed so that the pattern is varied.

4 Use a #1 liner to add fine white lines to represent the veins in marble.

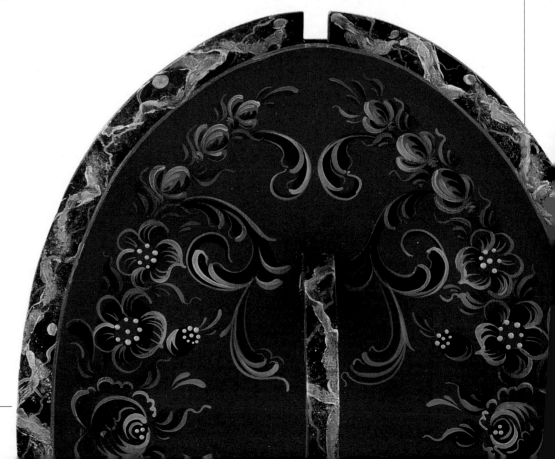

AMERICAN COUNTRY PAINTING

COLONIAL AMERICA was populated by various ethnic groups, each of which brought a rich cultural heritage and a wealth of skills. The Germanic people who settled the fertile valleys of Pennsylvania in the seventeenth century had a strong painting tradition which they adapted to create a simple, fresh style.

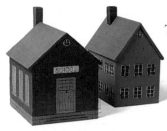

Naive houses

The Pennsylvania Dutch, the 'Dutch' being a misnomer for 'Deutsch,' worked hard and led simple lives. Events such as births, marriages and funerals were community occasions which were commemorated in *frakturs*, dower chests and mourning pictures. Regional variations in their folk art arose due to religious differences: Lutherans, who enjoyed color and decoration, decorated their barns with large hex signs; the Amish and other 'Plain Dutch' sects shunned such worldliness.

Frakturs, a beautiful and unique form of Pennsylvanian folk art, were profusely decorated records of births, baptisms, marriages, and houseblessings drawn in inks on laid paper and colored with watercolors or vegetable dyes. Fraktur lettering, or Frakturschrift, was in gothic German and often expressed a biblical sentiment. The decorated dower chest was a traditional part of a bride's dowry. Given to her by her father, it went with her to her new home filled with linens she had spun and embroidered. Often the owner's name and the year it was made were incorporated into the decoration. The bride box was usually a gift from the bridegroom, in which the bride saved her wedding veil and other small treasures. Similar to a hat box in size and shape, it usually depicted the bride and groom on the lid with a sentimental inscription. In the late eighteenth century, such household articles as coffee pots, trays, boxes and canisters were made of tinplate and, when japanning became popular, gaily painted with bold stroke designs.

Deutsch box

Pennsylvania Dutch painting is less ornate than its European origins. Motifs are simple and colors bright and bold: two characteristics of American country painting in general. Indeed, Pennsylvania Dutch style has become almost synonymous with American folk art.

Brightly painted whirligigs are a trademark of the American country style.

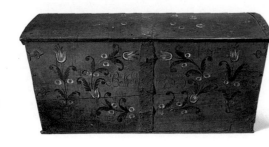

This chest is painted in the traditional Pennsylvanian blue.

DESIGNS AND VARIATIONS

American decorative painting conveys a sense that anything is possible. Unicorns and mermaids, angels and brave horsemen, symbolizing purity of heart and spirit, are featured boldly among stars and flowers. Farm animals are painted as if they have a special place in art, and color combinations are dramatic if not gaudy.

PRIMITIVE
Naively painted figures and animals have become a favorite aspect of American country style.

COLORS
Peacock plumage offers an excuse for bright colors.

straw peach

dusty blue

BIRDS AND BEASTS
Mythical and unlikely animals appear, along with the more mundane dove.

straw burnt sienna

HERITAGE
The shape, colors and decoration of this tine box point to a European tradition.

BORDERS
Simple designs make effective use of S-strokes, C-strokes and commas.

olive red oxide

Prussian blue rust

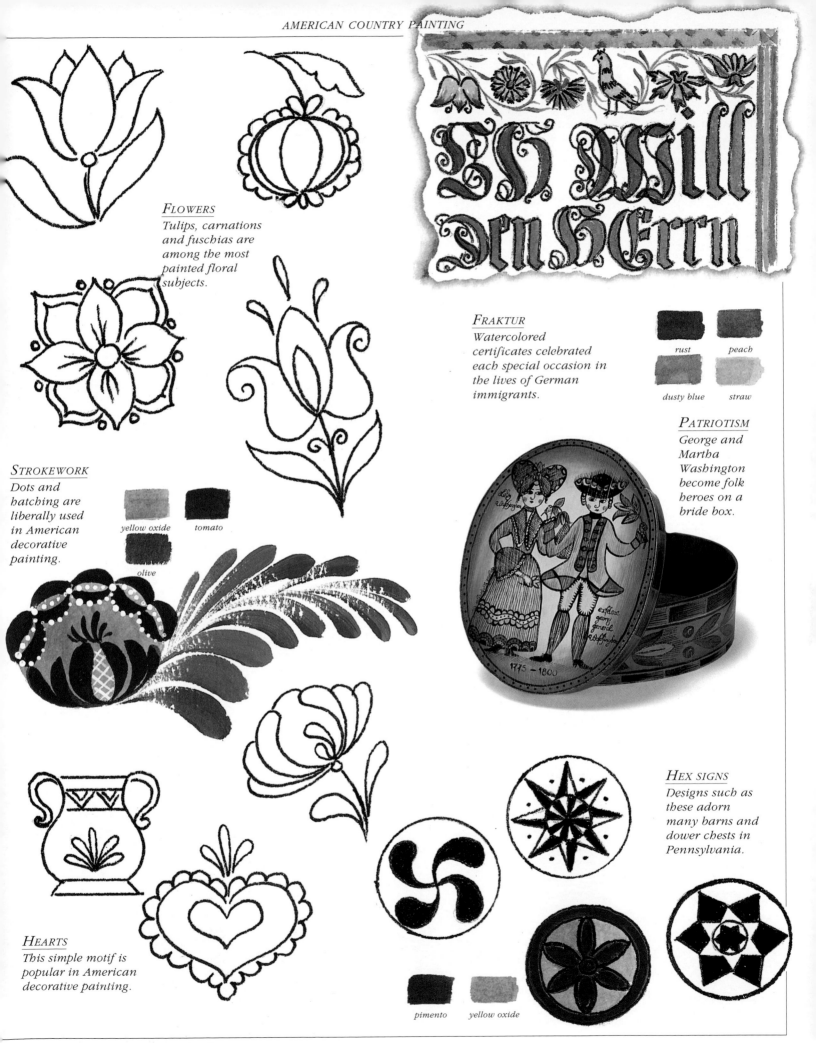

FLOWERS
Tulips, carnations and fuschias are among the most painted floral subjects.

STROKEWORK
Dots and hatching are liberally used in American decorative painting.

yellow oxide tomato

olive

HEARTS
This simple motif is popular in American decorative painting.

FRAKTUR
Watercolored certificates celebrated each special occasion in the lives of German immigrants.

rust peach

dusty blue straw

PATRIOTISM
George and Martha Washington become folk heroes on a bride box.

1775 - 1800

HEX SIGNS
Designs such as these adorn many barns and dower chests in Pennsylvania.

pimento yellow oxide

PROJECT: DOWER CHEST

This project was designed from a dower chest dated 1804
which featured urns of stylized flowers on white panels.
These panels have been cleverly antiqued to give them
depth and dimension.

Level of difficulty: Intermediate

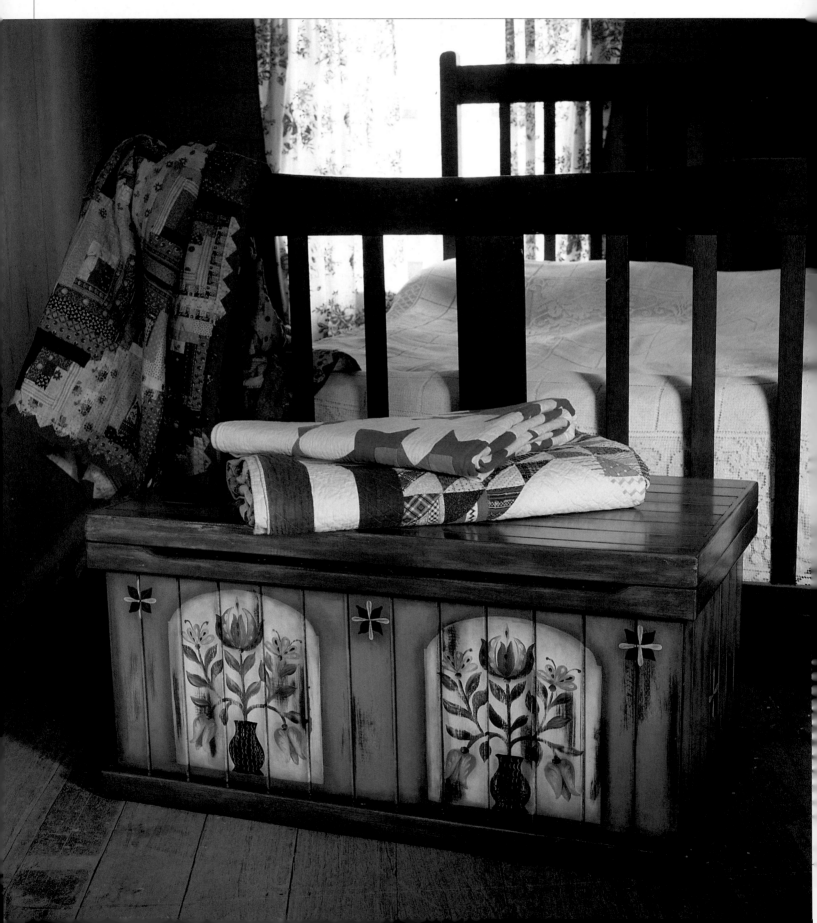

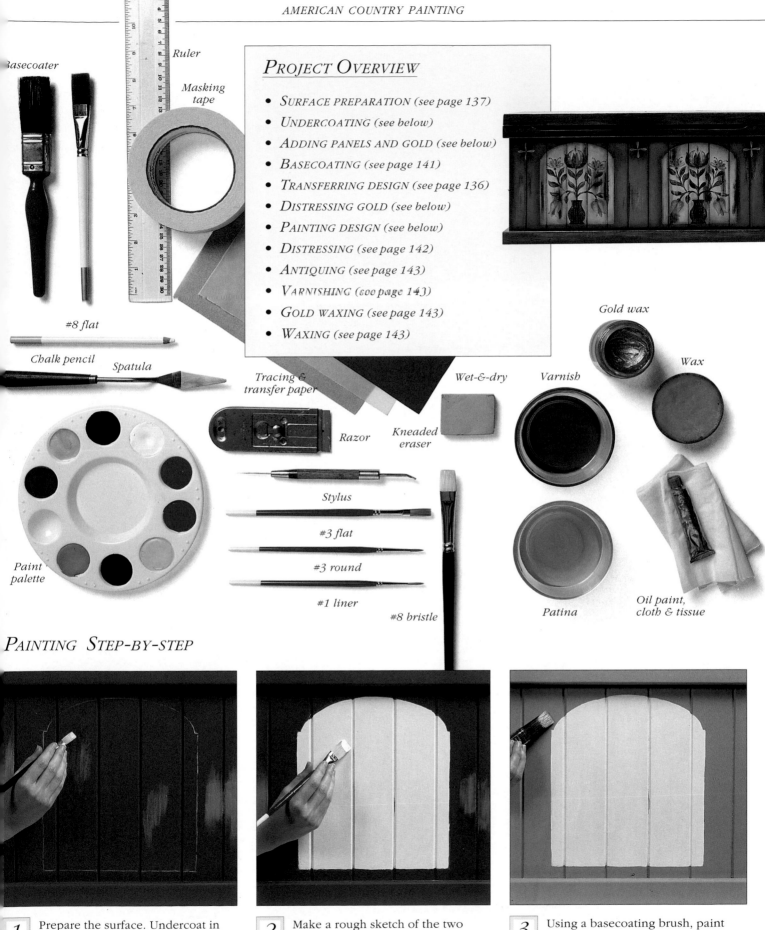

Basecoater

Ruler

Masking tape

#8 flat

Chalk pencil

Spatula

Tracing & transfer paper

Razor

Kneaded eraser

Wet-&-dry

Varnish

Gold wax

Wax

Paint palette

Stylus

#3 flat

#3 round

#1 liner

#8 bristle

Patina

Oil paint, cloth & tissue

PROJECT OVERVIEW

- SURFACE PREPARATION (see page 137)
- UNDERCOATING (see below)
- ADDING PANELS AND GOLD (see below)
- BASECOATING (see page 141)
- TRANSFERRING DESIGN (see page 136)
- DISTRESSING GOLD (see below)
- PAINTING DESIGN (see below)
- DISTRESSING (see page 142)
- ANTIQUING (see page 143)
- VARNISHING (see page 143)
- GOLD WAXING (see page 143)
- WAXING (see page 143)

PAINTING STEP-BY-STEP

1 Prepare the surface. Undercoat in rust. Transfer two panels with a chalk pencil and ruler. Using a #8 flat, paint patches of gold scattered over the chest, including several within each panel.

2 Make a rough sketch of the two panels on paper, noting the position of the gold patches. Use a #8 flat brush to paint three coats of white within each of the panels.

3 Using a basecoating brush, paint two coats of dusty blue all over the chest, excluding the panels. Transfer the design (page 162) onto each of the panels.

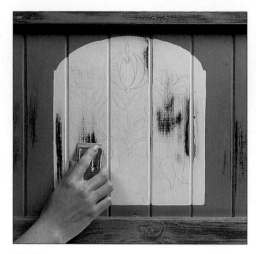

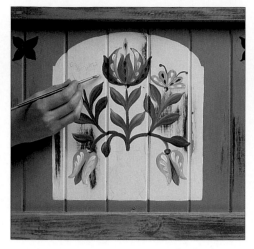

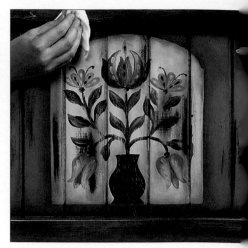

4 Referring to your sketch, heavily distress the gold areas of the panels with a razor, scraping right back to expose some of the woodgrain.

5 See opposite for painting stages. Paint the leaves and flowers with a #3 round using the wet-on-wet technique. Block in the vase with a #3 flat brush and scratch lines with a stylus.

6 When dry, erase all lines. Lightly distress the design with wet-and-dry paper. Antique and varnish. Using a cloth, apply gold wax around the rim and edges. Polish with clear wax to complete.

DOUBLE-LOADING

Double-loading produces a stroke with two colors which merge but remain distinct. It can be very effective on leaves and petals which are painted with comma strokes, giving them a softly shaded quality. A combination of a light and dark color works best.

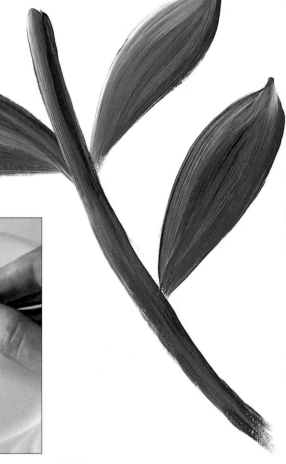

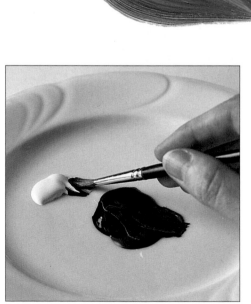

1 Wipe the brush through the main color, turning and wiping again so that it is thoroughly loaded with paint.

2 Take a single wipe through the edge of the contrasting color.

3 Use the double-loaded brush to paint blended strokes, reloading the brush as required.

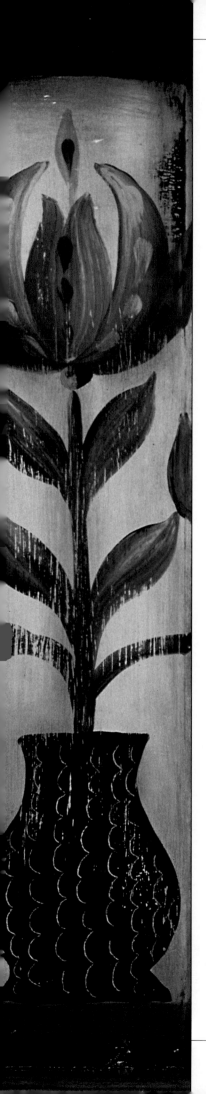

TULIP PAINTING STAGES

Paint central petals with
double-loaded brush.

pale orange orange

rust white

Paint outer petals and add overstrokes.

rust yellow oxide Prussian blue

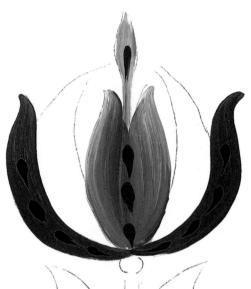

Complete petals and paint leaves and stem
with double-loaded brush.

dusty blue Prussian blue spruce yellow oxide white

PROJECT: AMERICAN TOLEWARE

Painting on tinware developed in the New England states where utensils such as this document box and coffee pot were basecoated in black or asphaltum and then decorated. In Pennsylvania, a red background and brighter designs were more common.

Level of difficulty: Intermediate

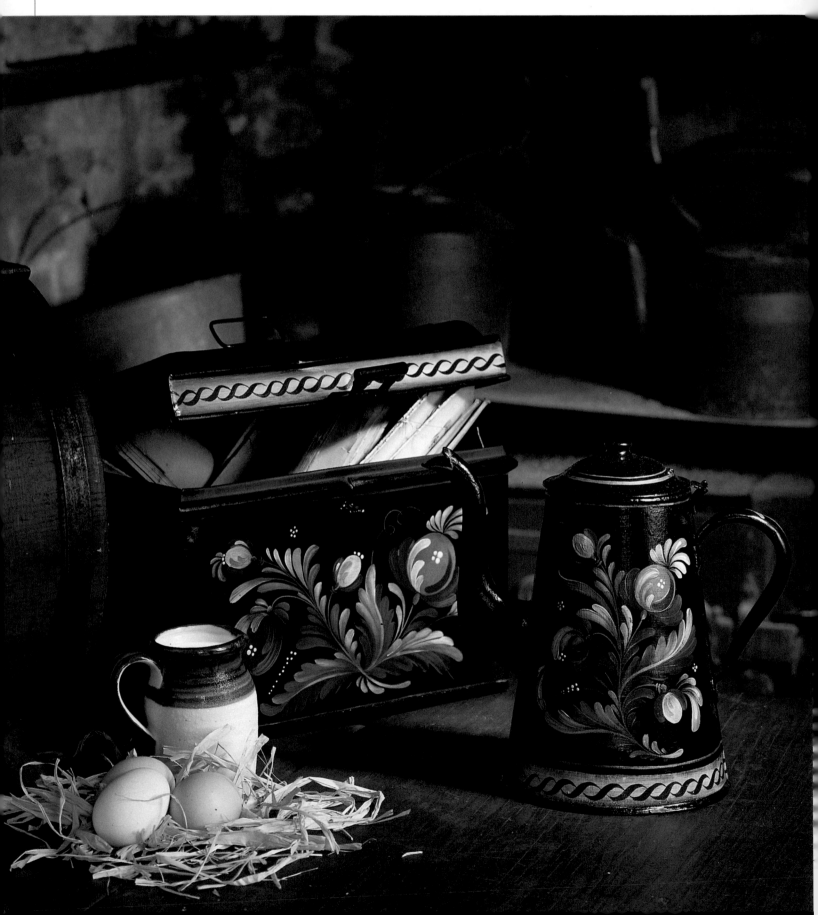

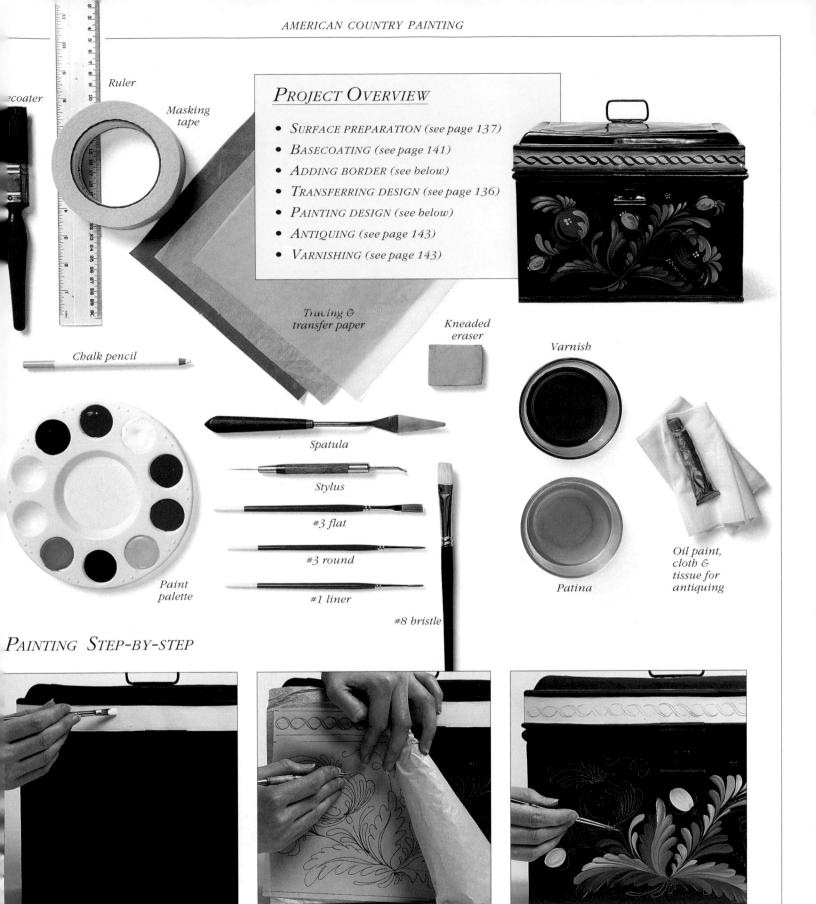

Ruler

Masking
tape

PROJECT OVERVIEW

- SURFACE PREPARATION (see page 137)
- BASECOATING (see page 141)
- ADDING BORDER (see below)
- TRANSFERRING DESIGN (see page 136)
- PAINTING DESIGN (see below)
- ANTIQUING (see page 143)
- VARNISHING (see page 143)

Tracing &
transfer paper

Kneaded
eraser

Varnish

Chalk pencil

Spatula

Stylus

#3 flat

#3 round

#1 liner

Paint
palette

Patina

Oil paint,
cloth &
tissue for
antiquing

#8 bristle

PAINTING STEP-BY-STEP

1 Prepare the surface. Basecoat with black. Using a chalk pencil and ruler, mark the border where appropriate. Paint three coats of cream on the border, using a #3 flat brush.

2 Transfer the designs (pages 163-4) onto the front and sides of the box, using light transfer paper for the main design and dark transfer paper for the border design.

3 See overleaf for painting stages. Paint the leaves and flowers wet-on-wet with a #3 round brush. Leave to dry. Add detail with a #1 liner. Paint ivory dots with the end of a brush.

4 Paint the border design in red oxide with a fine point #3 round brush. When dry, erase all design lines.

5 On the top of the box (or wherever appropriate) add gold trim lines. Paint the thin line with a #1 liner and thicker lines with a #3 round brush.

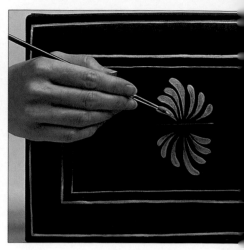

6 Paint a gold flourish with a #3 round brush. Leave to dry. Antique and varnish to complete.

FLOWER PAINTING STAGES

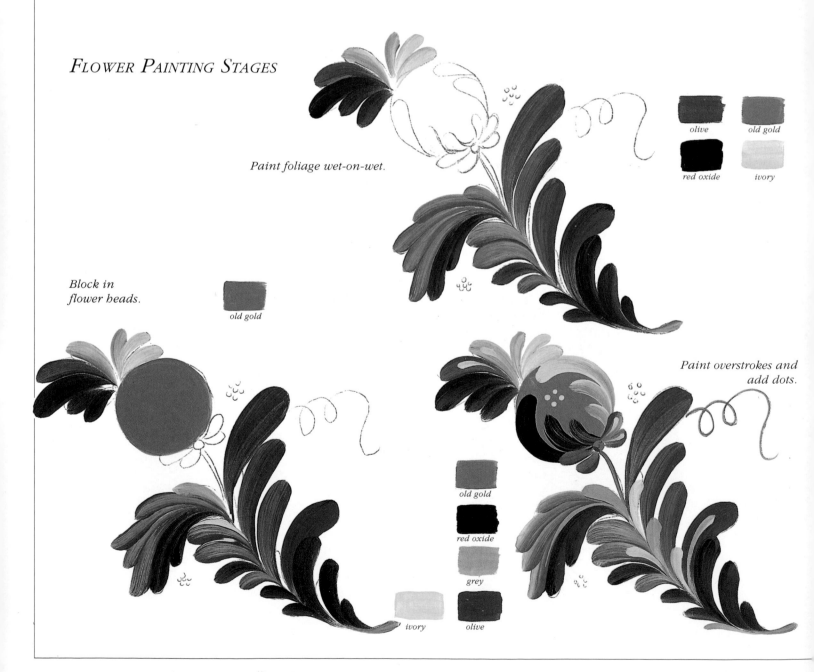

Paint foliage wet-on-wet.

olive

old gold

red oxide

ivory

Block in flower heads.

old gold

Paint overstrokes and add dots.

old gold

red oxide

grey

ivory

olive

COFFEE POT PAINTING STAGES

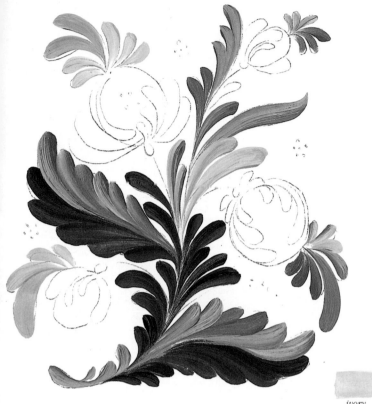

Paint foliage wet-on-wet.

 olive *old gold* *red oxide*

 ivory

Block in flower heads.

 old gold *red oxide* *ivory*

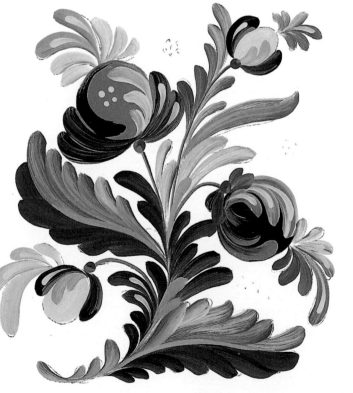

Paint overstrokes and add dots.

 ivory

 old gold *red oxide* *olive* *grey*

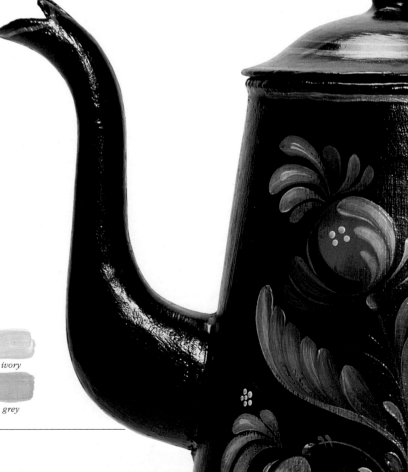

MEDITERRANEAN STYLE

THE CIVILIZATIONS OF THE MEDITERRANEAN have always been influential in design: the ancient Greeks and Romans provided the very basis of Western decoration. Although the Italians flirted with the extremes of baroque and rococo, the hallmarks of Mediterranean style today are simple motifs and pure colors.

Italian clock

Decorative painting in this part of the world is associated with ceramics rather than with wood. The Greeks often painted pottery vessels for holding wine or oil, leaving the red clay to show through the black design. As well as the human figure, these vases bore geometric borders, stylized acanthus leaves, bunches of grapes and other fruit. These motifs would reappear centuries later in the vocabulary of the neo-classical style.

The Moorish occupation of southern Spain lasted for centuries and left a strong Islamic mark, even after Christians reclaimed the area. Brilliantly colored mosaics, intricate plasterwork and gilded sunbursts still adorn the buildings of Andalusia.

Europe's love of painted furniture in the eighteenth century had little affect on such remote areas of the Mediterranean. The greatest impact was in the north of Italy where the country people had contact with their Swiss and Austrian counterparts. Headboards, armoires, chests and other provincial pieces were painted in Tuscany, Lombardy and the Veneto during this period and the floral designs reveal the northern influence.

In present times, Mediterranean decoration is most common on ceramics. Markets in Greece, Spain and Italy overflow with brightly painted tiles, plates and pots. In these countries, tiles are not simply used as a floor covering: they might adorn plain chests or appear on window boxes. Tiles often cover inside and outside walls, sometimes serving as a canvas for a large-scale picture instead of a series of repeated designs. There are some regional differences in ceramic painting: vivid yellow and green are favored in Spain and Portugal, while blue and white are popular in Italy and Greece. The motifs vary slightly but, in general, there is no mistaking the bold lines and confident colors of Mediterranean design.

Ceramic plate

Blue and white— the colors that summon Mediterranean style to mind—add charm to a Spanish street.

Ceramic tiles form a religious tableau.

DESIGNS AND VARIATIONS

Most painting in Greece, Italy and Spain is executed on ceramics. So, a simple step towards recreating the Mediterranean style is to paint on a white background. Designs are worked in pure colors and shading is achieved by floating one color rather than blending. The result has a fresh and clean feel which has great appeal for those of us surrounded by cluttered modern images.

FOLIAGE
The classic acanthus leaf is used as a free-standing element.

FLORENTINE
These brooches draw on Italian decoration for inspiration.

FRUIT
The seasonal harvest makes colorful subject matter.

olive

grape

mauve

rust

PATTERNS
Daisies, anthemions and quatrefoils can be repeated to create decorative patterns.

EMBLEMS
A flower is treated in such a stylized way that it becomes pure ornament.

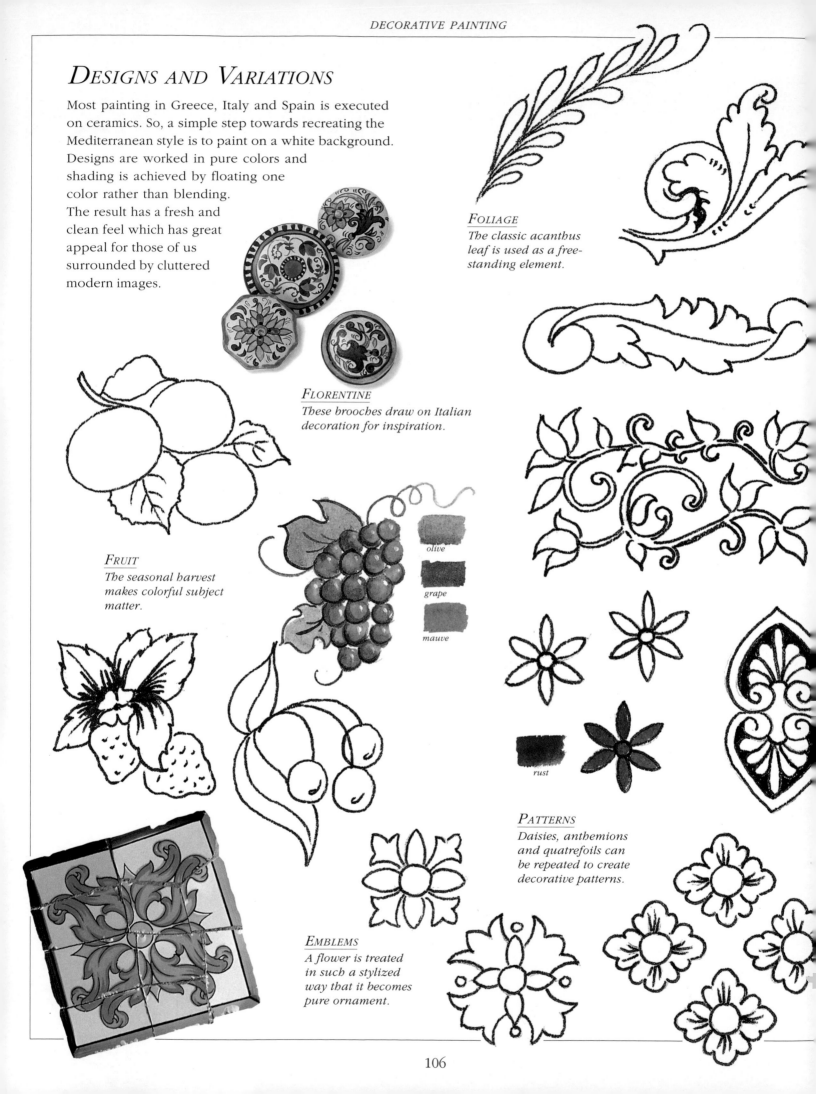

peach dusty blue

BORDERS
*Stylized leaves and
flowers are well-suited
for strip patterns.*

BEASTS
*The rooster is a traditional
Spanish motif. Fish are often
featured in Italian design.*

TREE OF LIFE
*A Mediterranean
version of the
emblem is shown
on this Italian dish.*

dusty blue Prussian blue

FLORALS
*Flowers are represented
simply, and are generally
shown front on.*

yellow Prussian blue

charcoal

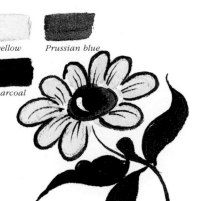

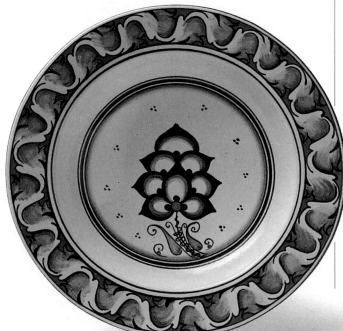

PROJECT: ITALIAN PLATTER

The fresh white background and clean blue lines of this simple
design sum up Mediterranean style. We have chosen a wooden
platter sealed with gesso; you may prefer to work with ceramics
paints to decorate a ceramic plate or series of tiles.

Level of difficulty: Beginner

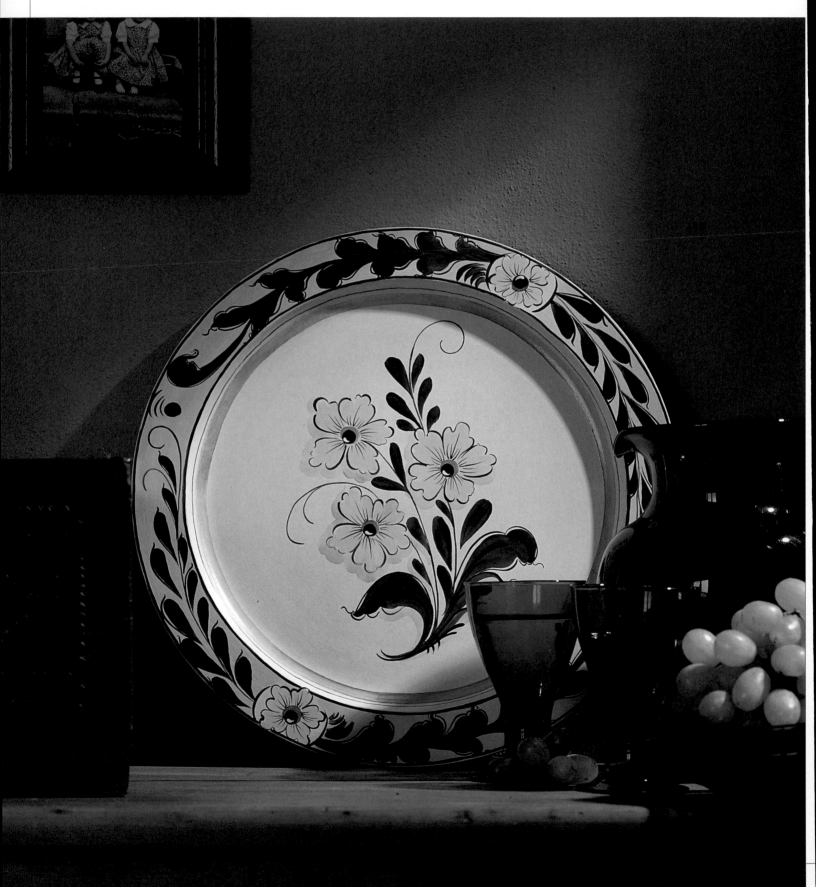

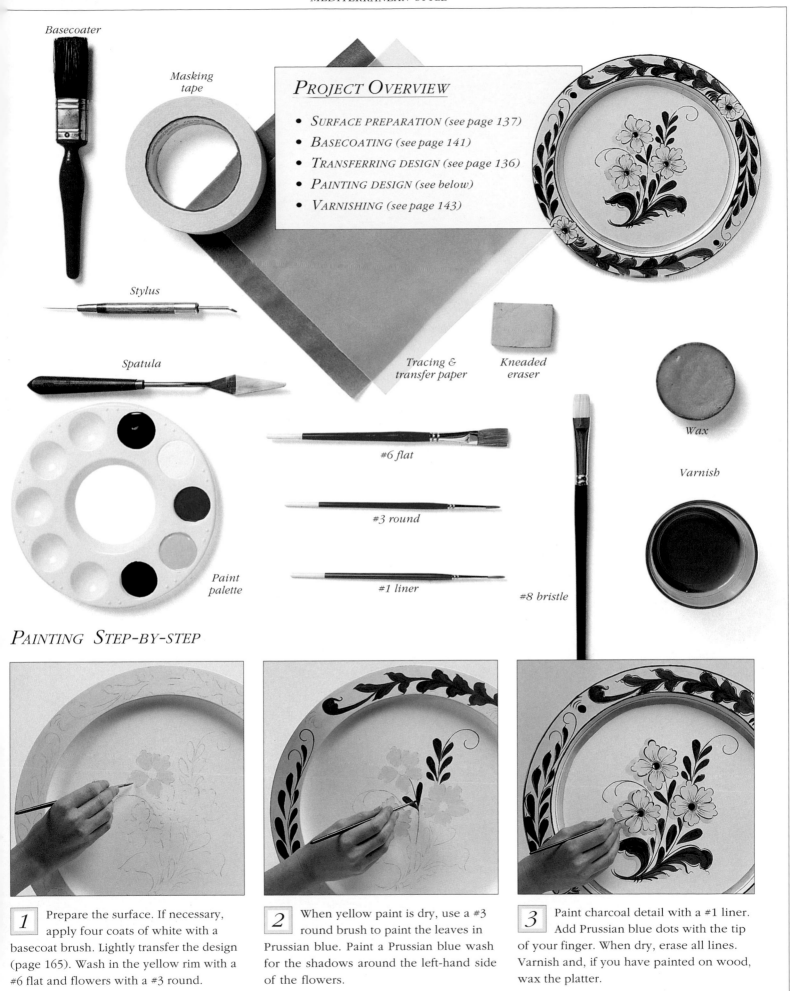

Basecoater

Masking tape

PROJECT OVERVIEW

- SURFACE PREPARATION (see page 137)
- BASECOATING (see page 141)
- TRANSFERRING DESIGN (see page 136)
- PAINTING DESIGN (see below)
- VARNISHING (see page 143)

Stylus

Spatula

Tracing & transfer paper

Kneaded eraser

Wax

Varnish

#6 flat

#3 round

Paint palette

#1 liner

#8 bristle

PAINTING STEP-BY-STEP

1 Prepare the surface. If necessary, apply four coats of white with a basecoat brush. Lightly transfer the design (page 165). Wash in the yellow rim with a #6 flat and flowers with a #3 round.

2 When yellow paint is dry, use a #3 round brush to paint the leaves in Prussian blue. Paint a Prussian blue wash for the shadows around the left-hand side of the flowers.

3 Paint charcoal detail with a #1 liner. Add Prussian blue dots with the tip of your finger. When dry, erase all lines. Varnish and, if you have painted on wood, wax the platter.

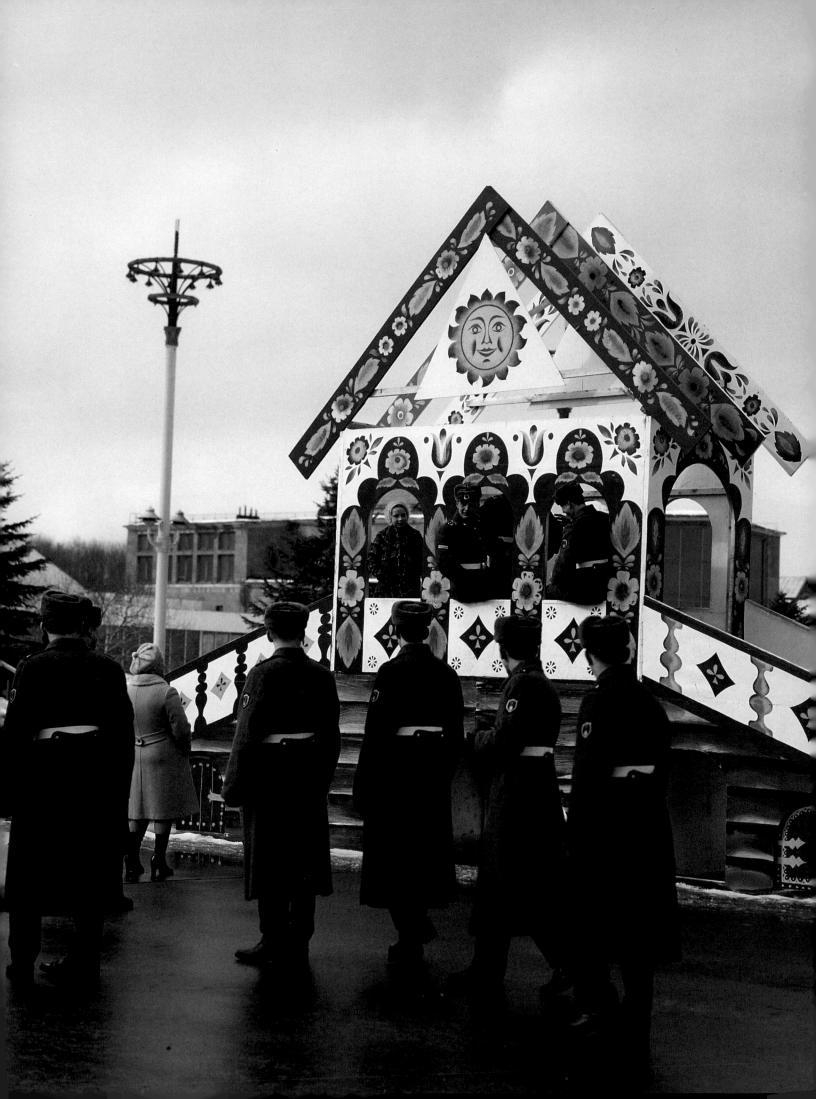

EASTERN SLAVIC FOLK ART

THE SLAVIC PEOPLES OF RUSSIA, Byelorussia and Ukraine each have their own culture, language and history, but they share a love of colorful decoration. Some elements of painting—the distinctive use of red, for example—are common throughout these countries. Other traditions are distinctively regional.

Khokhloma ware

Painting is one of the richest branches of Slavic folk art and has its beginnings in Ukrainian wall paintings, created with feathers, reeds, or straw wisps. Flowers, pine boughs, oak leaves, birds and animals all decorated walls above the hearth and bed, or the ceiling and beams. The colors, originally made from plants, were applied on a white, blue or green background and had to be repainted regularly. In the sixteenth century, however, people turned to painting on sheets of paper. These *malyovki* were painted when farm work permitted, generally in winter, and were glued on the walls for important festivities. Domestic articles were also painted, including wooden bread plates, sleds, distaffs for spinning flax, and *skrinyas*, or chests, for storing holiday clothing.

The village of Petrikivka in eastern Ukraine is famous for its floral painting. Most designs follow the tradition of painting three main flowers, symbolic of the Holy Trinity. Petrikivka

artists use brushes made of cats' hair, capable of both heavy strokes and extremely fine hatch lines, and they add egg to paint to intensify the color and make brushstrokes more expressive. They also employ a series of brushstrokes which makes their work quite distinctive.

The Volga region of Russia, on the other hand, is renowned for its dramatic lacquerware. Craftsmen in Khokhloma had long been making wooden utensils and painting them with exuberant red and black leaf designs and a protective coat of varnish. They knew that varnish turns yellow when heated and found that yellowed varnish over tin produces a rich gold finish. They adapted this to suit the wooden spoons and bowls made locally, soaking them in linseed oil and then rubbing with powdered tin, painting, lacquering and finally firing them. Today this peasants' gold, decorated with swirling motifs, can be achieved with modern acrylics.

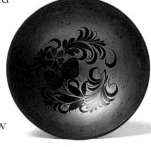

Ukrainian plate

While design and style vary across regions and countries, the folk painting of Eastern Slavic nations is generally vibrant in color and rich in symbolism.

Soldiers, like children, are attracted by the bright Slavic paintwork of a Russian fairground.

Russian pokerwork

111

DESIGNS AND VARIATIONS

For the Eastern Slavs, colors have symbolic meaning and carry clear messages for the viewer. White represents purity and innocence, yellow speaks of the harvest and hospitality, while the blue of the sky is the color of good health. Red, the most commonly painted color throughout the region, signifies happiness, hope and passion.

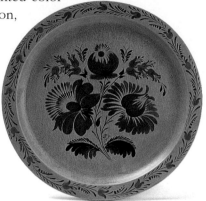

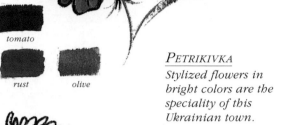

tomato

rust olive

PETRIKIVKA
Stylized flowers in bright colors are the speciality of this Ukrainian town.

BORDERS
Choose from floral shapes or simple geometrics in contrasting colors.

black

Prussian blue

red

BIRDS
For Ukrainians, a perched bird represents a protector of hearth and home.

ROSETTES
These circular patterns derive from the Slavic symbol for the pagan sun-god.

yellow oxide orange

burnt sienna

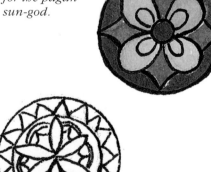

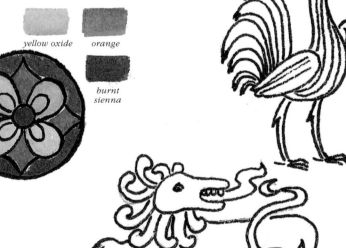

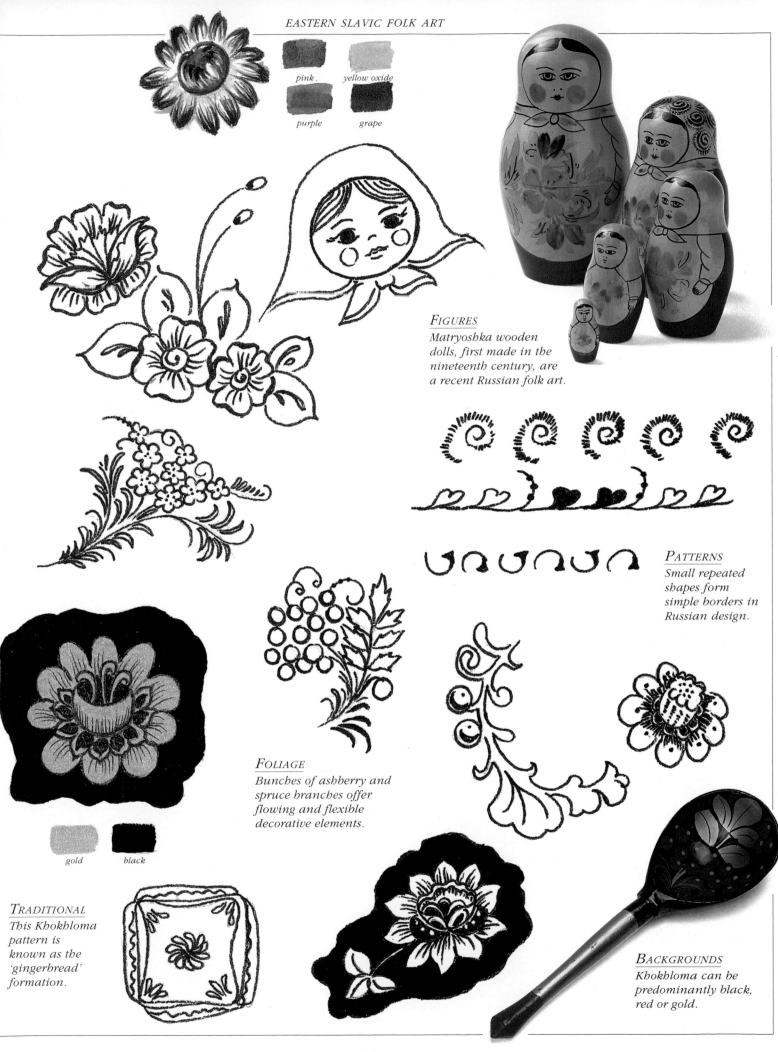

pink

yellow oxide

purple

grape

FIGURES
Matryoshka wooden dolls, first made in the nineteenth century, are a recent Russian folk art.

PATTERNS
Small repeated shapes form simple borders in Russian design.

FOLIAGE
Bunches of ashberry and spruce branches offer flowing and flexible decorative elements.

gold

black

TRADITIONAL
This Khokhloma pattern is known as the 'gingerbread' formation.

BACKGROUNDS
Khokhloma can be predominantly black, red or gold.

PROJECT: SLAVIC EGGS

The tradition of painting Easter eggs, known as *psyanka* in Ukraine, offers endless opportunities for decorative painters. The large wooden eggs shown below have been painted with a Russian matryoshka design and two Ukrainian geometric patterns.

Level of difficulty: Beginner

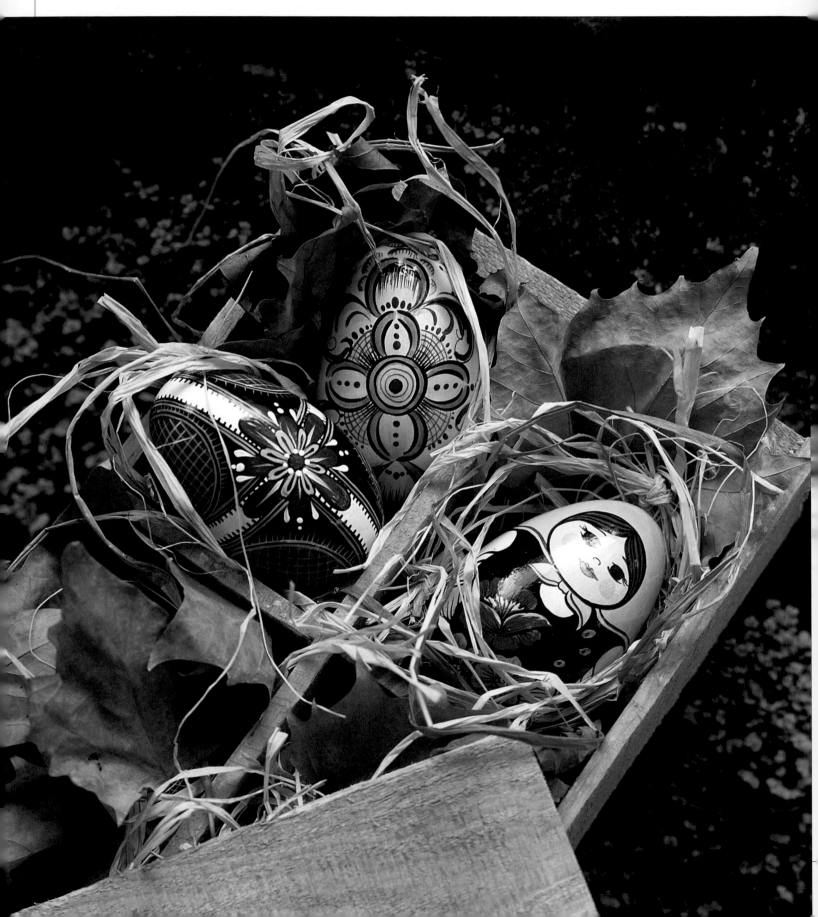

#6 flat Pencil

PROJECT OVERVIEW

- SURFACE PREPARATION (see page 137)
- BASECOATING (see page 141)
- TRANSFERRING DESIGN (see page 136)
- PAINTING DESIGN (see below)
- ANTIQUING (see page 143)
- VARNISHING (see page 143)
- WAXING (see page 143)

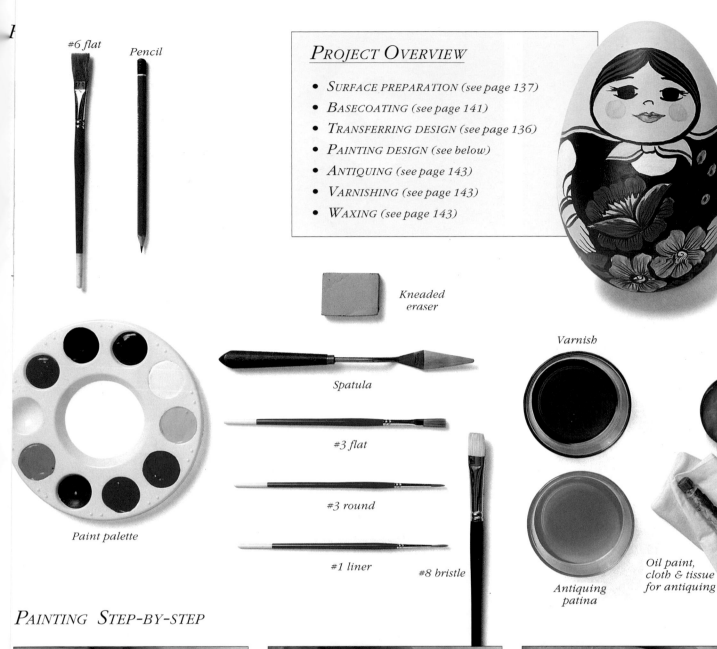

Kneaded
eraser

Varnish

Wax

Spatula

#3 flat

#3 round

#1 liner #8 bristle

Paint palette

Antiquing
patina

Oil paint,
cloth & tissue
for antiquing

PAINTING STEP-BY-STEP

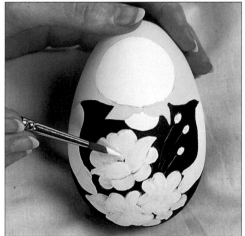

1 Prepare the surface, emptying a fresh egg or sealing a wooden one. Basecoat white with a #6 flat. Draw the design (page 168) freehand in pencil, omitting detail.

2 Using a #3 flat brush, paint the black dress and yellow shawl. Paint a second coat over each color.

3 Freehand, paint the flowers and foliage in white with a #3 round brush. Use the design for reference.

PROJECT: KHOKHLOMA TRAY

Gold, fiery red and black—the rich colors of Russian khokhloma—produce an extremely dramatic effect. The project is easier than it appears; however, the careful layering of colors and final varnishing will take some time and a degree of patience.

Level of difficulty: Intermediate

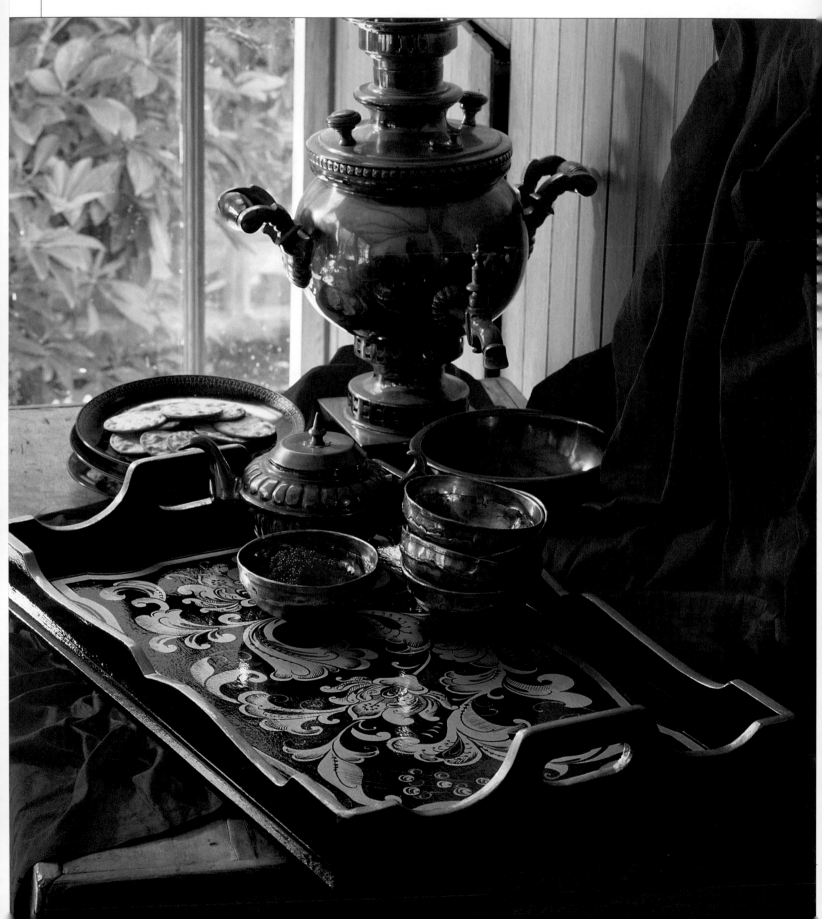

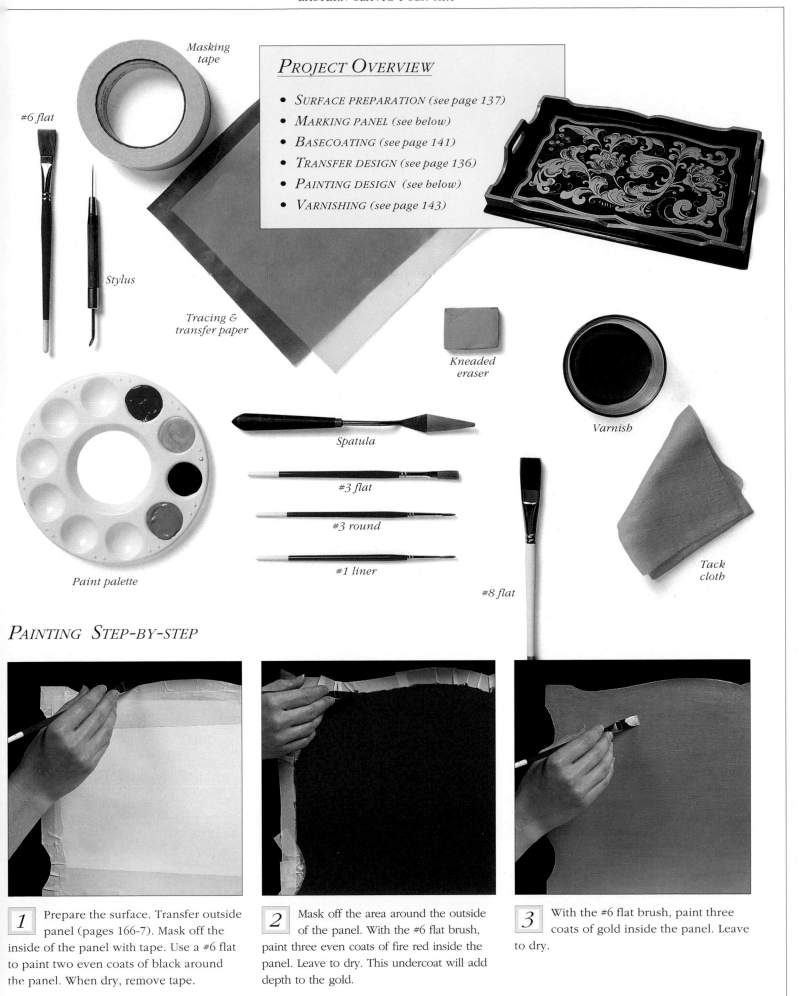

#6 flat

Masking tape

Stylus

PROJECT OVERVIEW

- **SURFACE PREPARATION** *(see page 137)*
- **MARKING PANEL** *(see below)*
- **BASECOATING** *(see page 141)*
- **TRANSFER DESIGN** *(see page 136)*
- **PAINTING DESIGN** *(see below)*
- **VARNISHING** *(see page 143)*

Tracing & transfer paper

Kneaded eraser

Varnish

Spatula

#3 flat

#3 round

#1 liner

Tack cloth

Paint palette

#8 flat

PAINTING STEP-BY-STEP

1 Prepare the surface. Transfer outside panel (pages 166-7). Mask off the inside of the panel with tape. Use a #6 flat to paint two even coats of black around the panel. When dry, remove tape.

2 Mask off the area around the outside of the panel. With the #6 flat brush, paint three even coats of fire red inside the panel. Leave to dry. This undercoat will add depth to the gold.

3 With the #6 flat brush, paint three coats of gold inside the panel. Leave to dry.

119

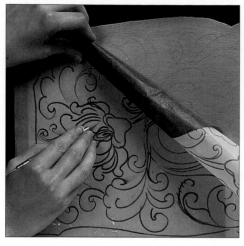

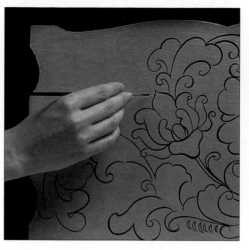

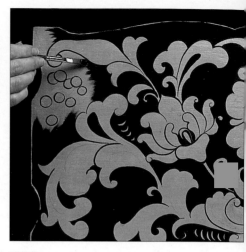

4 Remove the masking tape. Using dark transfer paper and a stylus, transfer the design (page 166-7).

5 Carefully paint the black outlining with a #1 liner. Leave to dry.

6 Block in black areas with a #3 flat brush, leaving a gold trim line around the panel. Strengthen black areas with a second coat.

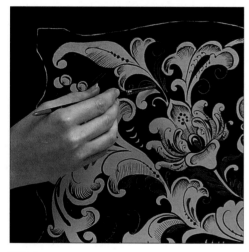

7 Add black detail with a #1 liner and the black dots with the end of a stylus or brush. Block in the orange-red with a #3 round brush.

8 Paint gold overstrokes with a #1 liner. Add a gold border with a #3 flat brush and strengthen the gold trim with the #1 liner.

9 When dry, wipe with a tack cloth to remove dust. Using a #8 flat, apply ten coats of gloss varnish, sanding between coats and drying in a dust-free place.

BERRIES PAINTING STAGES

Basecoat in gold and transfer design.

Outline in black.

Block in fire red and add black detail.

FLOWER PAINTING STAGES

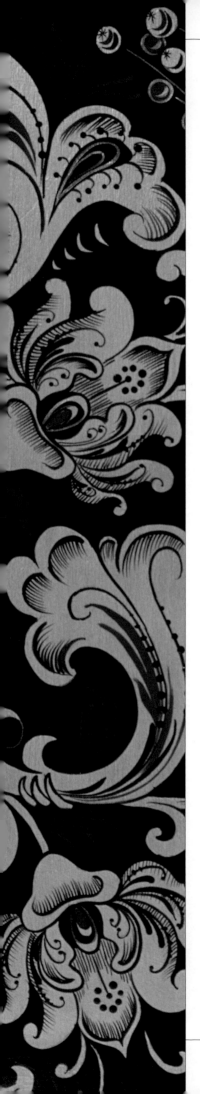

*Basecoat in gold
and transfer design.*

gold

Outline in black.

black

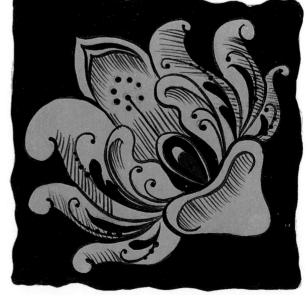

Add black and fire red detail.

black fire red

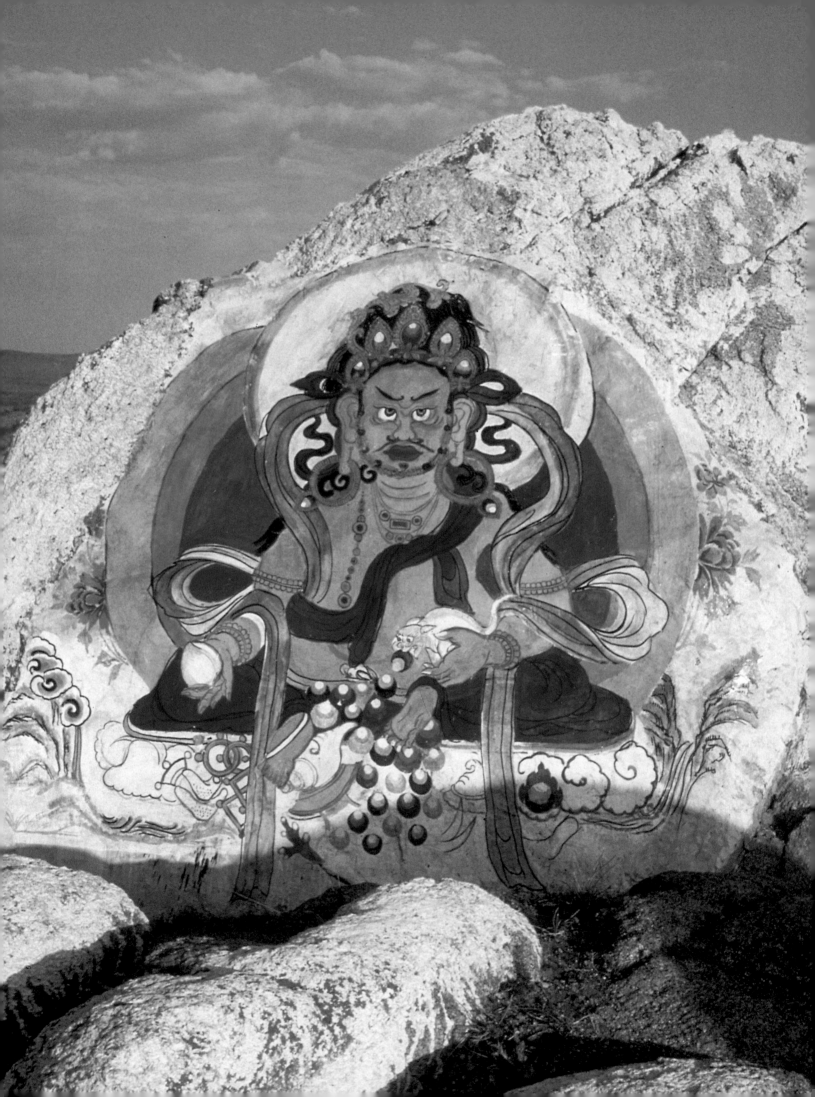

DECORATIVE PAINTING OF THE EAST

IN STYLE AND CONTENT, Eastern decorative painting spans a wide range, from the subtle and harmonious approach of traditional Chinese watercolor painting to the more vivid and vigorous representations found in Japanese, Indonesian and Indian art. Each form offers much inspiration for the folk artist.

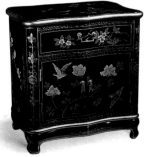

Japanese cabinet

Of these countries, China has the longest history of painting, spanning over two thousand years. As the most advanced culture in Asia for centuries, the influence of Chinese art on its neighbors—Japan, Korea and Thailand—is still evident today. Other countries further west, such as Indonesia and India, came under the influence of Islamic cultures, revealed in their use of contrasting colors and repeated shapes.

The role of the artist in China and Japan was also greatly affected by religion. Many objects were painted for festivals, funerals and other rituals and though often destroyed during the ceremony, great care was taken with the decoration. The process of painting was valued as a spiritual activity and as an integral part of the ceremony itself. Religious belief also affected the subject matter. Taoists believe that all of life can be depicted in the smallest thing—a twig or a butterfly—hence the attention to detail in much Chinese painting.

Chinese artists mainly used watercolors and ink made from pine soot, so their work is characterized by a fluid brushstroke which suggests forms rather than drawing them with precision. Ideograms, a form of Chinese script, were often included, expressing a line of poetry or a philosophical thought. Japanese painting also combines text and images in this way.

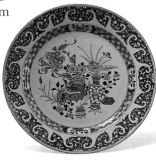

18th century Chinese dish

Throughout Asia, fans, umbrellas, boxes, bowls, trays and screens were commonly decorated items. In Japan and China, such wooden pieces were coated with a lacquer for strength and protection. Other Eastern artworks are less permanent: women in villages throughout India redecorate the entrances to their homes each day using pigments and colored dust.

An unusually bright rock painting in China reveals an Indian influence, carried through religion.

Masks for sale in a Singapore market

PROJECT: EASTERN LACQUERWARE

True Japanese lacquer is made from a tree sap and is a rare commodity.
Various finishes have been developed to emulate its sheen; this one is
known as *negoro nuri*. The design features the cherry blossom, a
favorite subject of both Chinese and Japanese decorative artists.

Level of difficulty: Intermediate

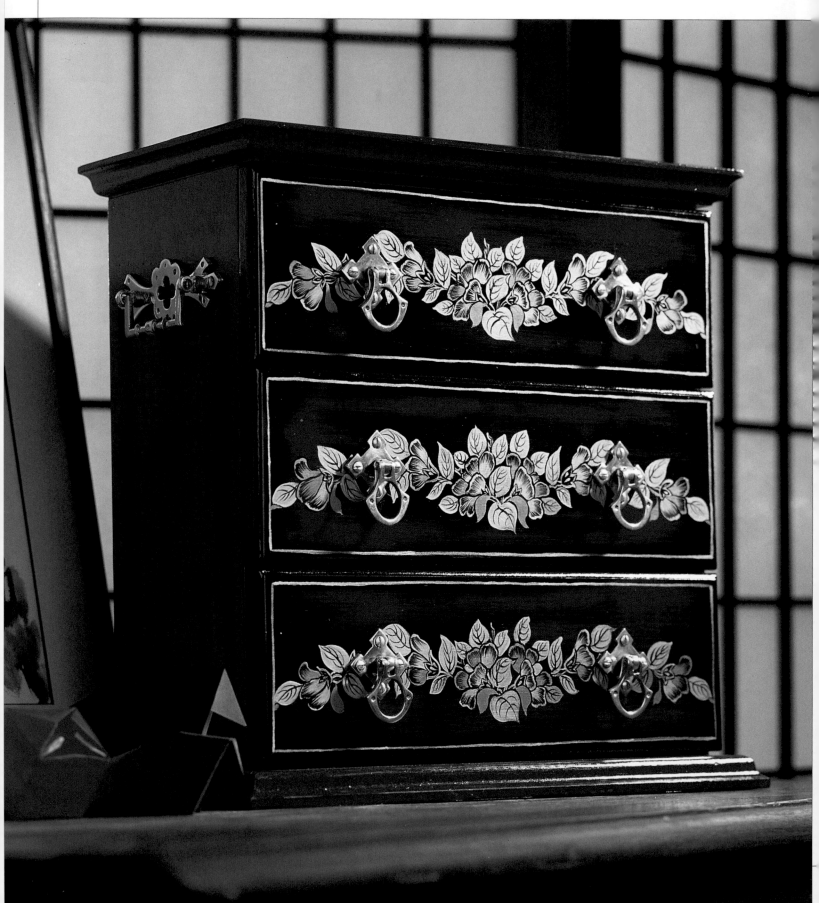

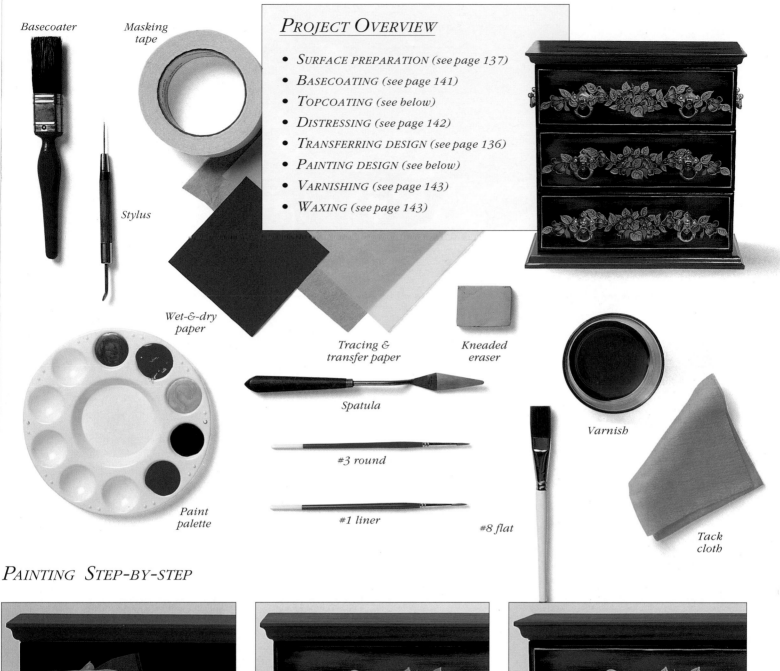

Basecoater

Masking tape

Stylus

PROJECT OVERVIEW

- SURFACE PREPARATION (see page 137)
- BASECOATING (see page 141)
- TOPCOATING (see below)
- DISTRESSING (see page 142)
- TRANSFERRING DESIGN (see page 136)
- PAINTING DESIGN (see below)
- VARNISHING (see page 143)
- WAXING (see page 143)

Wet-&-dry paper

Tracing & transfer paper

Kneaded eraser

Spatula

Varnish

#3 round

#1 liner

#8 flat

Paint palette

Tack cloth

PAINTING STEP-BY-STEP

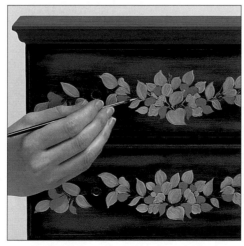

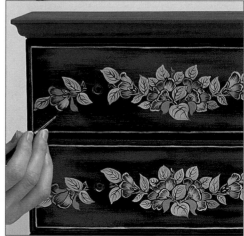

1 Prepare the surface. Basecoat drawers with three coats of xmas red and the remainder of the chest with three coats of black. Topcoat each drawer in black and the remainder in xmas red. Distress with wet-and-dry paper.

2 Using light transfer paper and a stylus, transfer the design (page 169). Using a #3 round brush, block in some leaves and petals with gold and others in copper. Paint gold detail and trim line with a #1 liner. Leave to dry.

3 Add black detail with a #1 liner. When dry, erase lines and wipe with a tack cloth to remove dust. Using a #8 flat brush, apply ten coats of gloss varnish, sanding between coats and drying in a dust-free environment.

DESIGNS AND VARIATIONS

Roses and Castles is not a subtle style: its bright colors and strong lines are designed to catch the eye. Following tradition, the decorative elements are painted quickly because the cost and speed of boat painting was a concern for canal folk. Stylized flowers and idealized landscapes are combined with geometric motifs to create a lively form of decoration.

FLOWERS & LEAVES
Roses are painted in quick, simple brush-strokes and the basic leaf shape is varied by highlighting.

BORDERS
Crescent shapes and multicolored diamonds offer simple but effective borders.

HATCH DESIGNS
Playing-card symbols, often painted on cabin hatches, can be used to fill small panels.

GARLANDS
Strings of daisies, another featured flower, alternate with bands of roses on this water jug.

xmas red yellow oxide French blue

black xmas red yellow oxide

xmas red

yellow oxide

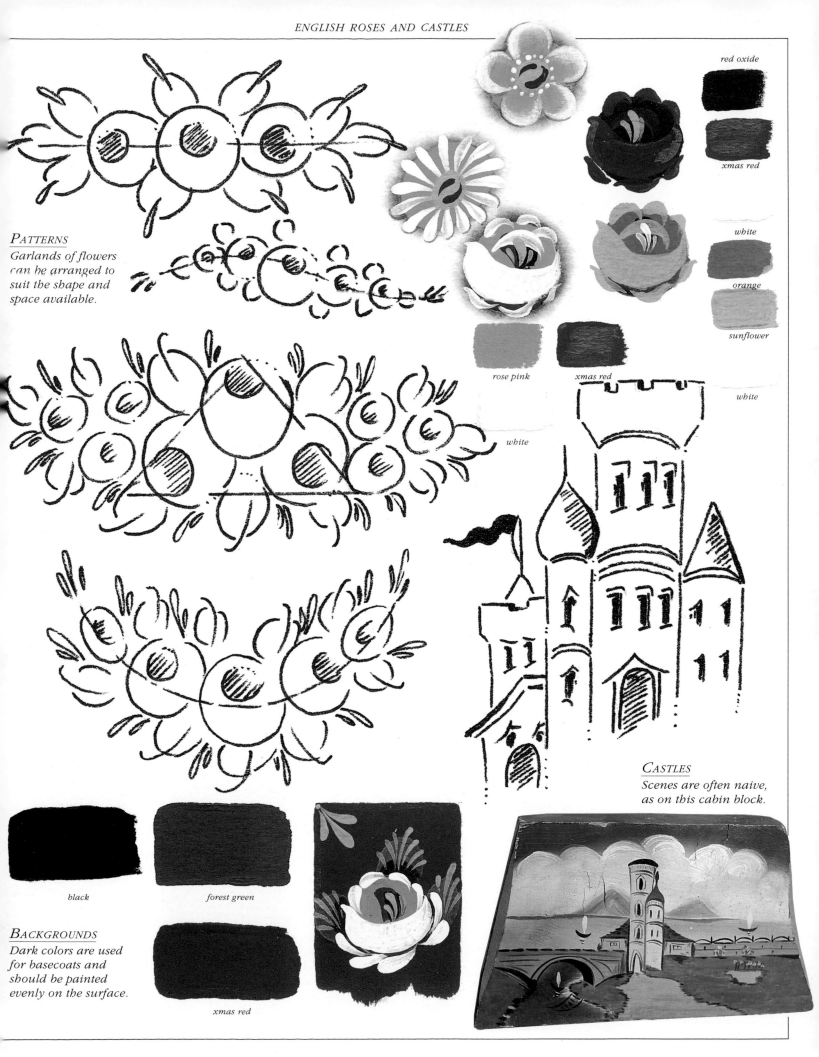

red oxide

xmas red

white

orange

sunflower

white

rose pink

xmas red

white

PATTERNS

Garlands of flowers can be arranged to suit the shape and space available.

CASTLES

Scenes are often naive, as on this cabin block.

black

forest green

xmas red

BACKGROUNDS

Dark colors are used for basecoats and should be painted evenly on the surface.

PROJECT: MILK CHURN

Water cans were commonly decorated utensils on narrow boats.
In this advanced project, a milk churn is adorned with a garlanded
scene and a swag of roses; these elements could also be used
separately on smaller items.

Level of difficulty: Advanced

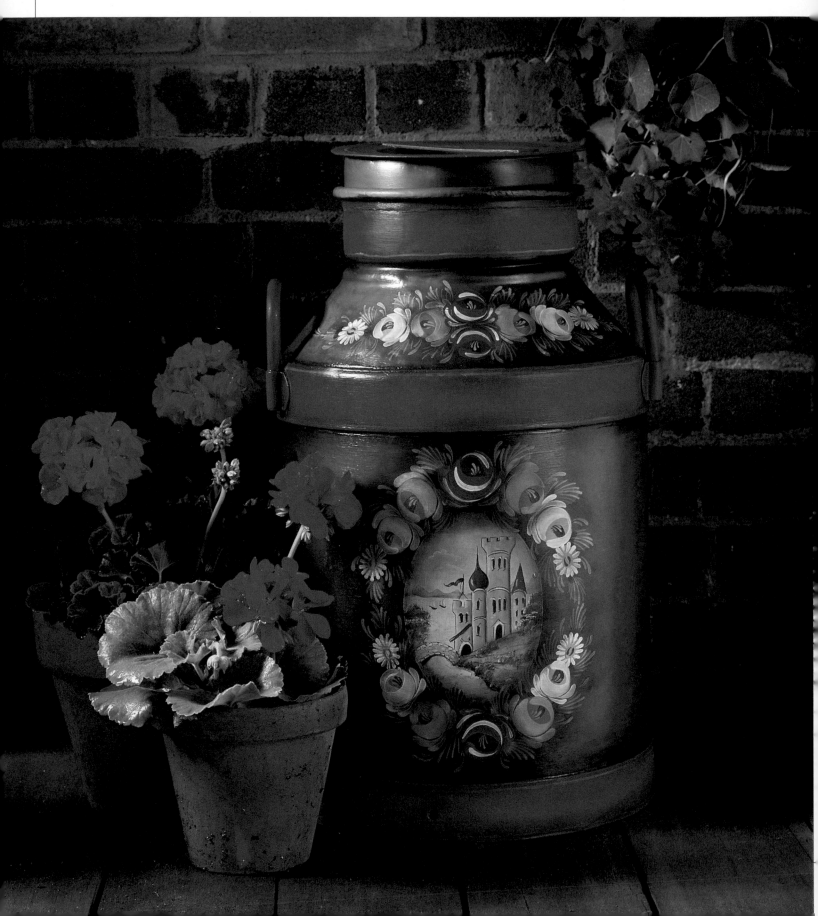

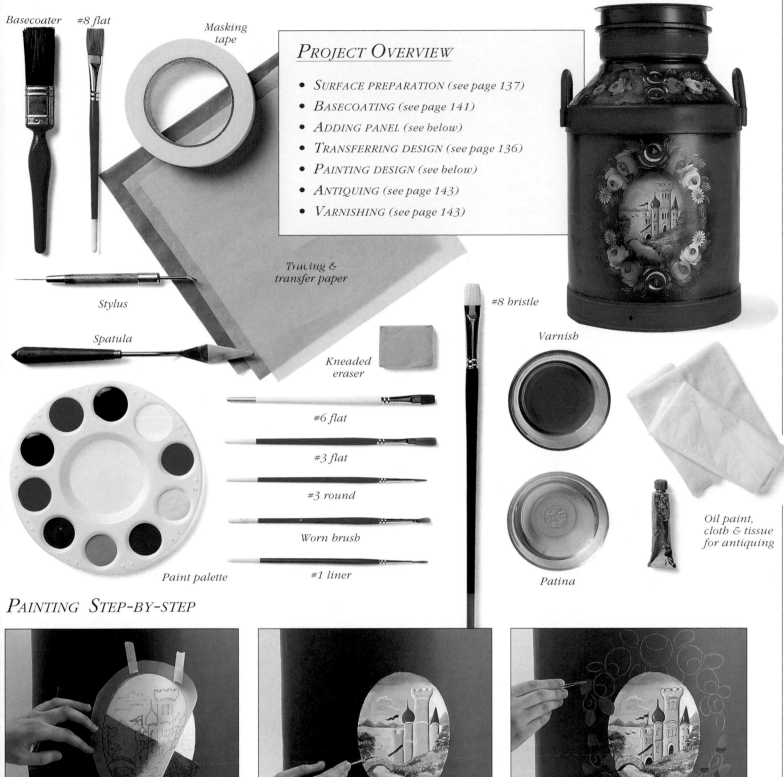

Basecoater

#8 flat

Masking tape

PROJECT OVERVIEW

- SURFACE PREPARATION (see page 137)
- BASECOATING (see page 141)
- ADDING PANEL (see below)
- TRANSFERRING DESIGN (see page 136)
- PAINTING DESIGN (see below)
- ANTIQUING (see page 143)
- VARNISHING (see page 143)

Stylus

Tracing & transfer paper

Spatula

Kneaded eraser

#8 bristle

Varnish

#6 flat

#3 flat

#3 round

Worn brush

Oil paint, cloth & tissue for antiquing

Paint palette

#1 liner

Patina

PAINTING STEP-BY-STEP

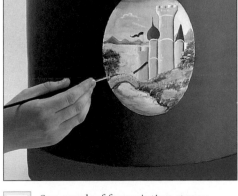

1 Prepare the surface and undercoat bands white. Basecoat churn in forest green with xmas red bands. Transfer the oval outline only (page 170) and, using a #8 flat, paint oval with three coats of white. When dry, transfer castle design.

2 See overleaf for painting stages. Block in sky with a #6 flat. Paint clouds with a sideloaded #3 flat. Wash in foreground and block in buildings with a #3 flat. Use a worn brush to paint bushes. Detail with a #1 liner.

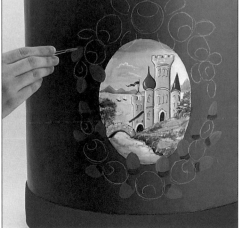

3 When castle scene is dry, transfer the surrounding garland design (page 170). Block in leaves and flowers with a #3 round brush. See overleaf for swag painting stages.

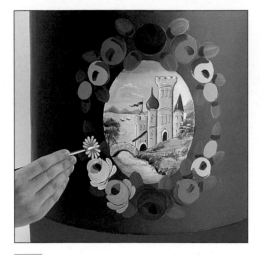

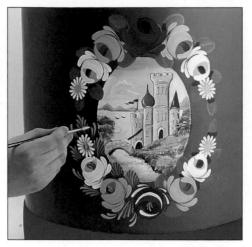

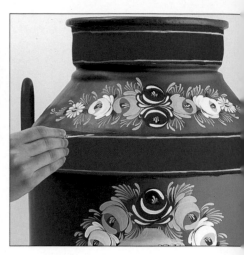

4 Use a #3 round brush to paint overstrokes on the roses and daisies. Refer below for colors and brushstrokes when painting the flowers and leaves.

5 Use a #3 round brush to paint overstrokes on leaves. Complete the garland surrounding the castle scene and the swag of flowers on the top of the churn.

6 Use a #1 liner to paint fine yellow lines on the red bands. Leave to dry. Erase all lines, then antique the churn and varnish to complete.

SWAG PAINTING STAGES

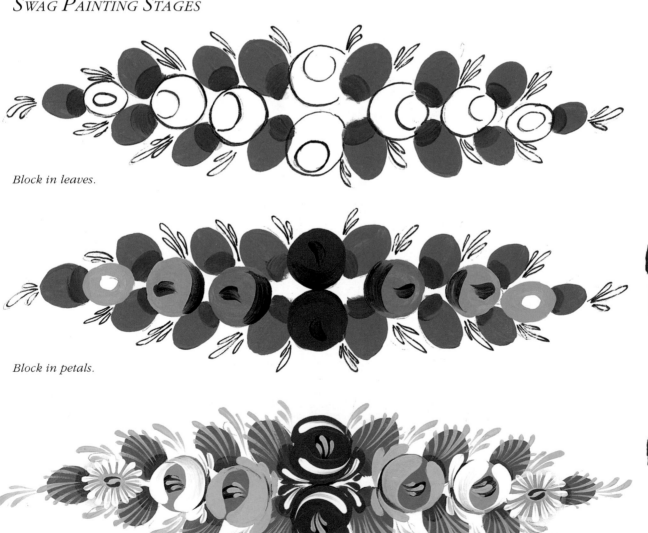

Block in leaves.

Block in petals.

Paint overstrokes.

olive

pimento

pimento yellow oxi

rose pink burnt umb

French blu

xmas red sunflowe

white

CASTLE PAINTING STAGES

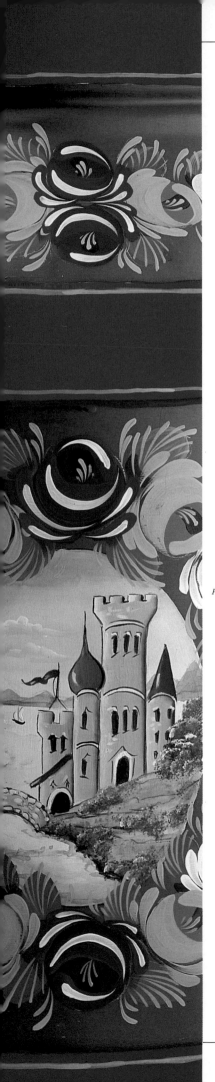

Wash in sky and water.

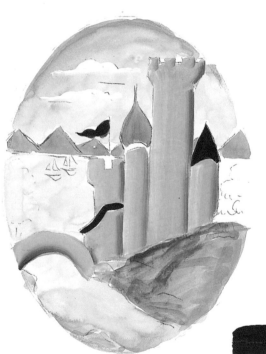

dusty blue wash

*Block in buildings
and background.*

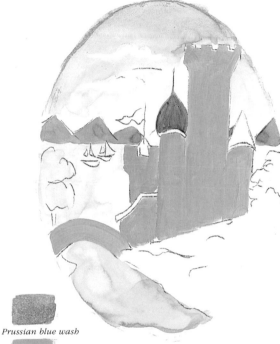

Prussian blue wash

apricot

Wash in foreground.

tomato

spruce wash *olive wash*

*Complete bushes
and add detail.*

black

white

GENERAL INFORMATION

The emphasis of this book is design, rather than technique, which is why this chapter appears at the back and not as the introduction. The information that follows offers a grounding in the basic methods of decorative painting but is not intended as a set of rules. In decorative painting, there are no real rules, and each person develops an individual approach to the craft.

DESIGN AND SCALING

The articles painted in the projects are suggestions only; it may not be possible to locate a similar piece or it may not suit your home. Choose items that are in keeping with the style in which you wish to paint. Likewise, you may wish to vary the color scheme or modify a motif or border. If so, you will find the Designs and Variations pages a good reference point.

A small design from the Moroccan shoe-box has been scaled up in size.

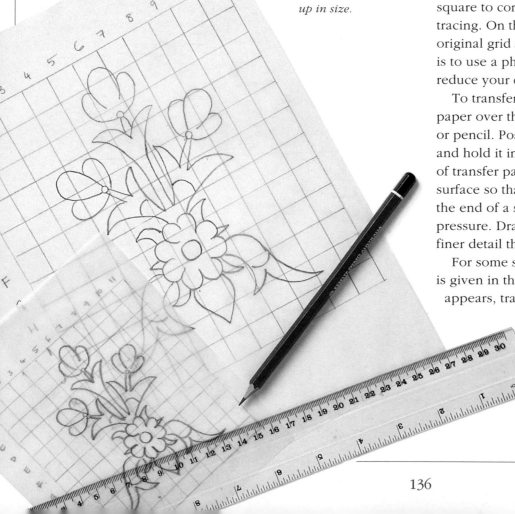

Many projects have several designs for different sides; you might find that not all are necessary.

Having chosen an article, decide whether the design will need to be adapted to fit a panel by repeating an element or deleting a section. If the basic proportions are suitable, assess whether the design needs to be enlarged or reduced.

To enlarge or reduce a design, first transfer it onto tracing paper and draw a grid over it, numbering each square. Take another piece of tracing paper the size of the panel or area to be painted, and draw a grid with the same amount of squares, numbering each square to correspond with those on the original tracing. On the second grid, copy the detail from the original grid square by square. An even easier method is to use a photocopying machine to enlarge or reduce your design by the required percentage.

To transfer the design onto a panel, place tracing paper over the design and trace the lines using a pen or pencil. Position the tracing on the painting surface and hold it in place with masking tape. Insert a sheet of transfer paper between the tracing and painting surface so that the coated side is facing the latter. Run the end of a stylus over the design using light pressure. Draw in the main lines only, leaving any finer detail that would be covered by base strokes.

For some symmetrical designs, only half the design is given in the back of the book. Where a dashed line appears, trace the half supplied then flip your tracing to complete the design. There are also some repeat designs of which only a sample section has been supplied. An arrow beside a design indicates that it should be turned so the arrow points up.

PREPARATION

While surface preparation is less interesting than painting the design, it is a necessary stage in a successful project. Most of the projects in this book have been painted on wood, however many other surfaces can be painted. Choose your surface keeping in mind the purpose to which the piece will be put. Carefully follow the preparation stages for the relevant surface.

NEW WOOD

Fill any holes with a commercial wood filler. Always allow the filler to dry thoroughly. Sand lightly with a medium grade sandpaper and then seal with a sealer or water-based varnish. When the sealer is dry, sand lightly with fine sandpaper.

OLD WOOD

If the finish on your old wooden article is good (not chipped, cracked, or peeling) then simply sand lightly and basecoat over the top. However, if the paint is cracked or peeling, it will need to be removed for a smooth surface. Old paint and varnish can be softened with a commercial paint stripper and then removed with a paint scraper. Smooth with a course sandpaper or some steel wool. Seal the article as for new wood.

If the old finish is good but dark and you plan to paint a light colored background, sand lightly and then paint the whole article with gesso. When dry, sand lightly.

NEW METAL

Scrub the article in soapy water using steel wool. Rinse in equal parts of water and vinegar. Dry the article thoroughly. Spray or paint on a rust-inhibiting primer. Leave to dry for at least twenty-four hours.

OLD METAL

If the article is painted, first strip with paint stripper. Remove any rust with a wire brush or steel wool. Badly rusted articles will require an application of a commercial rust converter. Clean, rinse and prime the article as for new metal.

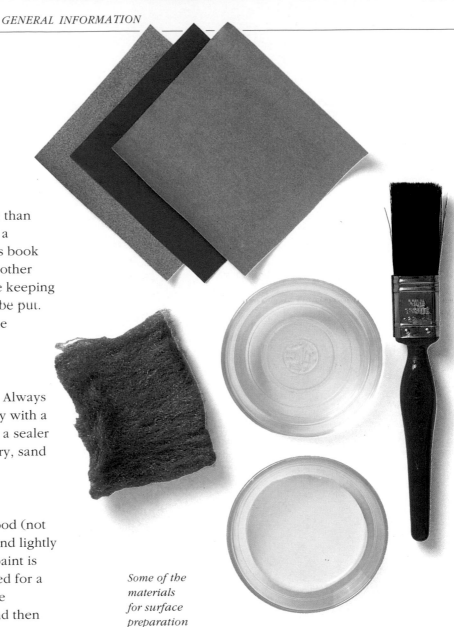

Some of the materials for surface preparation techniques such as sanding, sealing and undercoating.

PAPIER-MÂCHÉ

Whether you have molded your own or purchased a commercial papier-mâché piece, it will need no surface preparation. The surface is smooth and is already sealed with the paper and glue.

TERRACOTTA

Submerge the terracotta article in water. When the water has soaked in, remove the article and lay it upside down on a towel. Allow the article to half-dry and then paint the outside with sealer or water-based varnish. When this coat is completely dry, apply sealer to the inside of the article and leave to dry for a least twenty-four hours before painting.

MATERIALS

OIL PAINTS
A few toner colors are needed for antiquing.

ACRYLIC PAINTS
All projects were painted with acrylics, which are quick-drying and clean up with water. There are several commercial brands of acrylics designed for folk art and these offer a range of premixed colors.

WAXES
Clear wax and gold wax are used to finish many projects.

CONTAINERS
Film containers are useful for storing unused paint; a palette is essential for mixing paints.

PICKLING SOLUTION
A mixture of white paint and sealer for whitewashing raw wood.

PATINA
A mixture of turpentine and linseed oil for antiquing.

CRACKLE MEDIUM
A product which makes paint crack; available as an undercoat or topcoat medium.

SPATULA
A palette knife is useful for mixing colors.

BRUSHES
A # symbol denotes brush size or number. A basic kit includes a basecoater, round and flat brushes and a liner. Old brushes are useful for special effects. To care for brushes, rinse in water, wash in soap and gently shape tip into a point. Store upright

VARNISH
Satin finish is generally recommended.

CLOTHS
Openweave cloth, soft cotton rags and paper tissues are essential.

GLOVES
Protect hands when antiquing.

MASKING TAPE
Paper-backed tape for transferring designs and masking off sections.

BASECO...

Use a larg...
coat of pai...
article ade...

WASHI...

Mix a thin...
creating a t...
with a dam...
areas and a...
Load the br...
paper towe...
a time, ble...

SPONGI...

Submerge...
out. Lightly...
on a piece...
the paint c...
required c...

COTTON SWABS
Moisten with methylated spirits and use for cleaning up errors.

RAZOR
for stripping or heavy distressing.

ABRASIVES
Use sandpaper and steel wool for preparation and finishing; use moistened wet-and-dry (or silicon carbide) to distress pieces.

SCRAP PAPER
You will need paper towels and newspaper.

PATTERNING TOOLS
Cardboard combs and plastic wrap are useful for dragging and smudging.

PENCILS
Use chalk pencil on dark surfaces and carbon on light colors.

STYLUS
To transfer designs and paint small dots.

COMPASS
Useful for marking borders.

SEA SPONGE
Applies paint or any other medium in a subtle manner.

PASTE
Use a kleister medium or cornstarch paste for woodgraining.

RETARDER
A commercial medium, also known as extender, for lengthening the drying time of acrylic paint. Dip brushes in retarder before loading, or mix retarder into paint.

MAULSTICK
A padded length of wood for steadying the hand and keeping elbows off wet areas.

THREAD
Thick cotton thread is used for making drag marks.

MEASURING TOOLS
A ruler, set square and tape measure are useful for marking panels.

KNEADED ERASER
For removing design lines after painting.

TOOTHBRUSH
A old toothbrush is ideal for spattering.

TACK CLOTH
Cheesecloth impregnated with linseed oil for removing dust; store in an airtight container.

PIPING BAG
Used for working a relief pattern on a surface.

TRANSFER MATERIALS
Choose dark or light transfer paper as suitable. Tracing paper is available in various thicknesses.

139

RELIEF WORK

Use a cake decorator piping set with a fine nozzle filled with a thick bodied paint. Carefully pipe over the design. If the surface is curved, apply small sections at a time to avoid the paint running. Allow to dry for one to two days.

DISTRESSING

To distress an article lightly, use wet-and-dry paper and detergent. Gently rub the painted surface along the grain of the wood. Continue rubbing until some of the basecoat color has been revealed. For heavy distressing, use a scrapper or razor blade.

MARBLING

Marble comes in many colors and forms and, accordingly, there are different marbling methods. The following method is perhaps the simplest. Paint retarder on to the basecoated surface to slow down the drying process, and work a section at a time. Paint random lines in a contrasting color with a #3 round brush, then smudge lines with a sponge or piece of crumpled plastic wrap, changing the angle so that the smudge mark changes also. Use a #1 liner or a feather to add fine veins of paint. For an example, see page 91.

DRY BRUSHING

Dress a large dry brush with paint, then wipe it on a paper towel to remove most of the color. Paint on the desired area with short strokes in a dusting motion. Color can be built up using continuous strokes.

CRACKLING

Crackle medium separates the top layer of color, forming cracks which reveal the underlying basecoat color. Use a flat brush to apply the crackle medium over the basecoat. Leave for twenty minutes to an hour and then, with quick brush-strokes or sponging, apply an even coat of contrasting color. Do not re-apply paint after the crackling starts. Apply a thicker coat of paint for large cracks and a thin layer for fine cracks.

SPATTERING AND THREAD DRAGGING

This aging process is applied after the design is dry and before the finish is applied. Add water to paint for a very thin consistency. Dip a toothbrush into the paint and carefully stroke the bristles away from the article, so that spatters of paint hit the desired area. For thread dragging, dip the end of a length of heavy sewing thread in thinned paint and slap the loaded thread against the painting surface.

WOODGRAINING

Woodgrain effect can be achieved using a *kleister* medium or the following paste recipe: mix two tablespoons of cornstarch with one tablespoon of cold water to form a smooth paste. Add a cup of boiling water and whisk. Allow to cool, stirring occasionally. Store in a cool place for up to five days. Basecoat the wood a suitable color: red oxide to imitate mahogany or yellow-based paint for oak or walnut. When basecoat is dry, paint kleister medium or paste thinly over the surface and allow to dry. Mix four parts of paste or medium to one part of brown acrylic, such as burnt umber. Mask off the area to be woodgrained and brush the mixture on a small section. Use a tool—crumpled newspaper, a cardboard comb or a graining rocker—to mark the paste. Soften sharp lines with a sea sponge. Remove tape and clean up edges. For further illustration, see page 41.

VARNISHING

Before varnishing an article, erase pencil lines and remove dust with a tack cloth. Use a soft, flat brush to apply varnish, and work in a dust-free environment. Most pieces in this book have been varnished with a satin polyurethane varnish. Apply two coats (or more for added protection) and lightly sand with a medium grade sandpaper between coats, allowing each to dry for twenty-four hours.
For gloss varnishing or imitation lacquer, use a high-gloss polyurethane varnish and work under adequate lighting. Do not shake varnish, as this creates bubbles. Apply varnish in long even strokes in one direction. Remove air bubbles with gentle overstrokes. Allow to dry for at least twenty-four hours in a dust-free environment. Before applying the next coat, remove the sheen by rubbing in one direction using wet-and-dry paper and detergent. Wipe clean. Apply the second coat of varnish with brushstrokes in the opposite direction. Repeat until you have ten coats.

ANTIQUING

During the antiquing process, oil paint is applied on areas of an article. Burnt umber is the color most commonly used, but you might consider using Paynes gray on a blue-gray background or burnt sienna on a red background. A patina is also required to help spread the oil paint evenly over the surface. Commercial antiquing patinas are available or you can make your own by mixing three parts of gum turpentine with one part of linseed oil. As this mixture is highly combustible, it is advisable to wear surgical gloves during the process and to dispose carefully of any cloths used.
Allow the painted article to dry for twenty-four hours before antiquing. Using a soft cloth, lightly wipe patina on to the surface. Add a few drops of the patina to the oil paint and then paint a small amount of this oil paint on to selected areas with a #8 bristle brush. Remove excess paint with a paper tissue. Use a clean soft cloth to rub the remaining oil paint into the cracks and corners. If you are working on wood, rub with the grain. Allow to dry for several days. The article should be touch dry before it is varnished. For illustrations of these steps, see page 70.

WAXING AND GOLD WAXING

Apply furniture wax after varnishing using 0000 steel wool. Leave to dry for twenty minutes to an hour, then buff to a gentle sheen with a soft cloth.
Gold wax is sometimes used to enhance the finished article. Rub the wax on to selected areas using either your fingertip or a soft cloth. Leave to dry and then buff with a clean cloth for a rich sheen.

COLOR CHART

This chart is a guide for mixing the colors used in the projects. To mix every color, you will need each of the basic colors shown. Keep in mind, however, that many commercial brands carry a wide range of colors that save you the trouble of mixing your own.

When mixing light colors, start with the lightest basic color and add portions of darker colors until you have matched the color swatch. Always test your color by allowing a small patch to dry first, as acrylic colors tend to dry a shade darker.

It should also be noted that there are some subtle shade variations in some of the projects. Adjust colors by adding a dark toner or white. Where a wash is required, dilute the paint with water.

BASIC COLORS

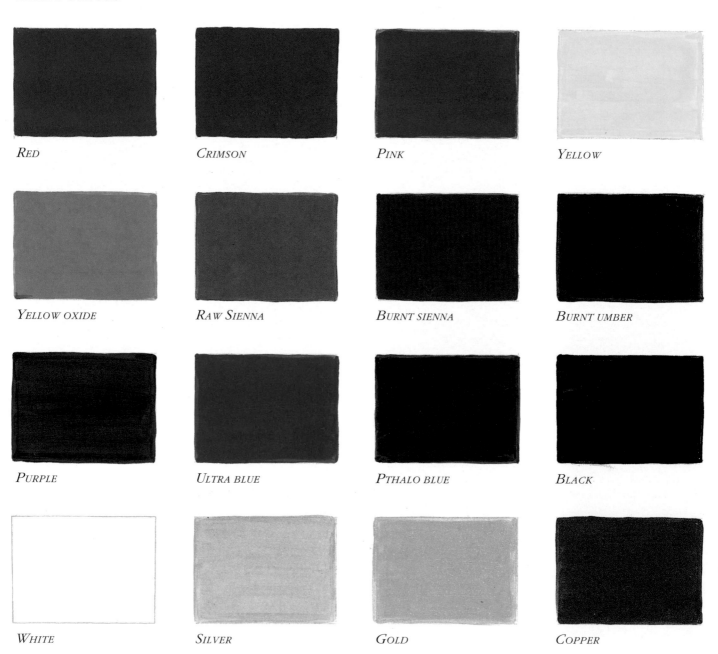

RED	*CRIMSON*	*PINK*	*YELLOW*
YELLOW OXIDE	*RAW SIENNA*	*BURNT SIENNA*	*BURNT UMBER*
PURPLE	*ULTRA BLUE*	*PTHALO BLUE*	*BLACK*
WHITE	*SILVER*	*GOLD*	*COPPER*

PROJECT COLORS

XMAS RED
1 part red
1 part crimson

FIRE RED
3 parts red
1 part yellow

TOMATO
4 parts red
1 part burnt sienna
1 part yellow oxide

PIMENTO
3 parts red
1 part burnt umber

RED OXIDE
3 parts crimson
3 parts burnt umber

DARK BROWN
4 parts burnt umber
1 part black

PEACH
4 parts white
1 part red
1 part yellow oxide
touch of burnt sienna

ORANGE
1 part yellow oxide
1 part red

CINNAMON
5 parts burnt sienna
2 parts white
2 parts red
1 part yellow

RUST
2 parts burnt sienna
1 part red

BROWN EARTH
6 parts burnt sienna
1 part burnt umber

BROWN
4 parts burnt sienna
1 part burnt umber

SALMON
8 parts white
1 part red
touch of yellow oxide

APRICOT
8 parts white
1 part yellow oxide
touch of red

ROSE PINK
8 parts white
1 part crimson
1 part red

MAUVE
4 parts white
1 part ultra blue
1 part crimson

GRAPE
4 parts white
2 parts crimson
1 part ultra blue

CHARCOAL
2 parts ultra blue
1 part black
1 part burnt umber

STRAW
4 parts white
2 parts yellow oxide
2 parts yellow
1 part burnt umber

SUNFLOWER
1 part yellow
1 part yellow oxide

OLIVE
3 parts yellow
2 parts black
1 part red

SPRUCE
3 parts ultra blue
1 part yellow

TEAL
3 parts pthalo blue
1 part yellow

PRUSSIAN BLUE
4 parts ultra blue
1 part black

IVORY
5 parts white
1 part yellow oxide
1 part burnt umber

PINE
3 parts white
1 part yellow oxide

OLD GOLD
4 parts yellow
1 part black
1 part red

FOREST GREEN
3 parts ultra blue
1 part yellow

AQUA
3 parts white
1 part pthalo blue
touch of yellow

FRENCH BLUE
4 parts white
1 part ultra blue
touch of black

CREAM
5 parts white
1 part yellow oxide

GRAY
4 parts white
1 part black

OATMEAL
4 parts white
1 part burnt umber

MINT
5 parts white
1 part yellow
1 part ultra blue

SLATE BLUE
2 parts white
2 parts ultra blue
1 part burnt umber

DUSTY BLUE
5 parts white
1 part ultra blue
touch of black

AFRICAN POT *(repeat designs)*

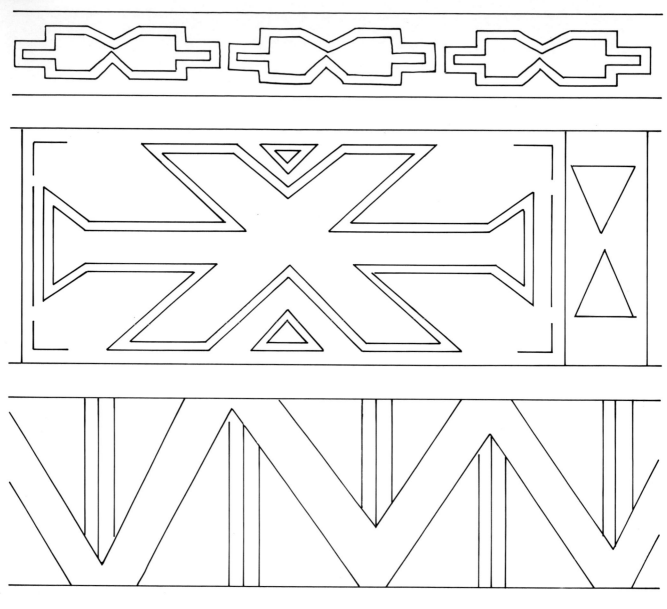

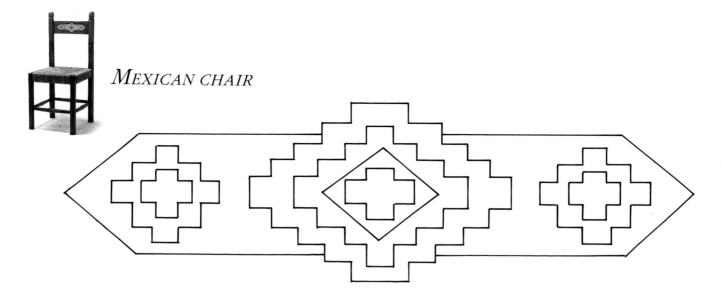

MEXICAN CHAIR

MEXICAN WASHSTAND

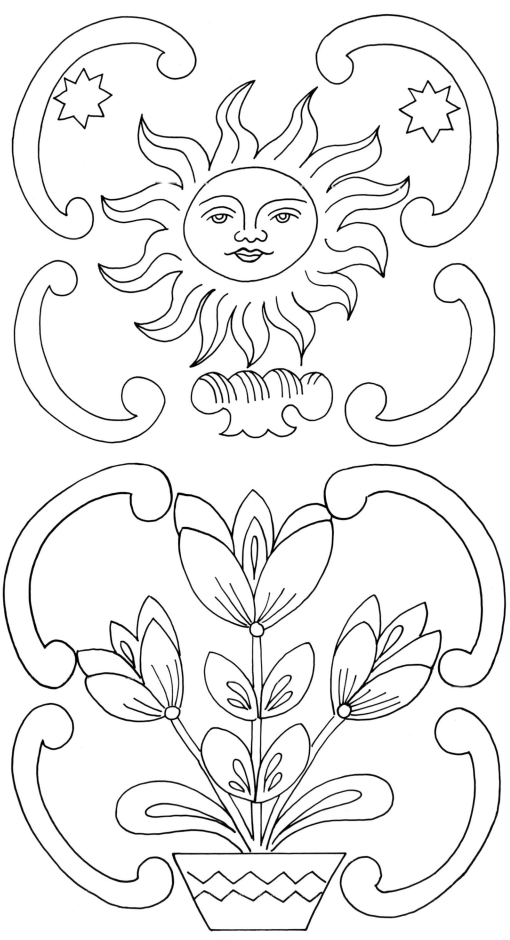

MOROCCAN SHOEBOX

lid

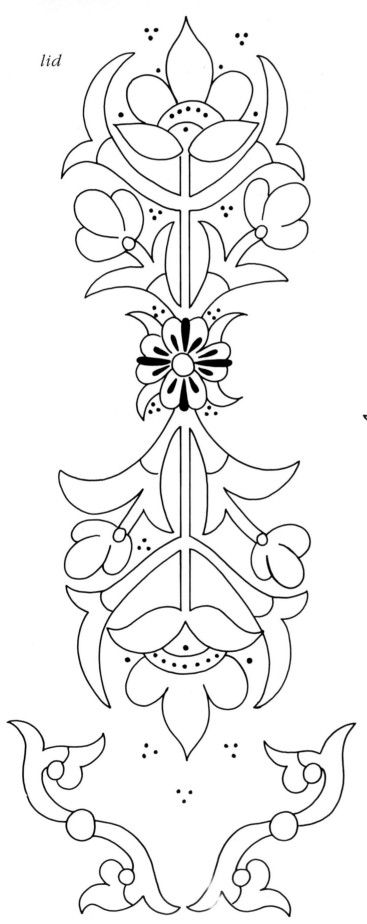

back

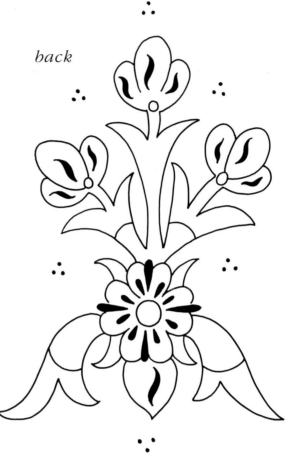

front

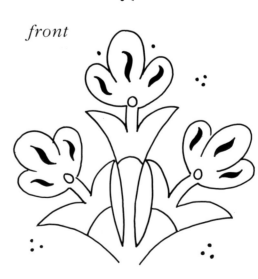

148

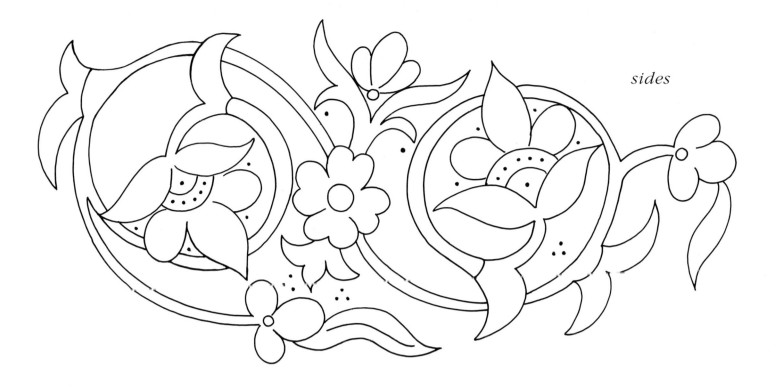

sides

*T*URKISH *CHEST* *(repeat design)*

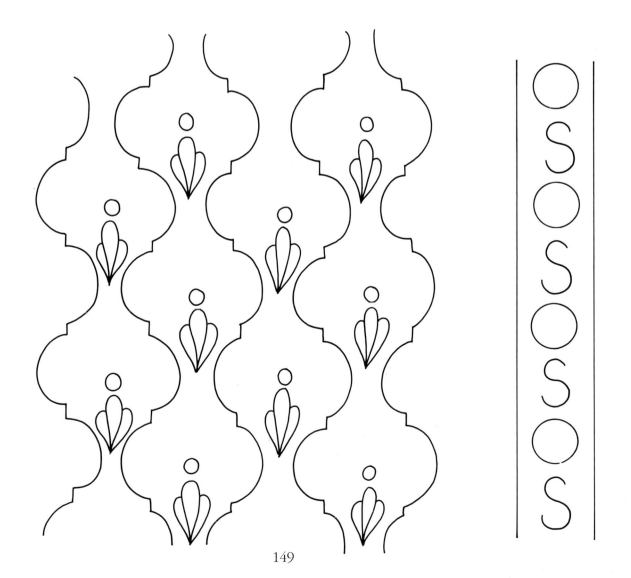

149

BERRY PICKER *(repeat design)*

GERMAN CHEST

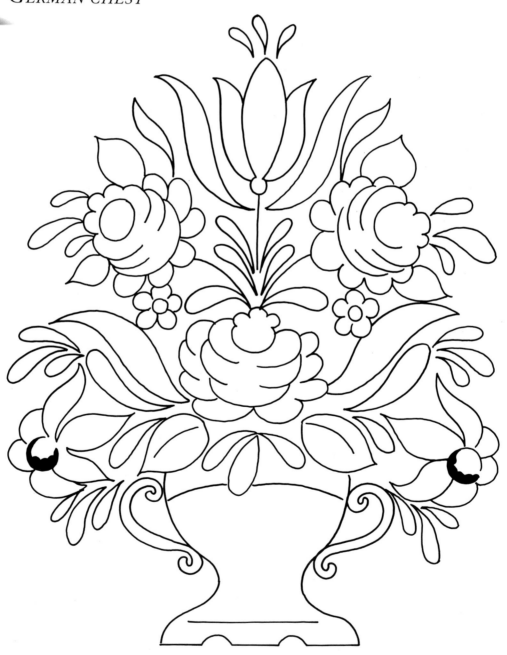

Swiss wall cupboard

top scroll

panel

sides

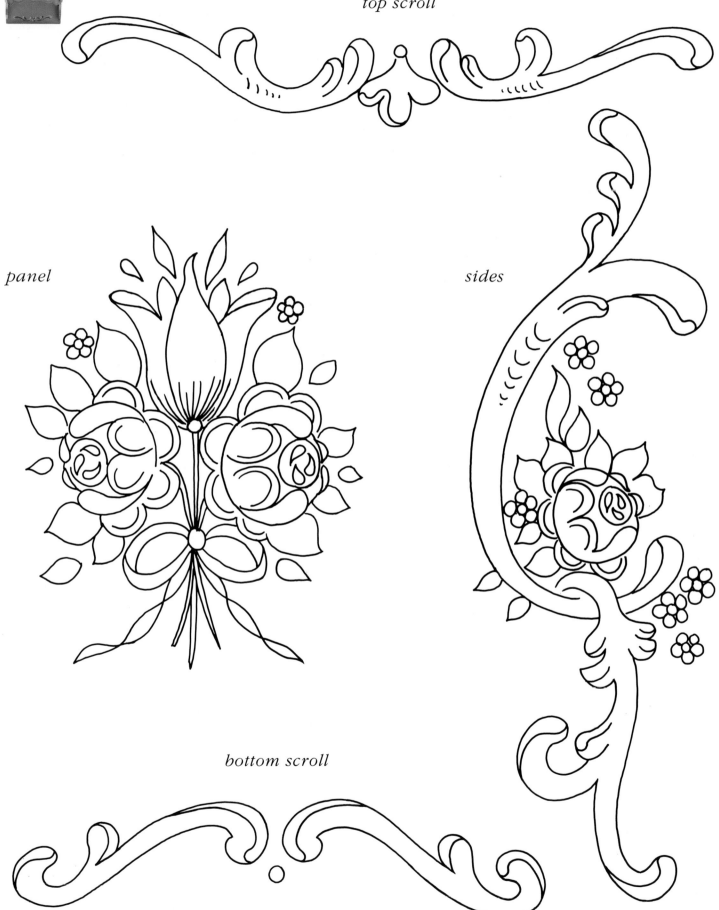

bottom scroll

AUSTRIAN CHEST OF DRAWERS

drawers

←

sides

chair

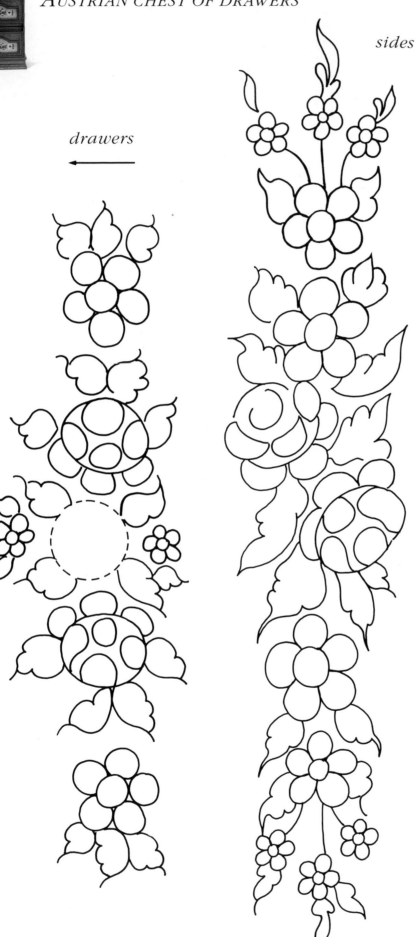

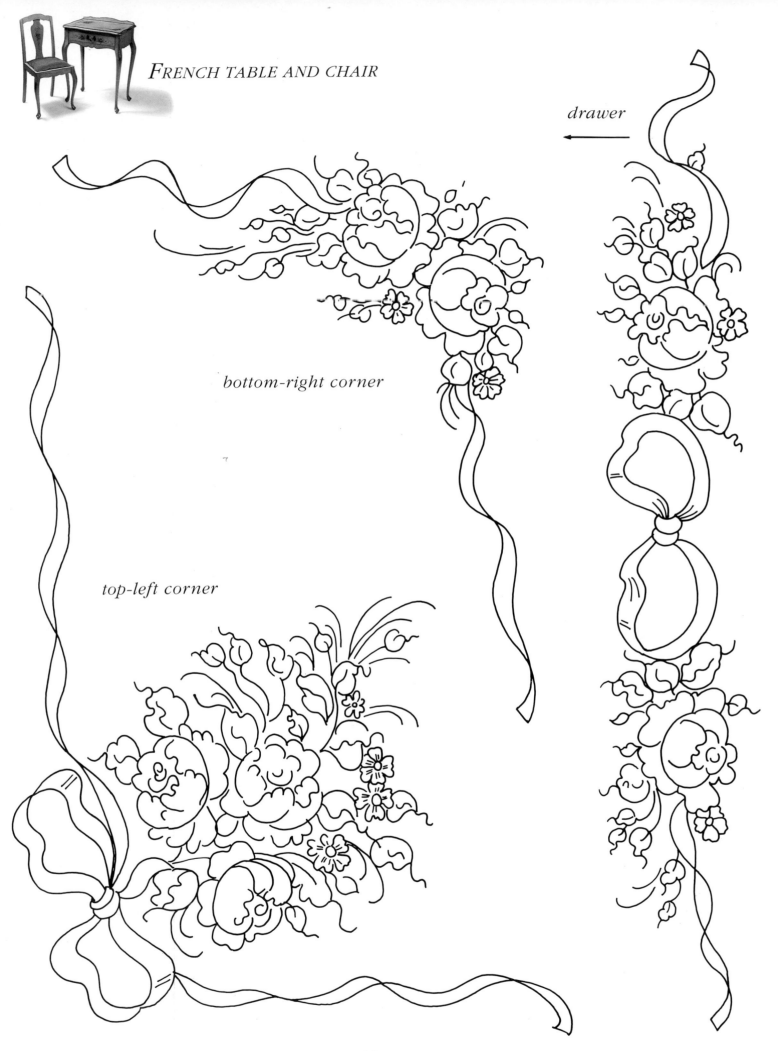

FRENCH TABLE AND CHAIR

drawer

bottom-right corner

top-left corner

top

front and back

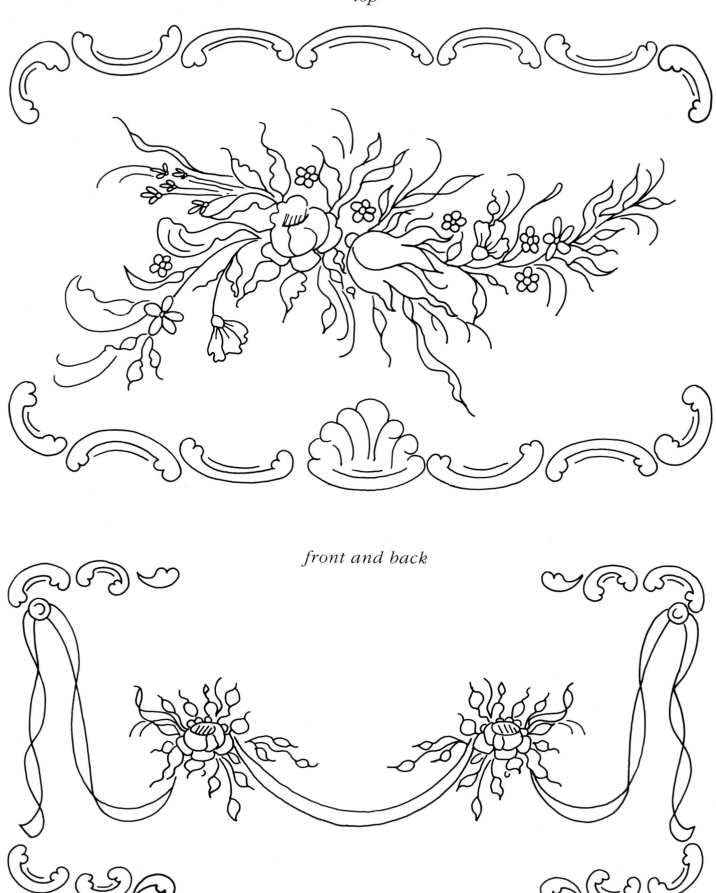

ends

S*WEDISH CHAIR*

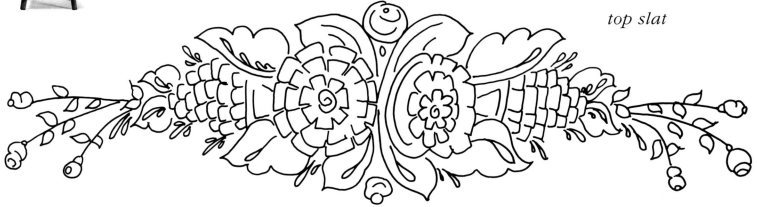

top slat

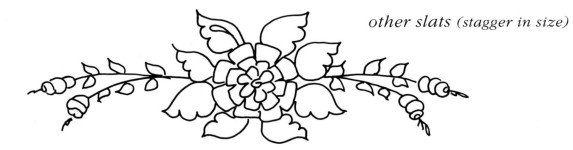

other slats (stagger in size)

155

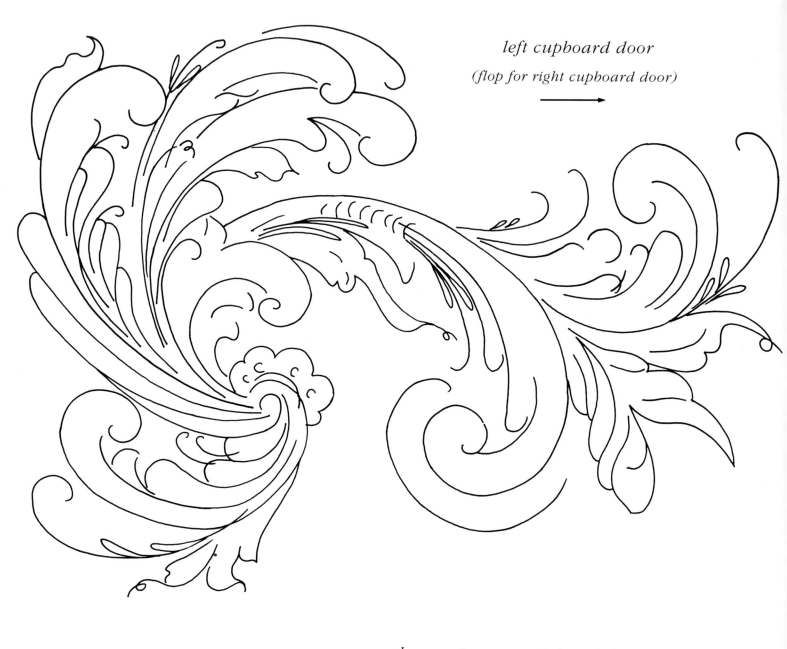

left cupboard door

(flop for right cupboard door)

→

drawer (symmetrical design)

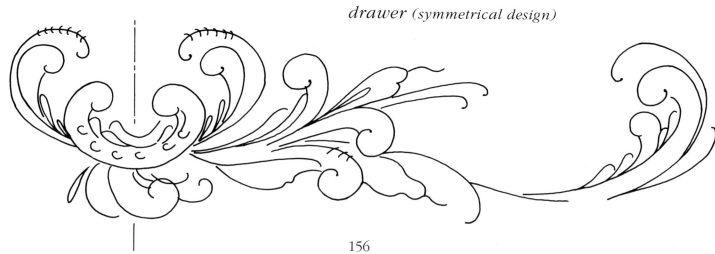

156

front panel (symmetrical design) ➝

sides

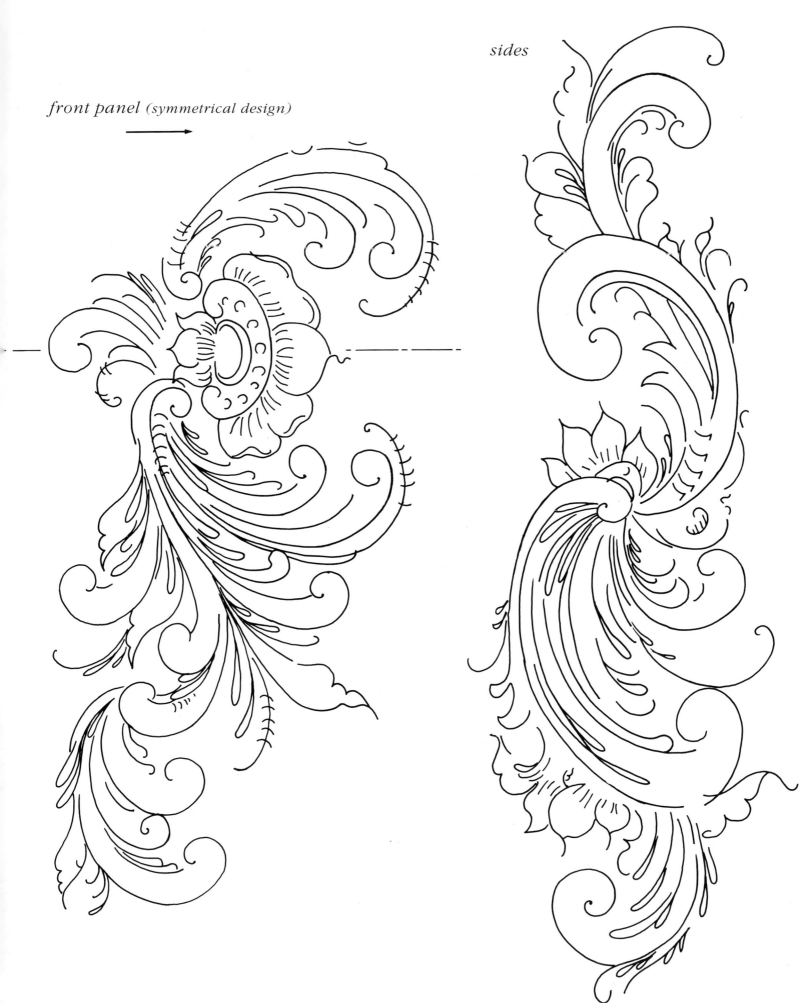

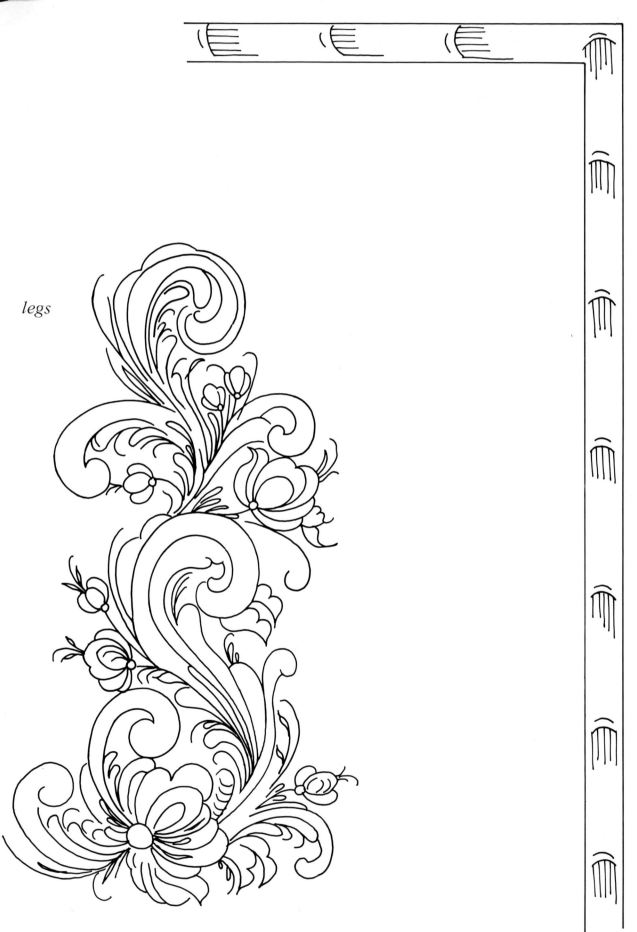

R OSEMALING BENCH

legs

top →

side flaps →

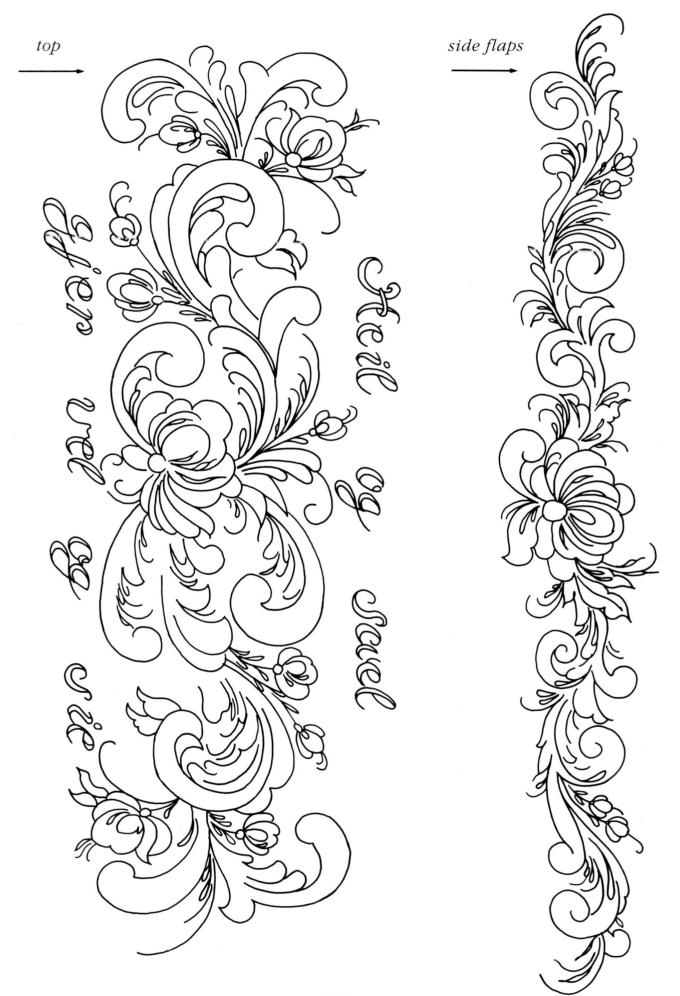

159

HINDELOOPEN BUTTE

lid (symmetrical design)

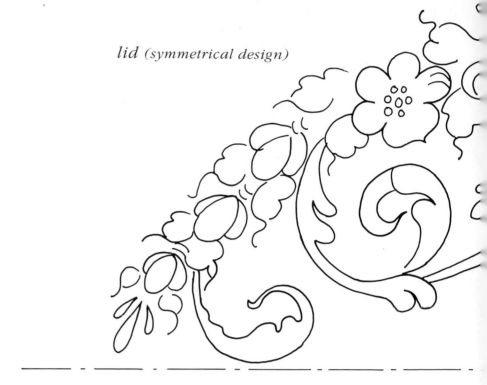

sides

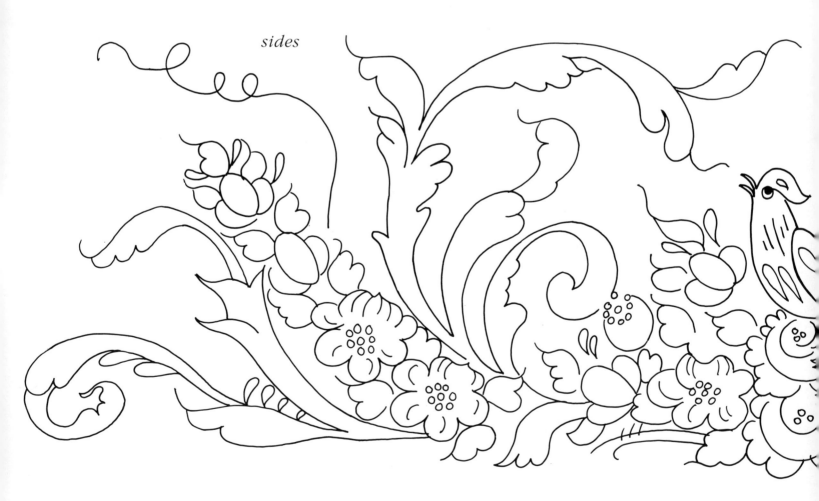

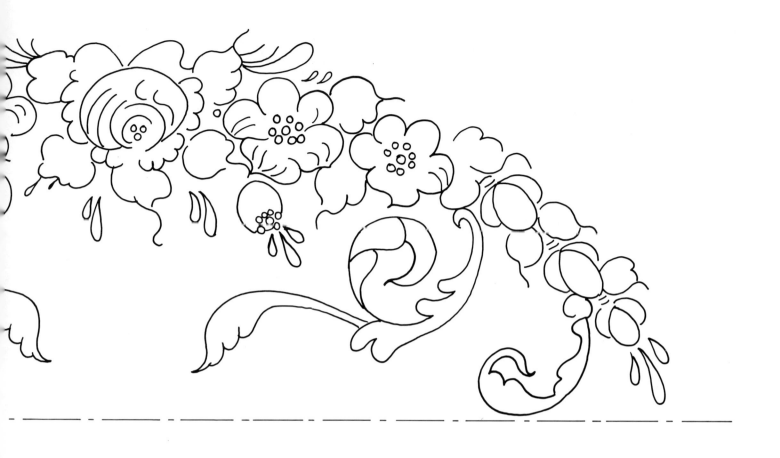

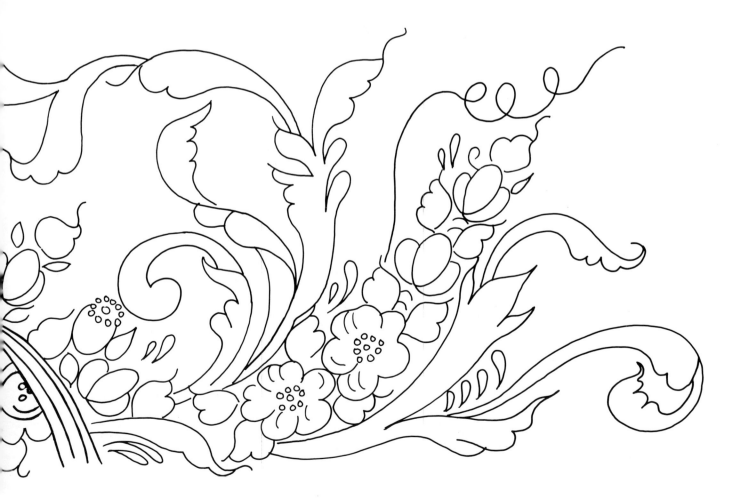

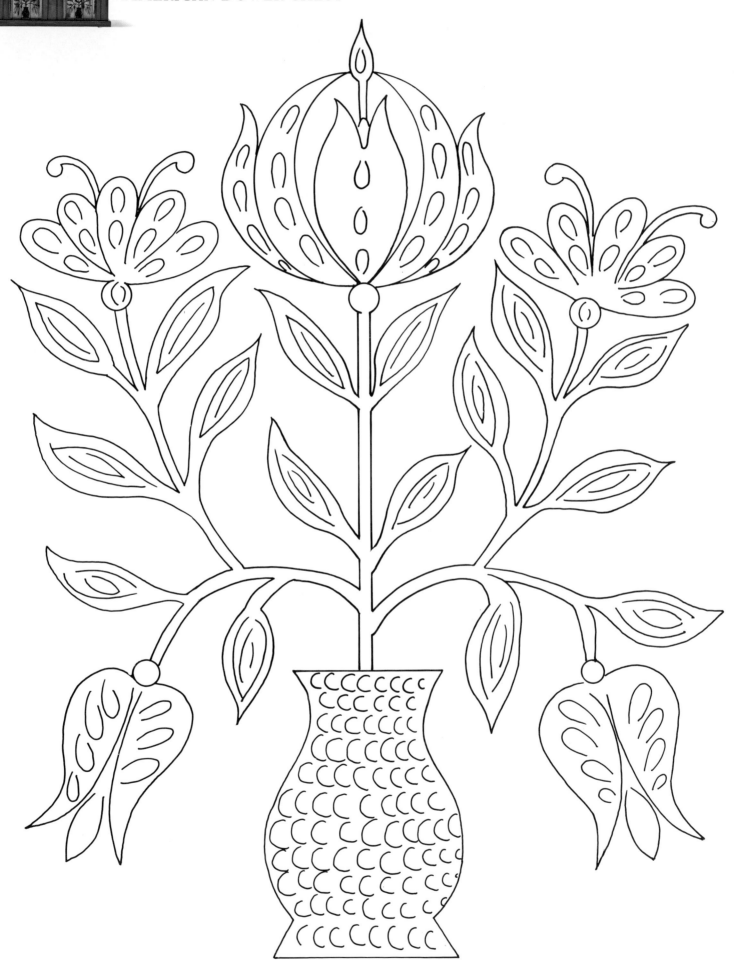

box front and back

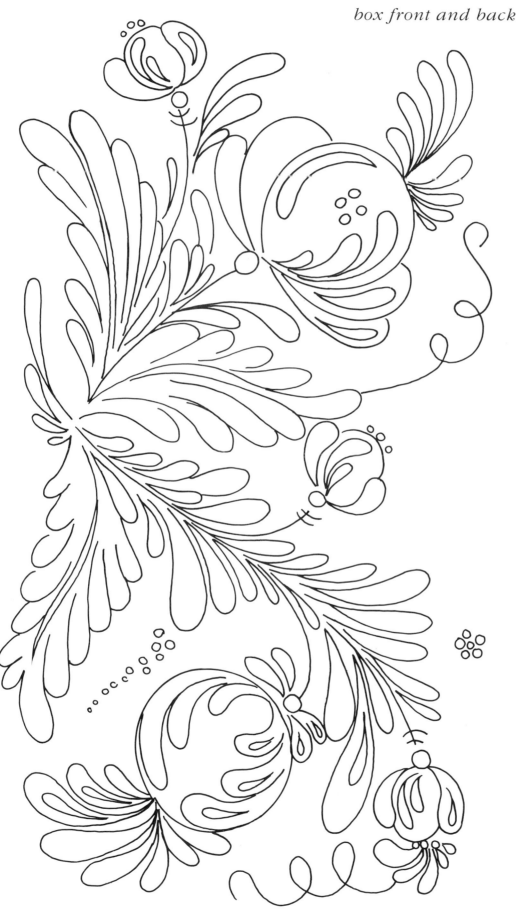

ACKNOWLEDGEMENTS

PHOTO CREDITS

ii Don Klumpp/The Image Bank; 8 Australian Picture Library/ ZEFA/ZENTRALE F; 9 M. Salas/The Image Bank; 12-13 Adam Bruzzone;14 Ignacio Urquiza; 15 D.W. Hamilton/The Image Bank; 24 and 25 Lisl Dennis/The Image Bank; 32 International Photographic Library; 33 Stockshots/Clifford White; 64 Elizabeth Whiting & Associates/David George; 76 International Photographic Library; 77 (chest and cupboard) The Norwegian Folkmuseum; 85 Harald Sund/The Image Bank; 104 Austral-International; 105 (tiled wall) Stockshots; 105 (clock) International Photographic Library; 106 (tile) Don Klumpp/The Image Bank; 110 International Photographic Library; 122 Nevada Wier/The Image Bank; 123 Stockshots/Philip Little; 128 Austral-International; 129 (collected items & table cupboard) & 131 (cabin block) A. J. Lewery; 132-135 Adam Bruzzone; other photography by André Martin.

Individual pieces painted by:

Jennifer Bowe - rosemaled tine on 78
Diana Brandt - chair on 33; writing box on 34; cupboard on 43
E. Tomason Ellingsplassen - chest on 77
Beverley Jones - hinderloopen butte on 85
Pamela Jones - spanschachteln on 34; cupboard on 35; Austrian box on 42; woodgrain box on 43 & 173;
Pennsylvania dutch box on 171
Else Jepperson - plate on 79
Dirk van de Lindt - clogs on 84; pot on 85; tray & scuttle on 86-7
Kerry Melbye - earrings on 106 and on 175
Glynne McGregor - target on 35; bucket base on 42; scene on 65; plate & bread holder on 66-7; spanschachteln on 93 & 95; tankard on 129; jug on 130
Pamela Taylor - spanschachteln on 33

Sincere thanks to those who gave their expertise, loaned pieces and supplied materials:

Leonie Draper for additional research and text
Mary-Anne Danaher for photography styling
Kathy Nordstrom for preparing and finishing project pieces
Chroma Acrylics for paints for projects
Myart for paints and brushes for projects
Australian Pioneer Village at Wilberforce for use of location
Antiques Avignon, Paddington for arch on 55; clock on 65 and chests on 66 & 93
Bliss, Woollahra for jug & glasses on 108; woven cushion on 28
Joan Bowers Antiques, Paddington for bowls on 118; shutters & cushions on 28
Coral Vangnes for rug on 79
Country Furniture Antiques for fruit on 16
The Design Establishment for lacquer box on 124
Jannie Drayer for bowl on 77
Elsa's Folk Art Studio for plate on 79
Folk Art Studio for woodgrain box on 43; cabinet on 35; butte on 85; box on 86; tine on 78; bowl & box on 111; plate on 112; dolls on 113; mug on 130; boxes on 171 and 173
Gallery Nomad, Paddington for beads on 30; lantern on 28
Annette Gero, Antique & Patchwork Quilts for quilts on 92 & 96
Home & Garden on the Mall for napkins, straw apple & orb on 38; glass plates on 108
IKEA for linen on 48
Interentre Australia for Mexican pieces on 15-17, 20 and 172
Dirk van de Lindt for designs featured on 86-7
Linen & Lace for gold folder on 56
Nazar Gallery, Paddington for samovar on 118
Patchwork Primitive for houses on 93 and 172
Vicky's Fabrics, Edgecliff for tassels on 44; seat fabric on 56